Turn of the Century

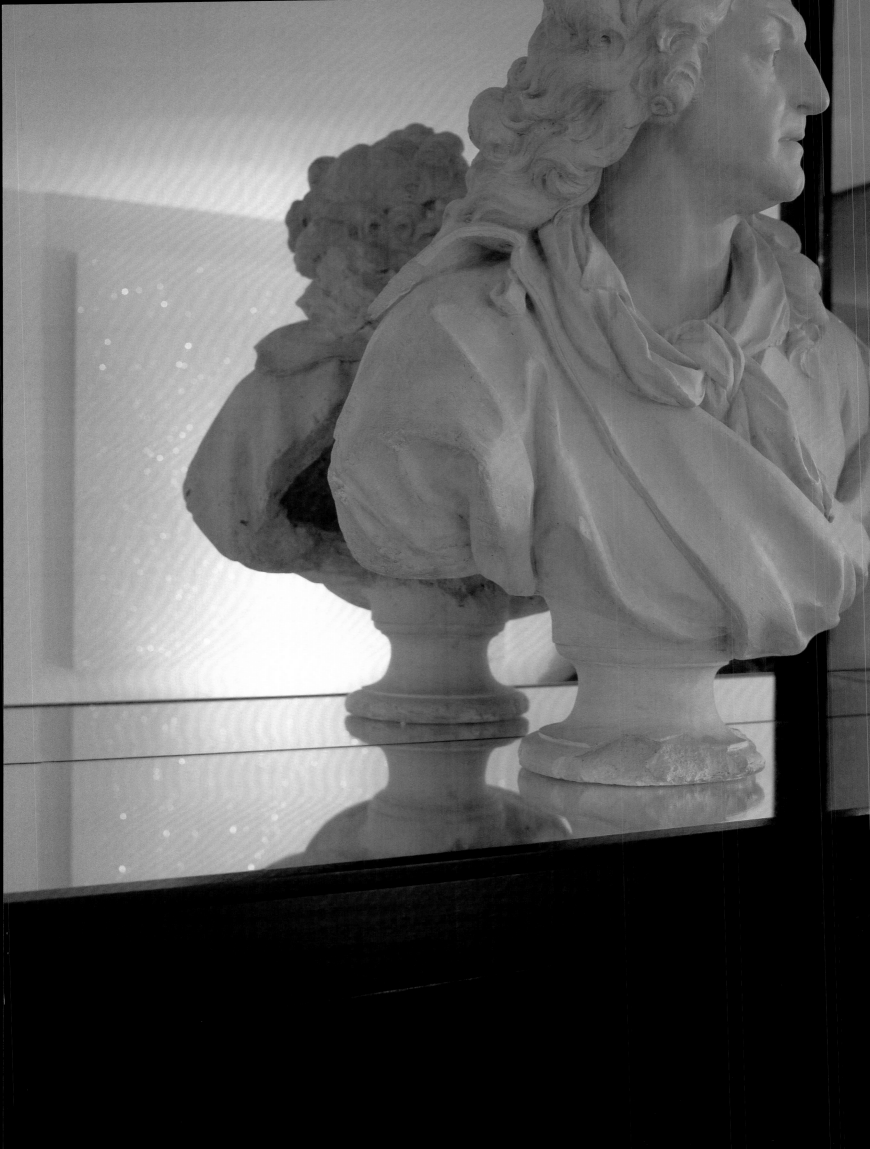

Portraits of Creative Interiors

Turn of the Century

Henry Bourne

Foreword by Jane Withers
Texts by Pilar Viladas with Robin Muir

RIZZOLI
NEW YORK

New York · Paris · London · Milan

Contents

Foreword
by Jane Withers

Welcome to Bourneville! A coquettish Zaha Hadid in a weightless white world. Amanda Harlech posing as a Stubbs stable boy in a Galliano evening gown. An abandoned council flat in a scruffy corner of South London overtaken by Roger Hiorns's otherworldly experiments in the chemistry of color. Richard Prince in the Catskills in the snow, hanging a painting on the exterior of his barn. What do these people and places have in common, and how did they find their way into this book?

When photographer Henry Bourne invited me to write a foreword for this collection of his interiors and portraits from around the millennium, he shared a hefty file of his progress. Scrolling through the images was unexpected and magical. It took me back to the people, places, and ghosts of the time.

The subject of the book is nominally interiors, but these are not homes for clients—they are the private worlds of their makers, and more about creativity than domesticity. The interiors here serve different purposes—a space for an artist to work, a home reimagined as a work of art, a frame for a socialite, a telescopic view of an inner world. Henry approaches them all with an artist's eye for composition and a fascination for the subtle choreography between people and the places they inhabit. Robin and Lucienne Day stand side by side in the dining room of their house on Cheyne Walk. By the mid-1990s the Days were already elderly, but Henry's generous eye is still intoxicated by their halo of glamour. We turn the page into their living room, where the mix of the modern, the nineteenth-century, and the primitive tells us all about the aesthetic journey of this British riposte to Charles and Ray Eames. A few pages on we encounter another creative couple, Tim Noble and Sue Webster, youthful post–YBAs posing at home with an iron and a vacuum cleaner in a ballsy parody of domestic life.

The exceptional thing about Henry's interiors is that they read like portraits. His gaze draws us into the corner of a room or isolates an impromptu vignette, lending the images an aura of hyperreality. We are invited to decode juxtapositions of objects as we do a gesture or posture in a portrait. In Paula Rego's studio, Henry reveals a series of tableaux sketchily assembled from eclectic props and inhabited by the sinister papier-mâché dolls the artist made to serve as models for the demonic characters in her paintings. In the grand Chelsea home of Victoria Press, once briefly inhabited by George Eliot, the birdish American connoisseur appears to live as an eighteenth-century aristocrat; practically the only murmur of modernity is a Belling warming cabinet, the old-school tool of the professional hostess. "I have always tried to approach interiors photography as an exercise in making a 'portrait' of an interior, too," Henry told me. "To attempt to bring out something of the essence of those who inhabit their own worlds."

I first encountered Henry in the 1990s, when he was working for magazines, and many of the stories in this book originated as commissions for *Elle Decoration*, *The World of Interiors*, *Vogue*, and *T Magazine*. His mastery of light and the technical aspects of photography are transformative, but always in the service of capturing the subject, revealing what Henry calls the *essence*. On set, this appears to happen with instinctive ease, but for Henry the preamble to a shoot is a period of tense research—getting under the skin of a subject, understanding the thinking that shapes an interior. Working with Henry on many occasions, I've been amazed by how intensely he analyzes a room and its contents—deftly shifting positions and gently cajoling his subject until he finds the frame that communicates what he intuits. Behind this is a deep appreciation for and literacy in design and interiors, evidenced in the beautiful spaces he inhabits with his wife, designer Harriet Anstruther.

Many of Henry's subjects illustrate what Peter Saville describes as "convergence culture"—the coming together of art, design, fashion, and pop culture; the cross-contamination of parallel worlds in a singular vision. Saville's own apartment is an eloquent example of this. A Mayfair flat known simply as *The Apartment*, it served as Saville's workspace and home in the mid-1990s. An homage to tinted glass and shagpile, it was a bachelor pad conceived as a commentary on the modern bachelor pad and loaded with ironic references from James Bond to Hugh Hefner. The images here, populated by mannequins, were inspired by Roxy Music's "In Every Dream Home a Heartache," a song that has been described as part critique of the emptiness of opulence and part love song to an inflatable doll. The padded, pink telephone number on the wall is reminiscent of the "calling cards" that used to be pinned up in red telephone boxes before sex moved into cyberspace. Damien Hirst's *Pharmacy* is another example of the hyperliterate interior, a restaurant that the artist re-created as a replica of a real-life pharmacy, where diners perched on pill stools amid vitrines of pharmaceuticals.

Henry is fascinated by the evolution of a house or building, and many of the stories featured here reveal the accumulation of lives that contribute to the character of a place. Lypiatt Park, a manor house dating back to the thirteenth century, was bought as a decrepit wreck by sculptor Lynn Chadwick in 1958, two years after he won the international sculpture prize at the Venice Biennale. Four decades later it is inhabited by his youngest son, Daniel Chadwick, also an artist, who has added his own work to the evolving story of the house. In Henry's narrative, he draws out what Pilar Viladas describes as "the most compelling dialogue" between two generations of artists.

Artists have often been pioneers in reshaping the map of a city. In 1950s New York, Abstract Expressionists invented the idea of *downtown* when they moved into scruffy factory buildings in SoHo. In London, the gentrification of the East End was presaged by artists moving to Hackney and Tower Hamlets in the 1970s and '80s in search of cheap studio space. Here we see Tim Noble and Sue Webster in their semiderelict studio in what was then still an impoverished corner of London, contrasted with the uncanny whiteness of the same building when Henry returned a few years later, now converted into the Dirty House by architect David Adjaye in what by then had become happening Shoreditch.

Looking back from today's vantage point, it's easy to feel nostalgic for a time before geopolitics revealed the fault lines in globalism and environmental reckoning cast a dystopian shadow on the future. Henry was fortunate to be documenting prominent cultural figures in worlds of their own making, at a time when there was still space for creativity in the cracks of everyday life. Henry approaches these people and places with an empathy and curiosity that draw out the best in them and make them topical long after the magazines have faded. It reminds me of an aside by Irving Penn in an interview in 2009: "We don't call them shoots here. We don't shoot people. It's really a love affair."

Introduction
by Henry Bourne

Over the past three decades, I have been lucky enough to have been asked to photograph some of the design world's most prominent and significant creative figures. Interior designers, architects, artists, and many others have generously shared their homes, studios, and their work for the images and stories collected in this book.

Often, my time with them turned out to occur at the very start of their careers or, serendipitously, at its cutting edge; in any case, I believe, always at crucial moments. So, this is essentially a collection of portraits of individuals, but set within the interiors they have created and often where they live and work. I have tried to include a variety of subjects to show the breadth of genius and imagination I have encountered over the years. Inevitably, finalizing the edit from such a wealth of talent was daunting, though in the end greatly rewarding. By necessity, this book offers merely a glimpse of the fascinating spaces and people I have had the pleasure to photograph. It has been a joy to have had such privileged access. I have always tried to approach interiors photography as an exercise in making a portrait, an attempt to bring out something of the essence of those who inhabit these private worlds, as well as, of course, to record their art and design. To step into the lives of other people, however fleetingly, and to meet some of my heroines and heroes, has been inspiring.

Although many of these pictures have been seen before, mostly in magazines, in nearly every case I have included new or previously unseen images. The limitations of print space and other variables left them unpublished in their time. Seen together now, I hope they highlight what I believe to be an intriguing period in the history of modern design.

I am apprehensive before any shoot: nervous about meeting these remarkable people, worried whether they'll like the pictures, anxious about the uncontrollable vagaries of light and weather. Happily, any nervousness usually evaporates as the front door (or its equivalent) opens.

When I look at my photographs of Robin and Lucienne Day's house, taken in 1996 (page 22), I remember being both excited and nervous on the day of the shoot. I had always admired Robin's furniture and Lucienne's textiles, having grown up with Robin's unbreakable stacking polypropylene chairs, designed for Hille in 1963, in every school classroom of my youth. Built to last (and 50 million units later), they withstood even a slovenly teenager rocking back and forth on two of the legs. Often orange-colored, they seemed to cheer up the dreary mid-1970s Britain of power cuts and the "three-day week." In fact, the Days' earlier designs had had a similar effect some twenty years before, part of a postwar optimism that affordable, modern design could improve people's lives in a 1950s Britain recovering from the hardships of the previous decade.

My grandmother had curtains made from a Lucienne Day textile; they made her home feel bright and stylish, though I knew nothing back then about textile designers. By then the Days' designs were not exactly new, but they felt, to my youthful self at least, contemporary and forward-thinking. Some twenty years on, while photographing the couple in their elegant early Victorian town house in London's Chelsea, its immaculate midcentury interior still looked as modern and daring as it must originally have been. I recall Robin and Lucienne discussing sustainable design, recycling, and protecting our planet's future. Today, the Days' opinions seem all the more prescient and pressing.

London's East End has always seemed to be in a permanent state of reinvention, its neighborhoods rising and falling in popularity as inhabitants move in and then move on. I lived there during the 1990s and saw firsthand the gentrification, for example, of Shoreditch. Once a largely working-class area and heavily bombed during the Blitz, it was an affordable part of the city that particularly attracted those in the creative industries, while much of neighboring Spitalfields had already been overrun by well-to-do artists and fashionable Londoners. When the city's art world underwent a renaissance in the runup to the turn of the century and a loose-knit group of friends and rivals, the Young British Artists (YBAs) and the post–YBAs, became successful, they converted their postindustrial live-work spaces into polished studios and homes.

Collaborators Tim Noble and Sue Webster were one such couple. Their East End studio-cum-home, the Dirty House (page 110), which they acquired in 1998, had once been a furniture warehouse on the "wrong side" of Liverpool Street before its reimagining in 2002 by architect David Adjaye. I met the artists around that time and took some photographs of the building before its renovation. Sex workers populated the street day and night. When the project was completed four years later, I was invited back to photograph the couple's reinvented home, now christened the *Dirty House*, for British *Vogue*. Essentially a black box, it now had a gleaming exterior that encompassed a capacious first-floor studio and a sleek apartment above. The sex workers, still around, used the studio's mirrored windows to check their makeup. Tim and Sue have moved on, and the Dirty House is now a popup store for major fashion brands. And so, the transience and transformation continue.

In 1980s and '90s Britain, the government granted residents of council houses (public housing) the right to purchase their rented homes, and many buildings that had lain empty for years were earmarked for future redevelopment at that time. Cholmeley Dene in Highgate, North London (page 80), was one such abandoned house, owned by the local health authority. In 1989 a group of young artists took over the building—in near total disrepair, and uninhabited for nearly ten years—and squatted there. They set about reimagining its interior, randomly restoring fallen plasterwork and papering the walls with pages torn from magazines. They alchemized a ruin into something scarcely imaginable: Cholmeley Dene became an artwork. Having discovered this extraordinary place, my friend Elspeth Thompson suggested it as a feature story to Min Hogg at *The World of Interiors*. They both recognized the beauty and significance of this domestic installation-cum-artwork, very much of its moment, and gave it ten pages in the magazine. A year later, the artists were forced out of the home they had created when their local council sought to reclaim the property and sell it to developers—also very much of the moment. Some of the artists moved on to an abandoned Quaker hall in Hackney and built *The Ark* (pages 89–91), taking with them remnants of their former home, and two years on, the house still sat empty. Today, Cholmeley Dene is, inevitably, luxury apartments.

I have included the studios of the late Paula Rego (page 188) and of Richard Prince (page 64), as well as the legendary if short-lived restaurant *Pharmacy*, set up by Damien Hirst (page 72), and Roger Hiorns's spectacular installation *Seizure* (page 128). They're here partly because I think they are important additions to understanding how we work within our spaces and how the worlds of art, design, and architecture collide, but also because they offer fascinating insight into the artmaking process itself, and how these artists' pioneering spirits even shape how and where we choose to live.

In some cases, I have photographed creative people at multiple stages in their careers and lives, such as the industrial designer Marc Newson. I've included Marc's bachelor-era apartment (page 92) from 1999 along with the current home he shares with his wife, the fashion consultant and then *Vogue* contributor Charlotte Stockdale (page 142). I'm not only fascinated by the evolution of his aesthetic, but also intrigued by the results of their collaboration—a unique melding of their very personal styles. I found a parallel in the homes of Faye Toogood and her husband, Matt Gibberd (page 176), a design-world couple with markedly different tastes. Matt's instinct for pared-down modernism and Faye's for collections and the arrangement of objects somehow collided without conflict.

The call time to photograph the late Zaha Hadid's home in Clerkenwell, London, for British *Vogue* (page 134), was nine in the morning. Our team of eight people, a relatively small one by *Vogue*'s standards, gathered outside her front door. We rang the intercom but there was no answer. Did we have the wrong day? Zaha's go-between, Roger Howie, arrived. We did have the right day, he said, seemingly unperturbed at the lack of a welcome. He called upstairs; still no reply. When he finally managed to speak to Zaha, she told him she didn't wish to be photographed after all. Roger suggested the rest of us go for coffee so he could "begin the negotiations." He had clearly done this before. Around eleven he called to say that Zaha had conjunctivitis and wouldn't be able to participate. I suggested that this could easily be solved in post-production.

More discussions followed until at last we found ourselves inside Zaha's hallway. I met with Zaha alongside *Vogue* editor Nonie Niesewand, Roger, and the magazine's ever-stoic photography director-cum-diplomat Michael Trow. We sat with Zaha over Turkish coffee and discussed her extraordinary work, what the article would cover, and how incredible her home was. "But I didn't build the apartment," Zaha protested. "You can take a portrait, but you can't photograph the apartment." I spent the rest of the day taking portraits of her. Gratifyingly, there was no sign of any conjunctivitis, as far as I could tell. When I returned the next day to photograph the apartment, I understood why she might be reticent about sharing her home so publicly. Inside, it was a private world, showcasing a range of her futuristic furniture and other work. At first the session felt a little unsettling, then after a while it became strangely calming and intensely personal.

I owe a huge debt of gratitude to all the magazine editors who commissioned me over the years. My life has been the richer for their trust in me. The late Min Hogg, founder and editor in chief of *The World of Interiors*, was an inspiration. She celebrated the incongruous and exulted in the paradoxical, combining—way before anyone else—glamour and decay, vintage and modern, clutter and minimalism, the urban and the rustic. Always the unexpected. I first met Min in the late 1980s; I showed her some photographs I had taken of New Age travelers, a subject surely irrelevant to interiors photography. Immediately she gave me my first assignment (in 1987), and in so doing introduced me to a world of insiders and outsiders, many of whom have become lifelong friends.

I started taking photographs for the British edition of *Elle Decoration* from its inception in 1989. This was a significant time for interiors photography as well as for design publications. Founding editor Ilse Crawford and editors Jane Withers and Sue Skeen, among others, sought pictures that brought buildings and interiors to life, and brought something idiosyncratic to the pages of the magazine—portraits, rather than still lifes, of spaces that included the owners or custodians, or at least some personal trace of them, a photographic style uncommon in those days. When photographing unpopulated interiors, we would ask ourselves, Who has just left the room?

I am indebted to all those who opened their residences, and often themselves, to me. It is no easy thing to let someone inside your home to photograph it. I know how intrusive it can feel to have strangers in one's most personal space, often rummaging around every corner and recess and moving things about to get the perfect shot. Even photographing the home I shared with my wife, designer Harriet Anstruther (page 196), felt uncomfortable to me. I appreciate the trust that my subjects have placed in me. I like to believe that on most occasions I came in as a stranger but left as a friend.

Looking back, I am struck by how timeless so many of the older stories still seem to be. They might easily find a place in the pages of current publications without looking incongruous. Further, although I have arranged the book chronologically by decade, many of these spaces and buildings could easily have been created within any of the last three decades—or indeed beyond.

A few years ago, I asked my artist stepdaughter, Celestia, which era she considered old-fashioned. She replied, "anything last-century," and I unthinkingly assumed she meant the nineteenth century. Perhaps timelessness is subjective.

Opposite: Pages from Henry Bourne's Polaroid scrapbooks, 1990s.

Villa Volpi by Tomaso Buzzi

Though he was a captain of industry and a controversial fin-de-siècle politician, Count Giuseppe Volpi is chiefly remembered for bringing electricity to the northwest of Italy and to many of its neighboring Balkan states. But he was also an art lover and bon vivant—he founded the Venice Film Festival and, alongside his wife, Countess Nathalie Volpi, threw legendarily glamorous parties in the couple's opulent Venetian palazzo, brimming with film stars and the international glitterati of the early 1930s.

The count died in 1947, and in the early 1950s his widow's thoughts turned to commissioning a new home. She hired the Milanese architect Tomaso Buzzi, who had earlier worked for the Volpis on restoring Villa Barbaro, their magnificent house northwest of Venice that was designed by Andrea Palladio in the late 1550s, and who had led extensive renovations on Piero Portaluppi's Villa Necchi Campiglio in Milan, built between 1932 and 1935. The balance of history and innovation was a Buzzi signature; he was a leading light of the Novecento movement, a Milan-based group that advocated classical ideals of architecture in response to the modernism of the 1930s. From 1932 to 1934, the multifaceted Buzzi was art director of the Venetian glassmaker Venini, for which he designed pieces in his signature elegant, classically inspired but clean-lined style.

For Countess Volpi's new home on the Tyrrhenian coast southeast of Rome, Buzzi conceived the neoclassical Villa Rocca del Circeo, commonly referred to as Villa Volpi. Completed in 1958, it appears to rest upon a sand dune overlooking the sea. Supported by giant concrete foundations buried deep under the sand, the wings of the villa are discreetly connected by underground tunnels. While the house has a symmetrical neo-Palladian layout with its arches and Ionic columns, it also has a modern spareness that reflects its era. Buzzi designed the original furniture for the villa in a similarly scaled-back, neoclassical style.

The countess entertained widely at the Villa Volpi, shown here in photographs from 1997. Even then, there was an almost palpable aura of the dazzling guests who had partied and vacationed there. One could easily imagine Maria Callas and Cecil Beaton sipping cocktails on the extravagant terraces with the countess.

When she died in 1989, the villa passed to her son, Count Giovanni Volpi, the flamboyant former owner of the celebrated Scuderia Serenissima Formula 1 team. Count Volpi sold the villa in 2018, and with that a glamorous era came to a close.

Villa Volpi by Tomaso Buzzi, Sabaudia, photographed in 1997.

Page 14: Count Giovanni Volpi. *Page 15:* View of the villa from the beach. *Page 16:* A brick building with reproduction statues, behind the villa. *Page 17:* Terrace with views of the sea and Mount Circeo. *Pages 18–19:* Salon with reproduction Pompeian bronze furniture. *Page 20:* Bedroom with reproduction antique furniture. *Page 21:* Terrace with Palladian-style Ionic columns.

Villa Volpi
by Tomaso Buzzi

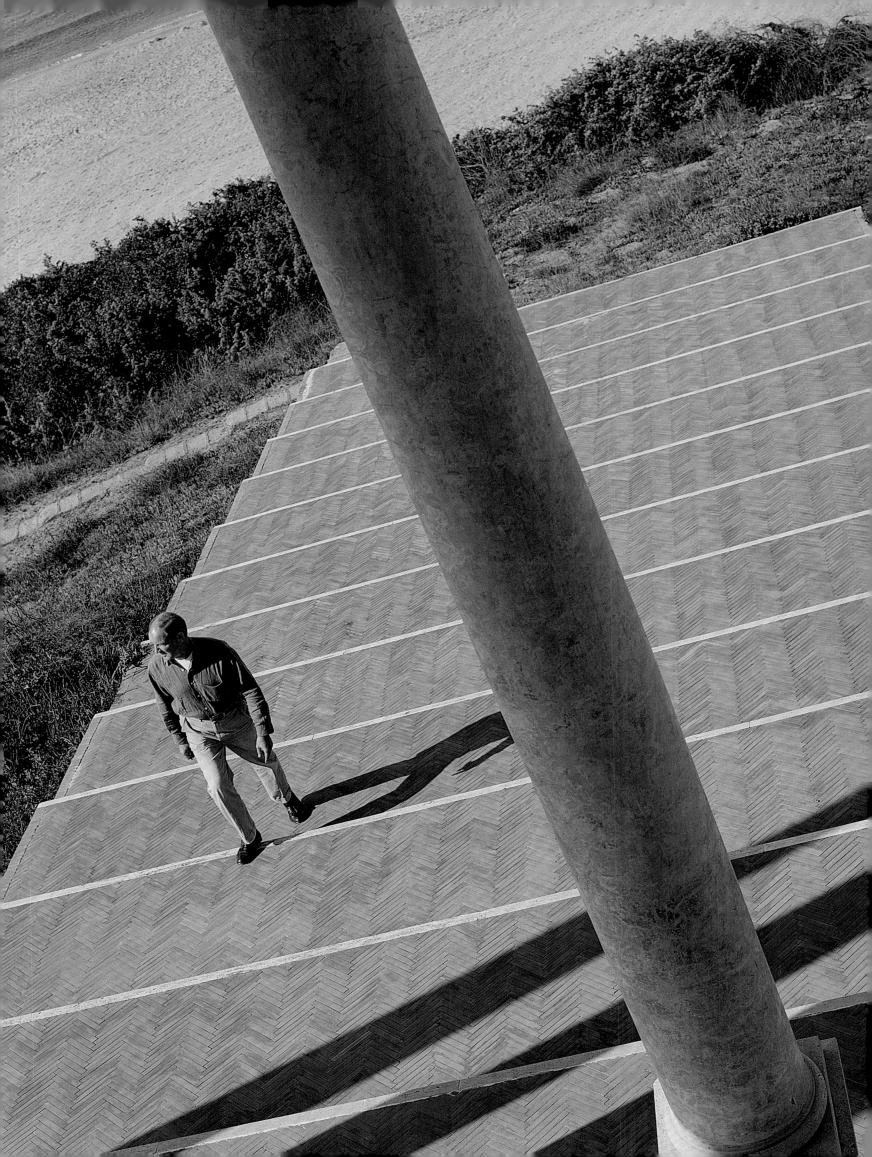

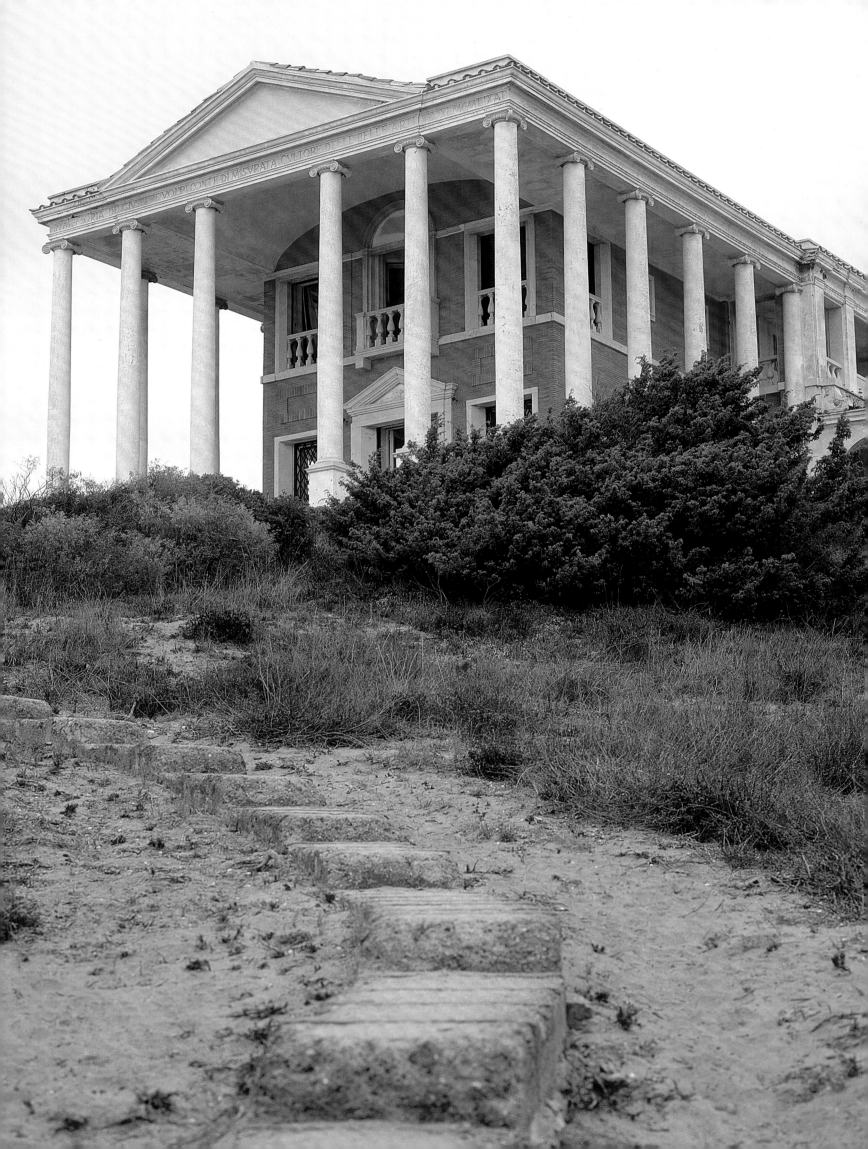

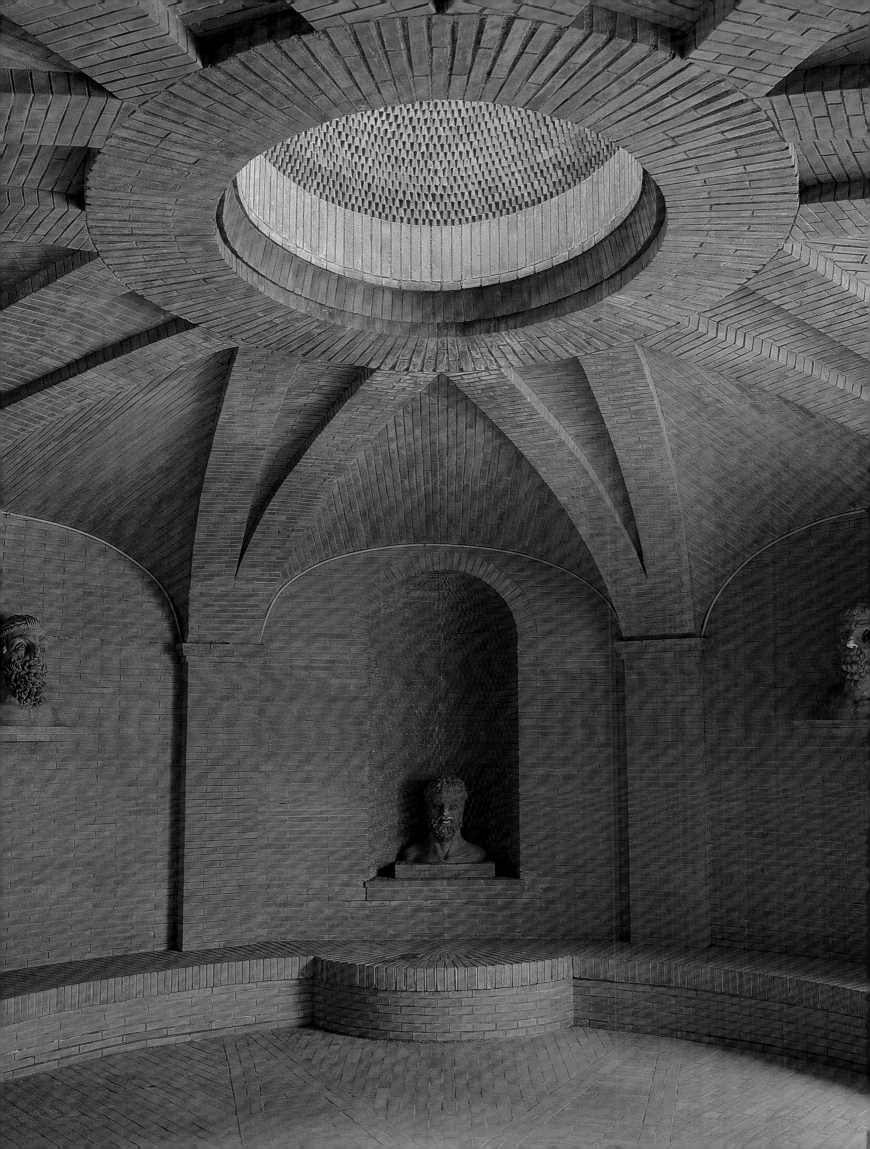

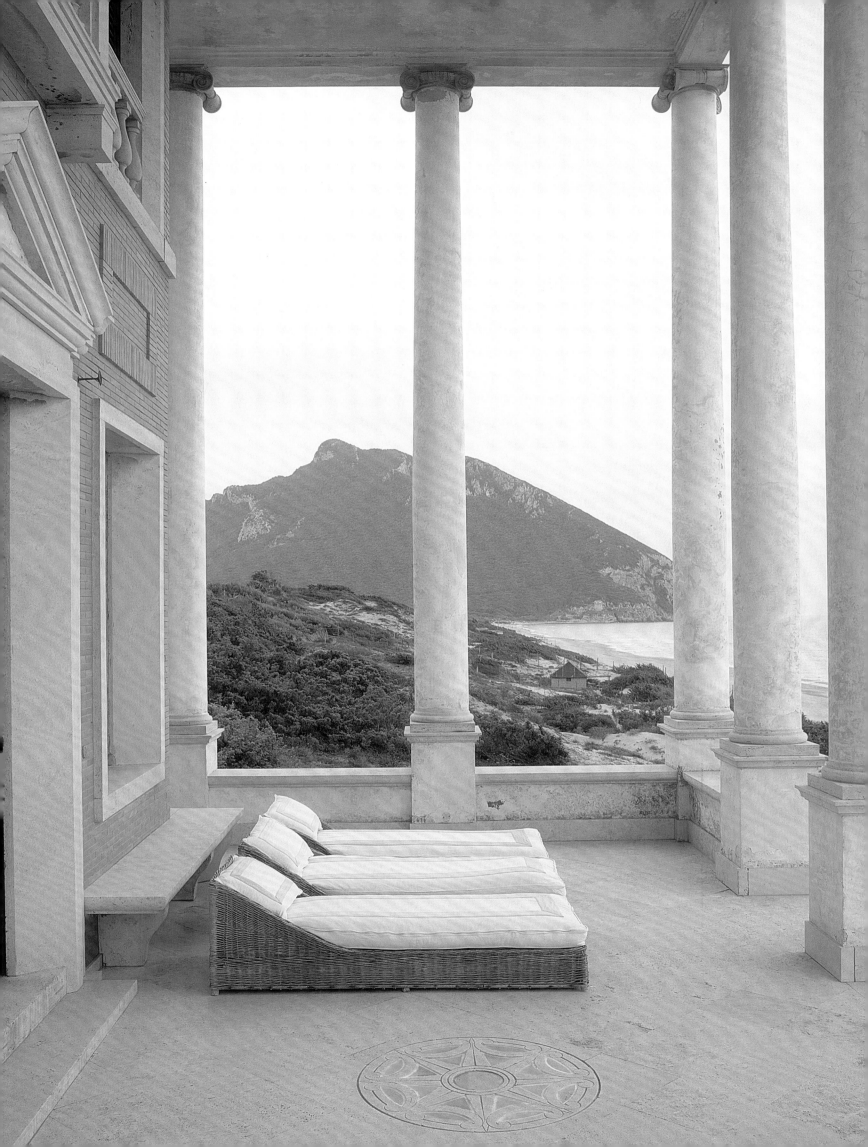

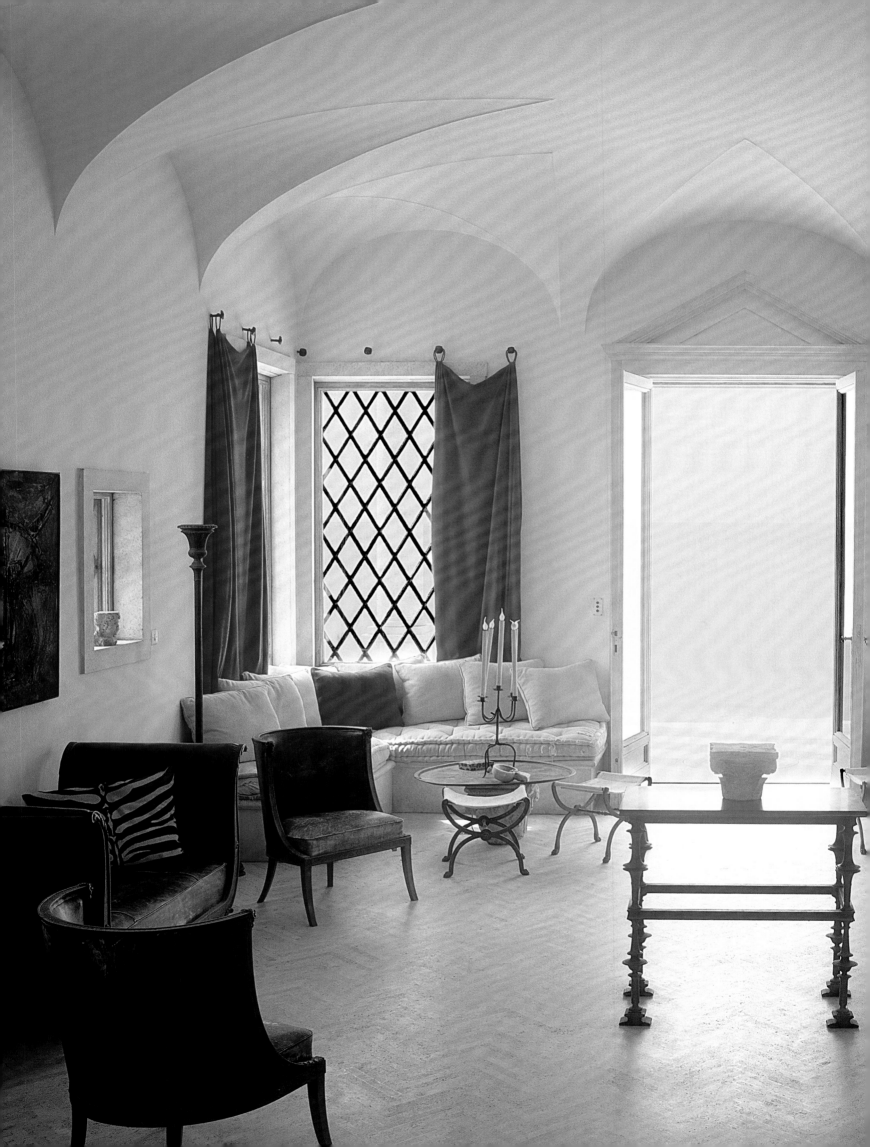

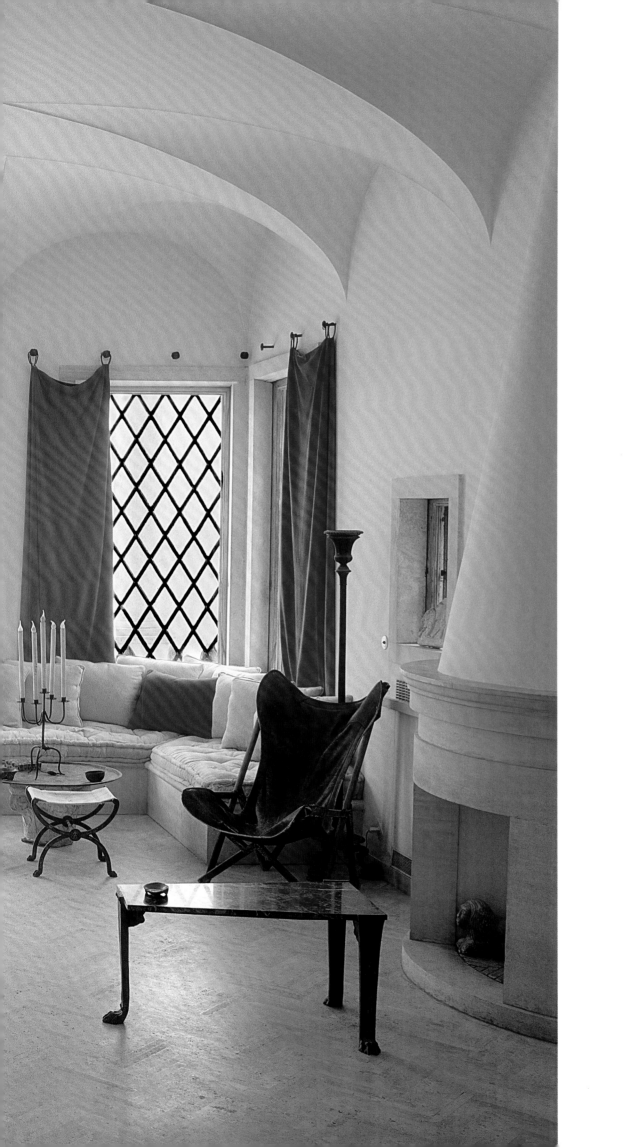

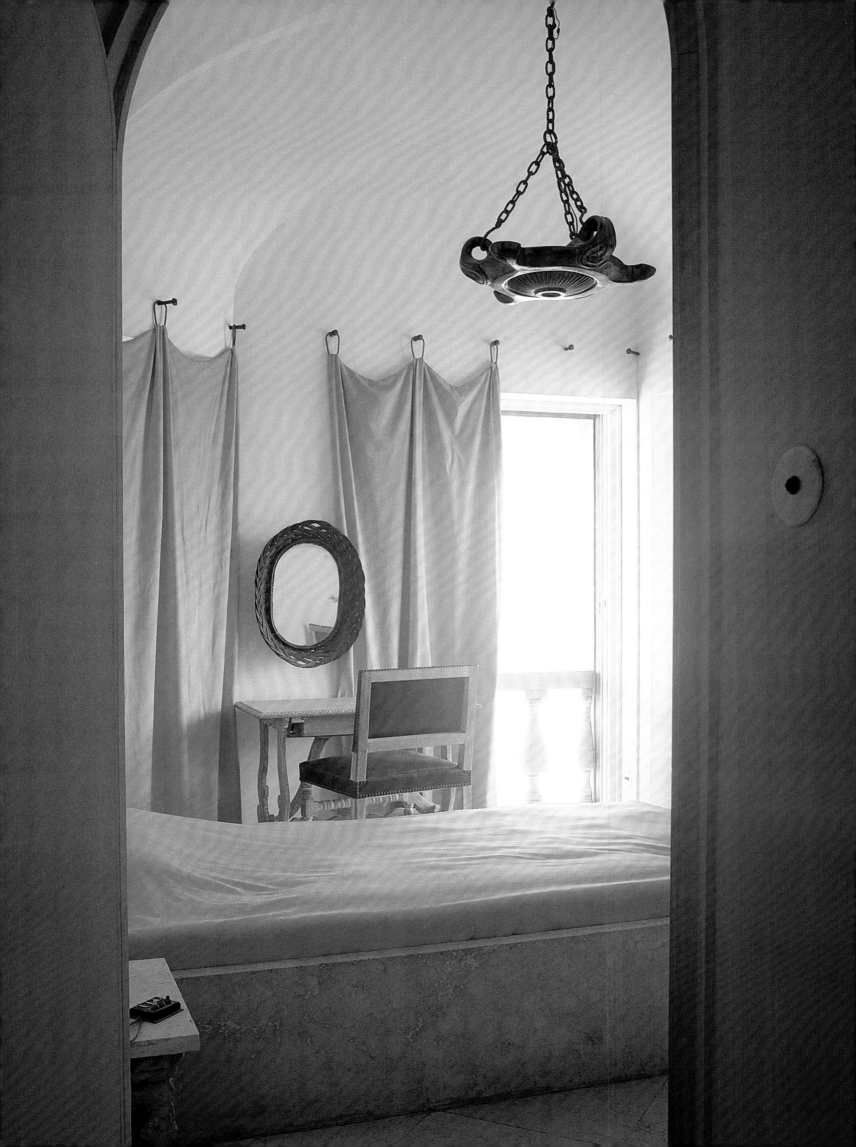

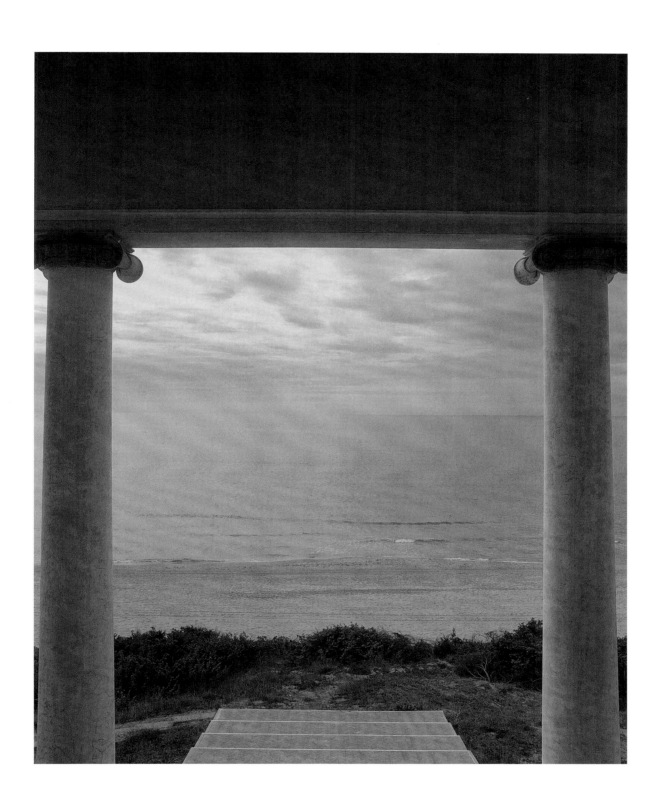

Robin & Lucienne Day

Robin and Lucienne Day's house on Cheyne Walk in London was one of the most celebrated interiors in postwar British modernism, and the Days themselves perhaps the best-known and most influential designers of the era—he with furniture, she with textiles. The couple met in 1940 as students at the Royal College of Art, London, and married two years later.

When Robin and his colleague Clive Latimer won first prize in the International Competition for Low-Cost Furniture Design, held by the Museum of Modern Art in New York in 1948 (they had submitted a design for a modular plywood storage system), it led to a commission to design all the furniture—including auditorium seating for audience and orchestra, the restaurant, and lounge chairs—for London's Royal Festival Hall, built for 1951's Festival of Britain. This in turn led to a long and productive relationship with the British furniture company Hille. Robin's first low-cost stacking chair—these would make his name—was the elegant bentwood Hillestak, and he would go on to design in 1963 the world's first polypropylene chair, its shell molded from the then-new plastic and mounted on a metal stacking base. Fifty million units were sold, and Hille has produced it in successive incarnations ever since.

For Lucienne, too, the Festival of Britain was a turning point. After several years of designing textiles for fashion companies, she decided to move into fabrics for the home. She designed screen-printed fabric and wallpapers for rooms that Robin had created for the festival's Homes and Gardens pavilion. One of these, Calyx, a lively and abstract print for Heal's, was an instant success. She went on to design many more such textiles for Heal's, as well as successful lines of tableware for Rosenthal, but by the late 1970s Lucienne was concentrating instead on artworks, chiefly her silk mosaics, colorful one-of-a-kind pieces that she continued to make through the next decades.

The Days moved into their Cheyne Walk home in 1952, transforming an early Victorian house into a showcase of what then stood for the most contemporary of design. In 1996, when these photographs were taken, the interiors had changed little. The couple shared an open-plan studio on the ground floor, while Robin used a basement room as his workshop. The living room was sparely furnished with Robin's designs, mostly for Hille, including his elegant Reclining Chair from 1952. In time those would be replaced with his handsome timber-cased Forum sofas, created in 1964, and later still by an acrylic-and-glass coffee table, one of Lucienne's silk mosaics, and a chain-link curtain separating the living and dining areas.

The Days shared the postwar optimism that progressive design had the power to improve people's lives. But they further believed that modern design should be well made, functional, and comfortable—and affordable. As their daughter, Paula, who established the Robin and Lucienne Day Foundation in 2012, recalled, "Like every child, I took my parents' lifestyle for granted, and, like every adolescent, I rebelled against it. Meanwhile, of course, I was absorbing their underlying values and aesthetic—a sense of calm spaciousness, long, low lines, honest open structure, enjoyment of organic materials, as well as sparing use of rich colors. I understand that these are, of course, characteristic of modernism, but they were also expressions of my parents' personal strength and integrity. I now live with many of their designs in my own home, where they look—well—very at home!"

In the late 1990s, designer Tom Dixon, then creative director of Habitat, collaborated with Robin on the reissue of several of his signature pieces, including the Forum sofa and chair. This was part of Habitat's 20th Century Legends collection ("I had this idea to revisit some of my heroes," Dixon says), and the company also revived some of Lucienne's textiles. Regrettably, this renewed interest did not last beyond Dixon's tenure.

Not long after, the Days departed Cheyne Walk for a town house in Chichester, West Sussex. The new millennium saw Robin continuing to work, including consulting on the 2006 refurbishment of the Royal Festival Hall, with which he had been so closely associated half a century before. There has been a steady revival of interest in their oeuvre, not least with an exhibition at the Barbican Art Gallery in 2001, and that same year a documentary, *Contemporary Days: The Designs of Lucienne and Robin Day*.

Lucienne died aged 93 at the beginning of 2010 and Robin at 95 as the year wound to a close, but the enthusiasm for their legacy has not flagged. As Paula notes, "Our Robin Day and Lucienne Day centenary celebrations in 2015 and 2017 greatly raised their profiles, certainly here in the U.K.," adding that her parents' pioneering work "is increasingly viewed not just as fashionably 'retro' or 'midcentury,' but as transcending its time through its sheer quality—it is justifiably classic."

Robin and Lucienne Day's house, Chelsea, London, photographed in 1996.

Page 24: Robin and Lucienne Day. *Page 25:* Dining room with polypropylene chairs by Robin Day for Hille; rosewood dining table by Robin Day; and *Faunes et Flores d'Antibes*, 1960, a lithograph by Pablo Picasso. *Pages 26–27:* Sitting room with Forum II sofas, 1964, by Robin Day and *Boat House*, a silk mosaic by Lucienne Day.

Robin & Lucienne Day

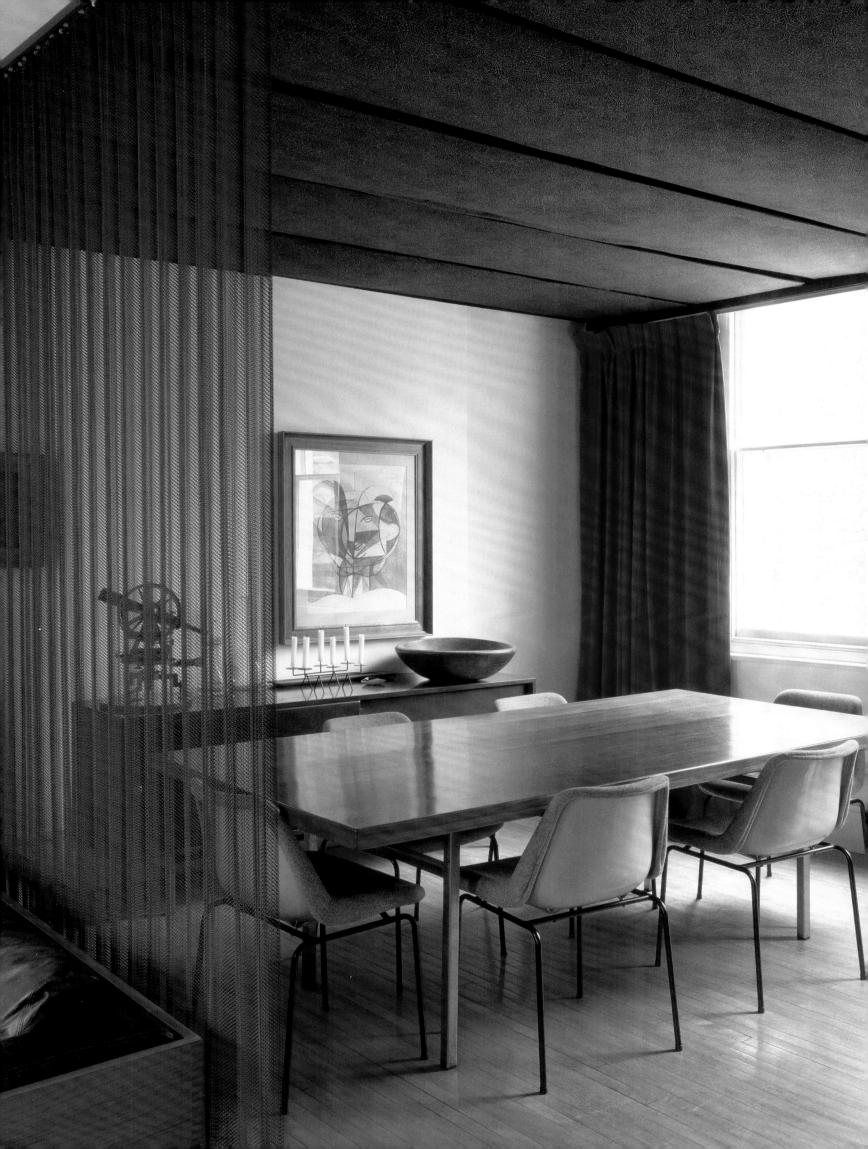

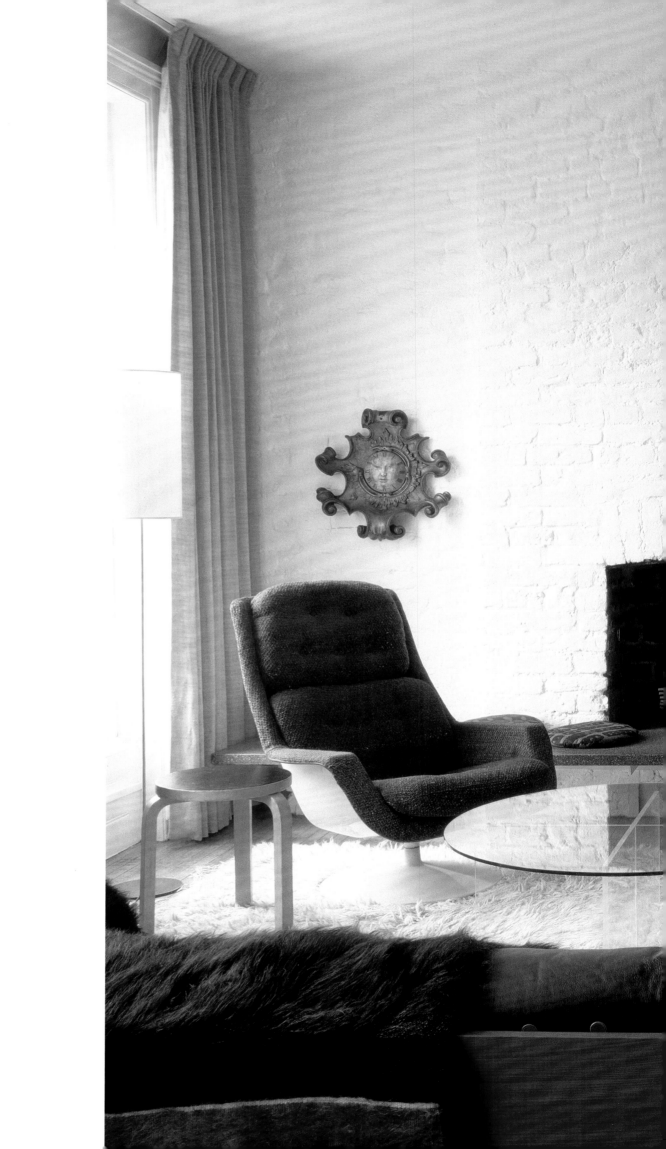

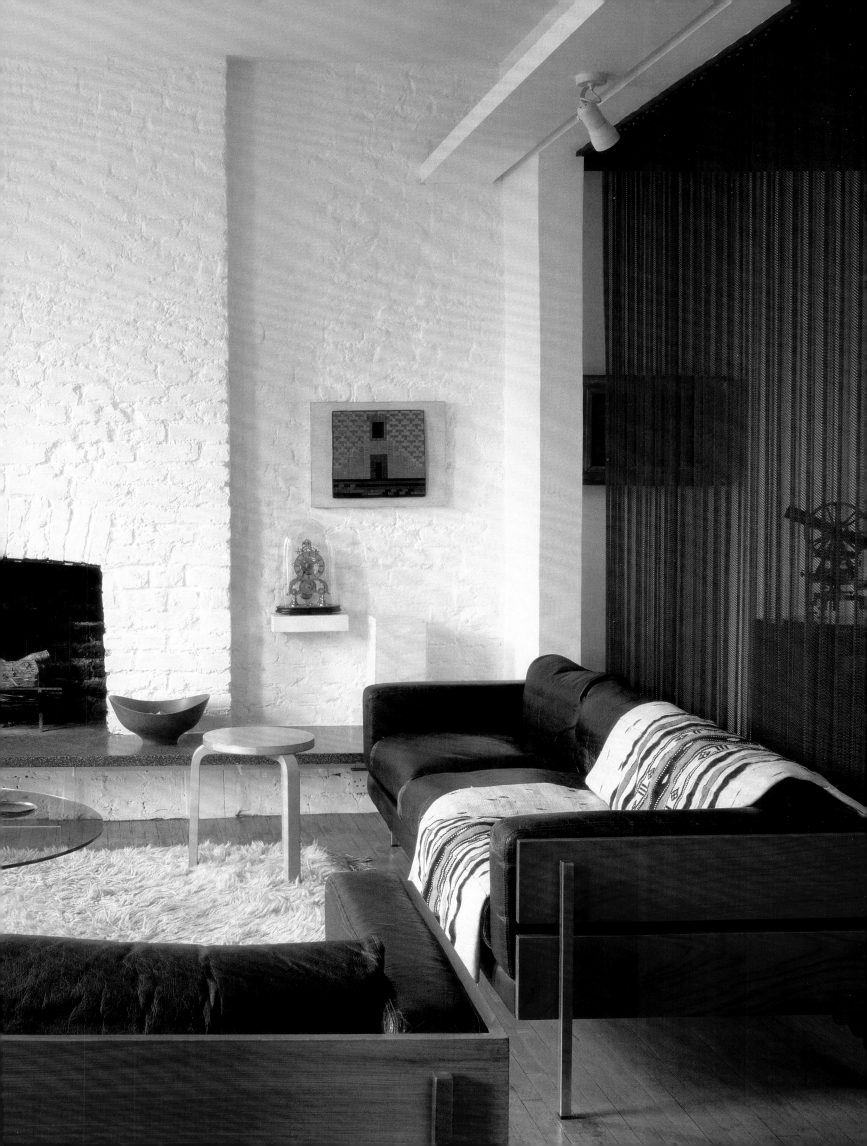

Vincent Van Duysen

Belgian architect Vincent Van Duysen is known for his elegant, understated, clean-lined architecture, interiors, and furniture. Since establishing his practice in Antwerp in 1989, he has designed everything from residences in Europe and Asia to the New York headquarters for the fashion house Loro Piana and the La Rinascente department store in Milan. He has also designed products for the Italian lighting company Flos, the Danish textile maker Kvadrat, the Italian ceramics firm Mutina, and the Italian furniture company Molteni&C, where he has been creative director since 2016.

When these photographs of Van Duysen's apartment in Antwerp were taken in 1996 for *Elle Decoration*, it was, almost unbelievably, the first time his work had been seen in print. His postindustrial space occupied the top floor of a former spice and rubber warehouse; its neutral colors and refined textures were perceptibly lighter in the kitchen and study, while the living room and bedroom were rendered in slightly darker tones and with more pronounced textures. Van Duysen retained the rough wood floors and exposed plumbing, conserving much of the apartment's historical footprint.

The repurposing of industrial buildings was nothing new in 1996, but Van Duysen's juxtapositions of serene monochromatic colors with authentic features and patinas were ahead of their time. The magazine feature also informed a new style of interior photography—relaxed and naturalistic, warmed by Van Duysen's informal presence (although his color-coordinated outfits were nothing if not flawless). The founding editor in chief of British *Elle Decoration*, Ilse Crawford, adopted the style as something of a template for future editorials.

The impact and influence of Van Duysen's apartment still resonate. In 2019 the *New York Times* included the living room on the *T Magazine* list of "The 25 Rooms That Influence the Way We Design," alongside such iconic spaces as the vast living room in Cy Twombly's apartment in a seventeenth-century Roman palazzo; the beaux-arts reading room of Paris's Bibliothèque Sainte-Geneviève, by Henri Labrouste; the salon of Pierre Chareau's Maison de Verre, also in Paris; and, of all places, Stonehenge. For Van Duysen, the apartment was home. "Design," he says, "is my life, working every day, thinking and sketching in my mind, to share the beauty of the world. It is a process that never stops."

Vincent Van Duysen's apartment, Antwerp, photographed in 1996.

Pages 30–31: Living room. *Pages 32–33:* Vincent Van Duysen with artwork by Alex Hartley. *Page 34:* Kitchen. *Page 35:* Vincent Van Duysen.

1990 s

Vincent Van Duysen

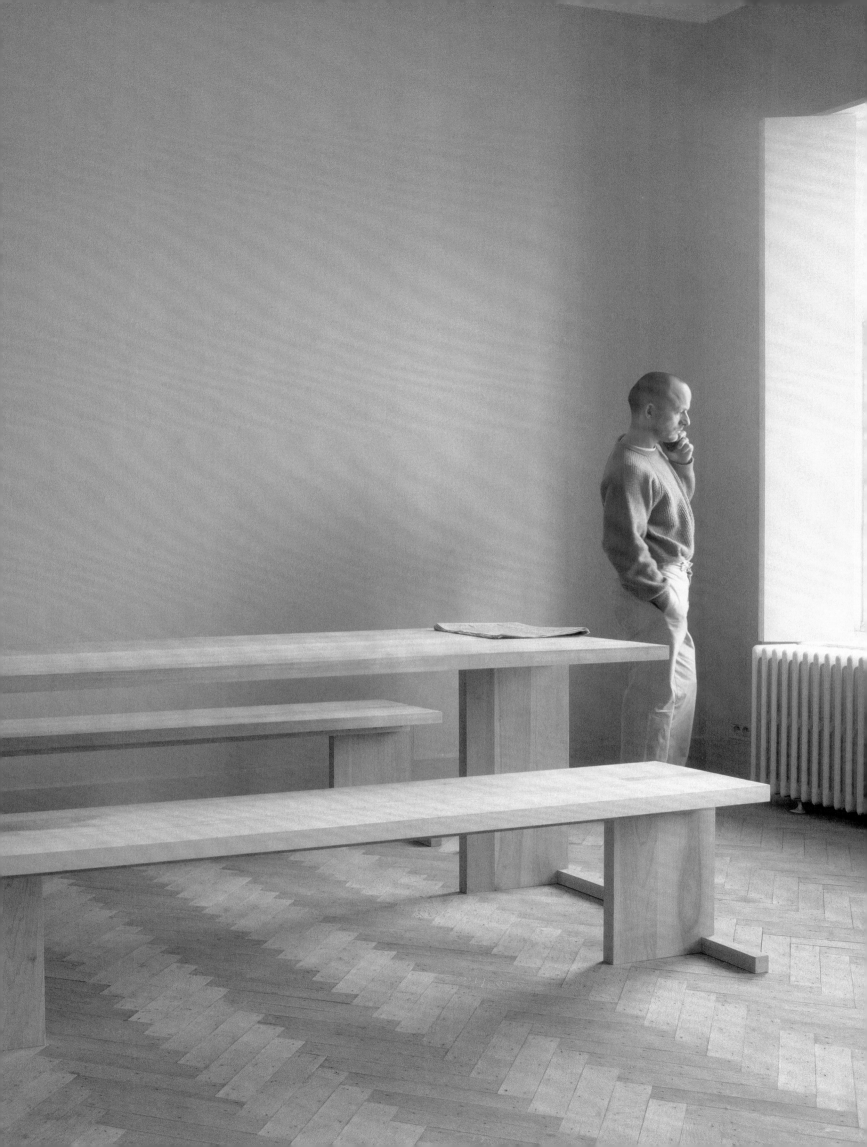

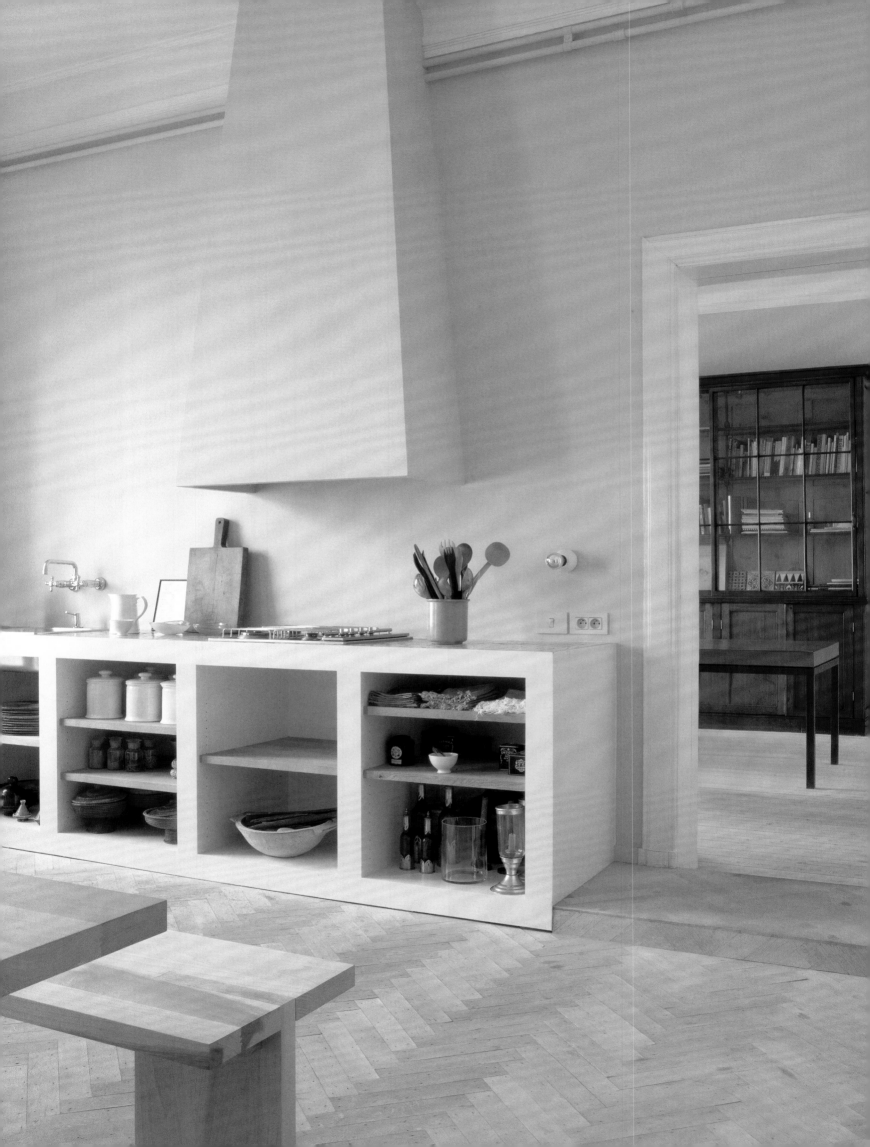

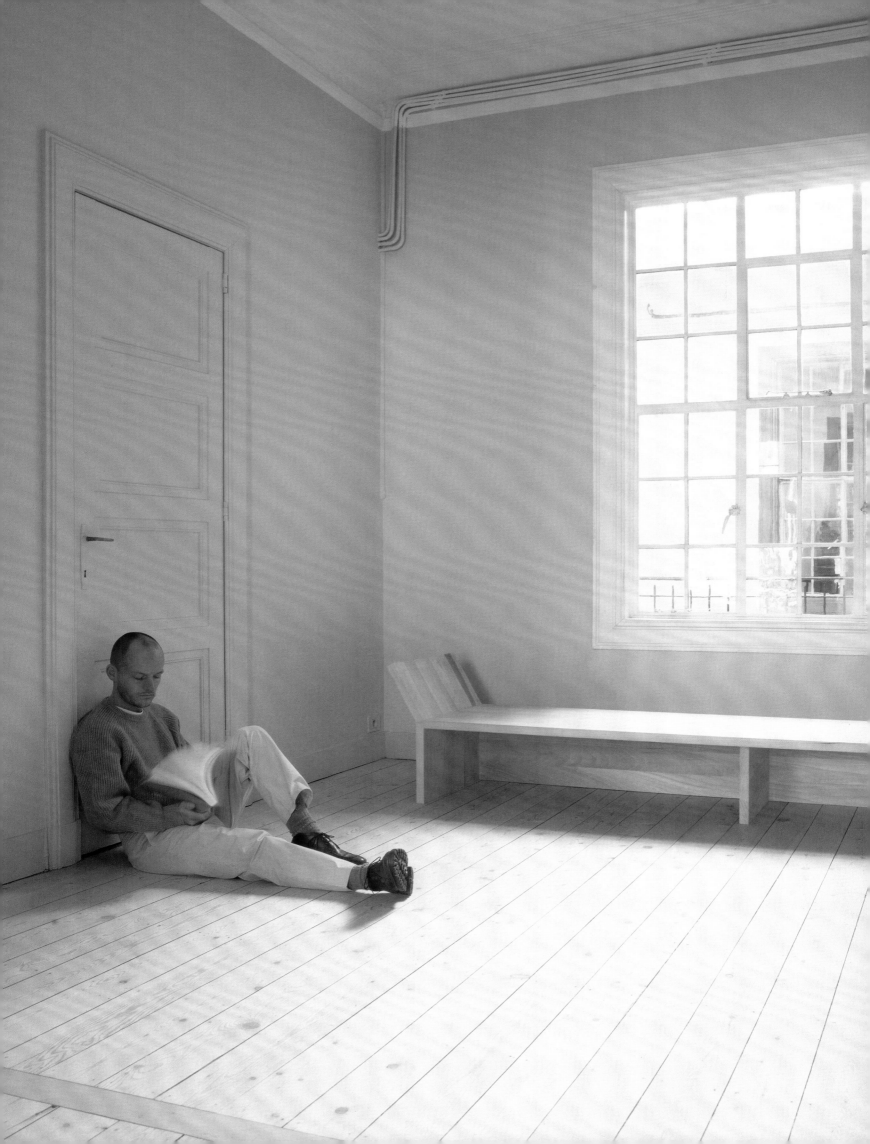

Amanda Harlech

A prominent figure in the fashion world for nearly four decades, creative consultant Amanda Harlech opened up her idyllic—and, it must be said, somewhat drafty—Shropshire family home in 1995 for *W* magazine. At the time, Harlech was working as creative director for the fashion designer John Galliano, and their artistic partnership lasted some thirteen years. They met when he was a student at London's St Martins School of Art and she a junior fashion editor at *Harper's & Queen* (formerly, and later again, *Harper's Bazaar*). Their connection was immediate and deep, and they collaborated on Galliano's collections and shows, initially producing them with minimal budgets but impressive ingenuity.

By 1995 Harlech divided her time between London, Paris, and this inspiring, romantic, and entirely self-effacing house in the wilds of the Shropshire countryside, on the family estate of her then-husband, Francis Ormsby-Gore, Lord Harlech. With its peeling paintwork and threadbare curtains, it might appear poles apart from the rarefied world of haute couture—but among the overcoats and jackets piled onto coatracks and the mountains of hats and gloves, a pair of orange suede Manolo Blahnik sandals nestles among rows of muddy riding boots.

Harlech, a famously accomplished equestrian, appears in a Galliano creation alongside one of her horses, Joyita, and later in immaculate tweeds she had earlier worn to muck out the stables. Harlech's then-six-year-old daughter, Tallulah, now an actress who also works in fashion, wears a costume from the dressing-up collection kept in the attic.

In 1997 Galliano was named chief designer at Dior, and Harlech went on to become a creative director with Karl Lagerfeld at Chanel, another longstanding association that ended only with Lagerfeld's death in 2019.

Today, the indefatigable Harlech works with an array of designers including Kim Jones and Silvia Fendi. Andrew Bolton, curator in charge of the Costume Institute at New York's Metropolitan Museum of Art, asked Harlech to consult on the museum's 2023 Karl Lagerfeld exhibition, "an investigative and emotional exploration," as she put it, of her late friend. Harlech has long since departed the Shropshire house. "It's strange to see how some things never change; the farm I live in now echoes to the sound of that dream world," she says, remembering the former family home. She still rides, although she has just one horse now, which, she says seems "odd—there always used to be foals and yearlings in the fields." Harlech continues, "The long view is very important to me, and my new home is now surrounded by the magnificent blue hills of Wales."

Amanda Harlech's house, Shropshire, photographed in 1995.

Page 38: A stack of hats and gloves in the bedroom. *Page 39*: Amanda Harlech. *Page 40*: Harlech's desk. *Page 41*: Kitchen. *Page 42*: Boot room with a pair of Manolo Blahnik sandals. *Page 43*: Harlech with her horse Joyita. *Page 44*: Tallulah Harlech. *Page 45*: Harlech wearing a gown by John Galliano.

1990s

Amanda Harlech

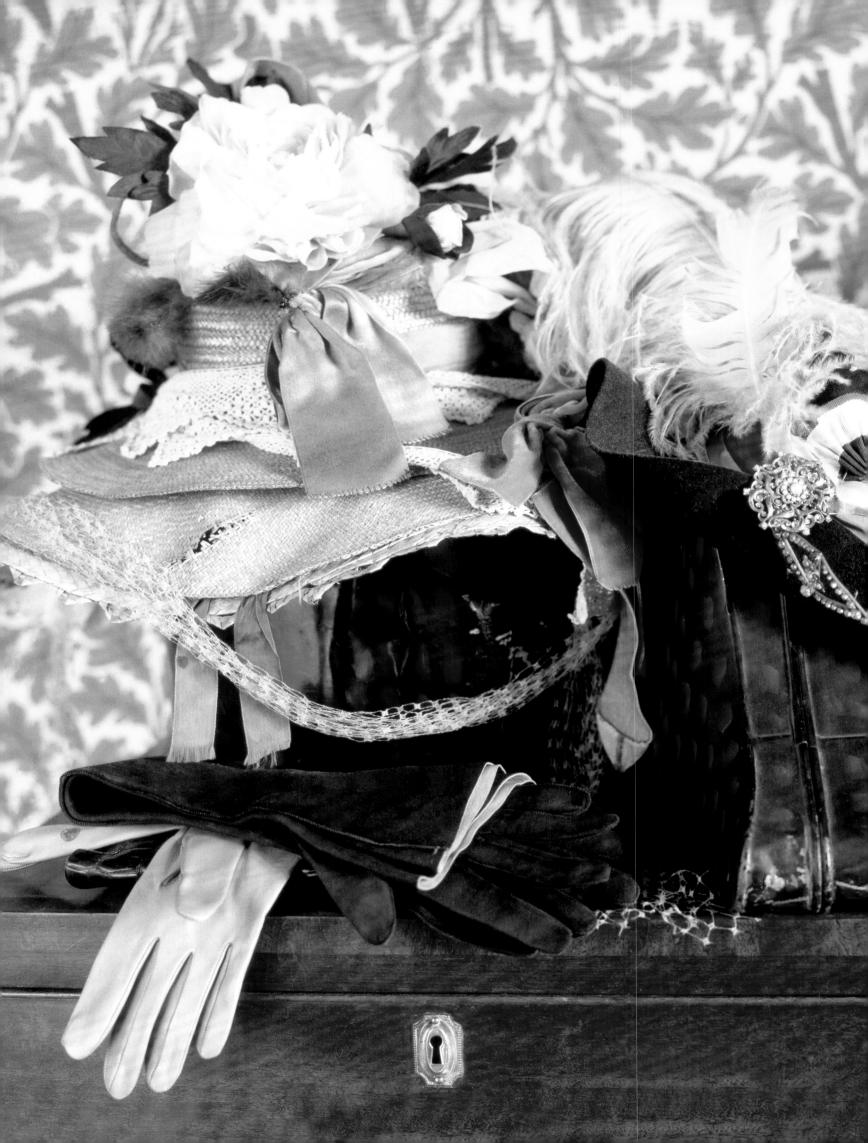

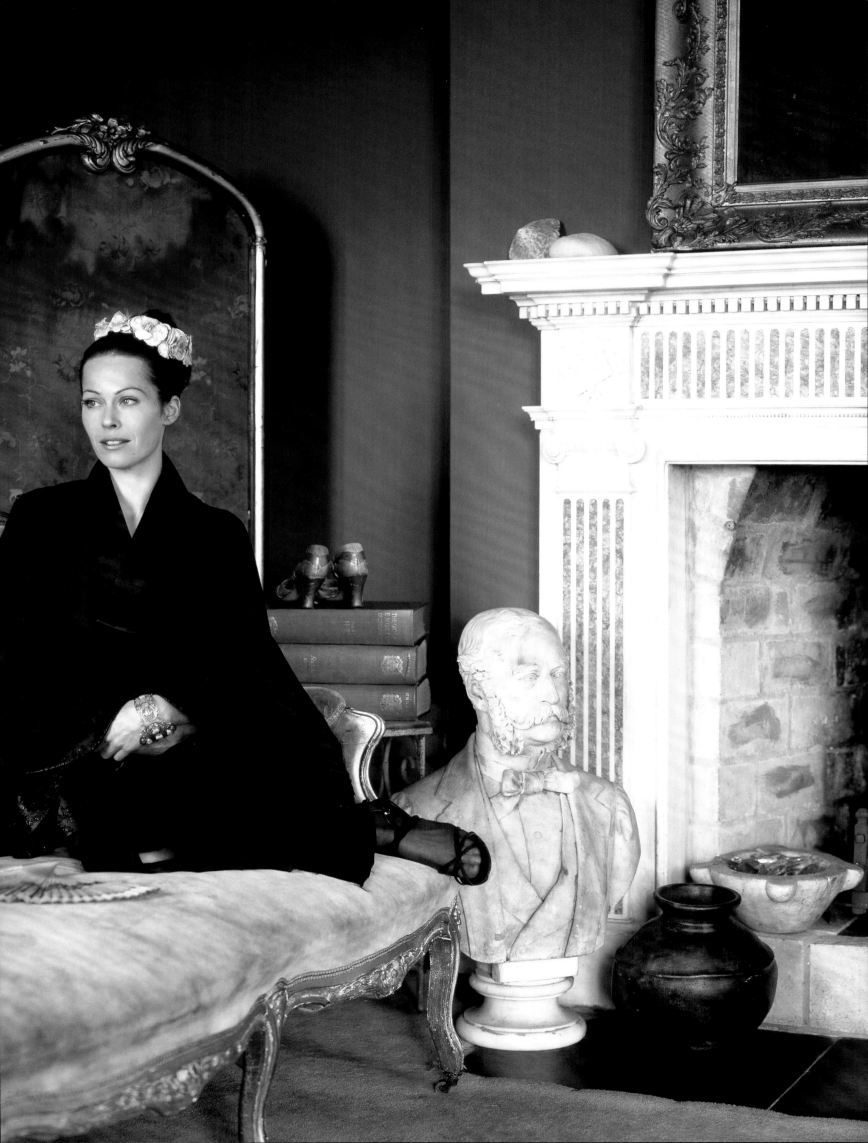

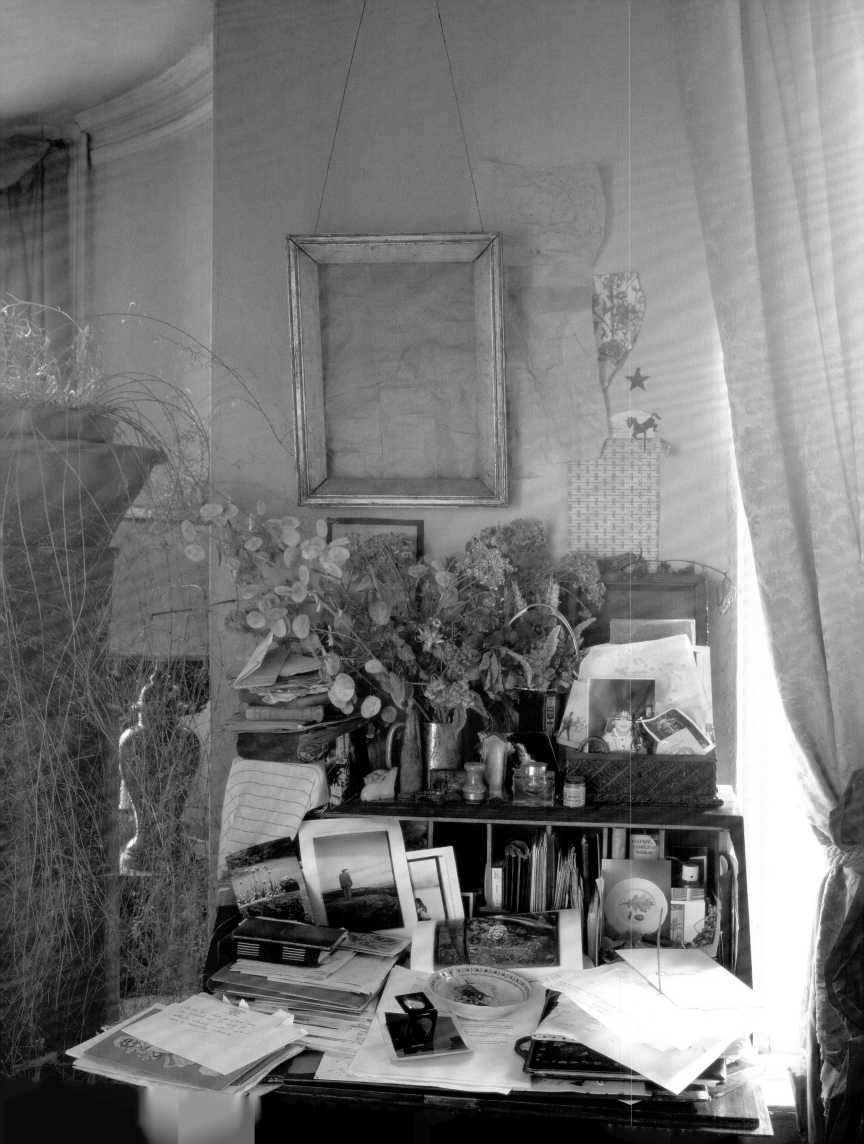

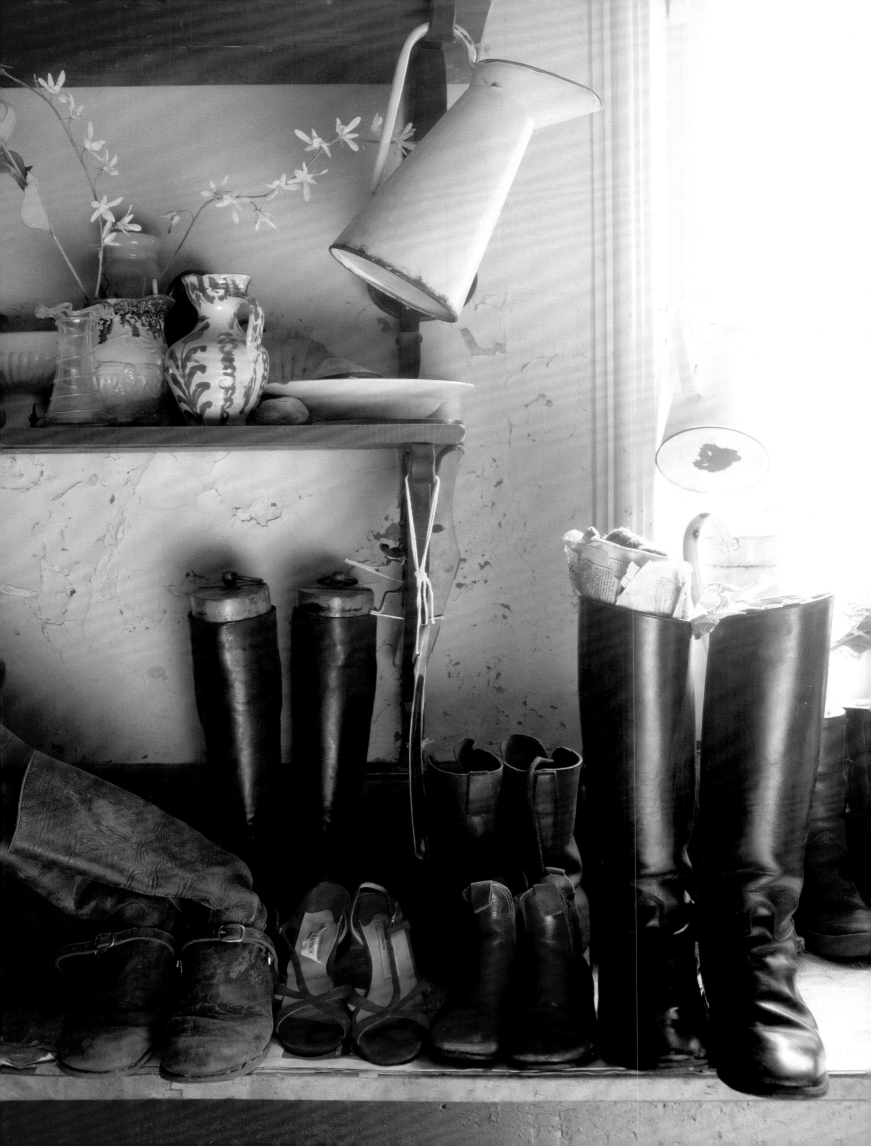

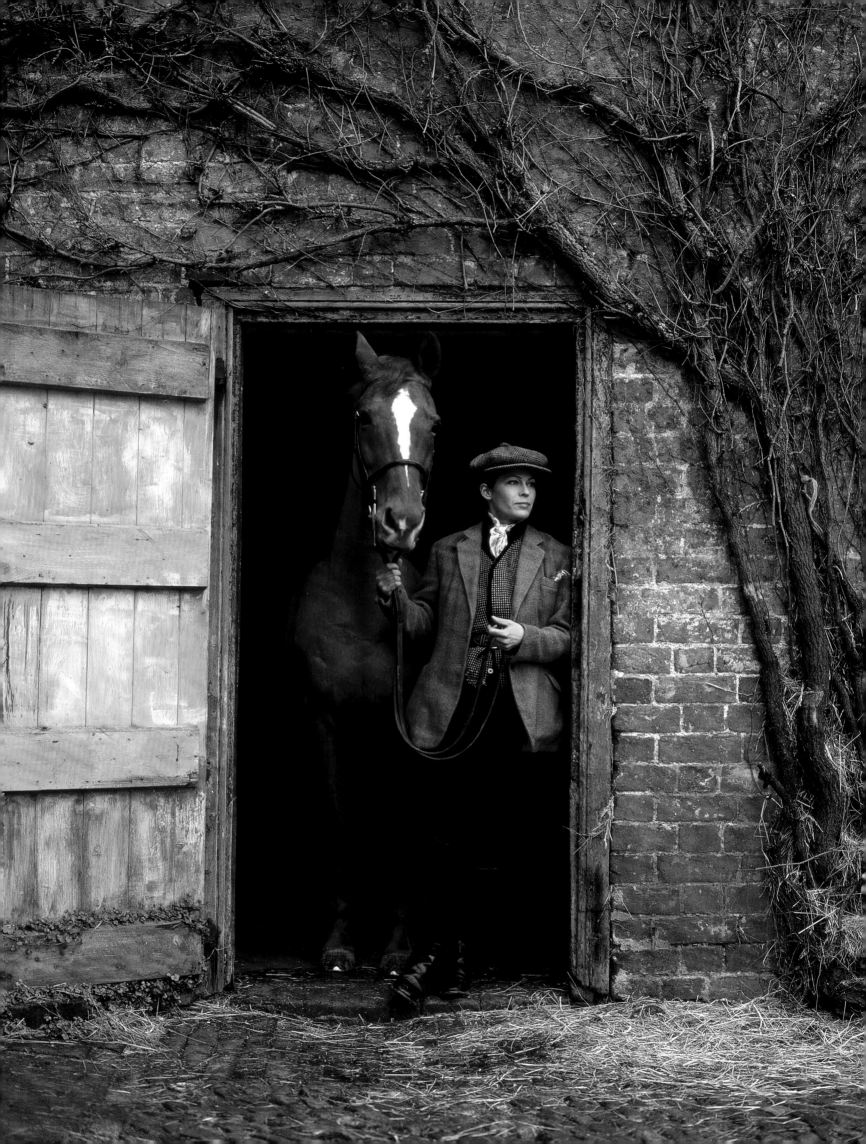

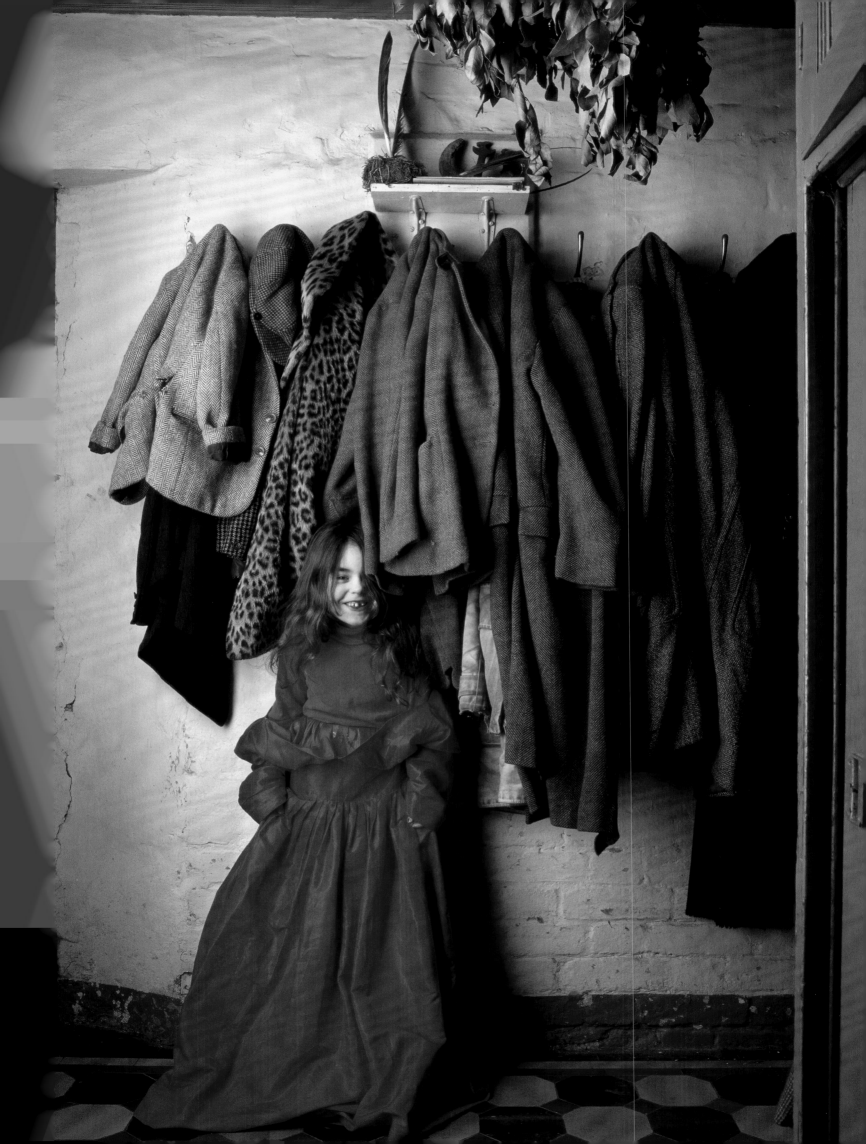

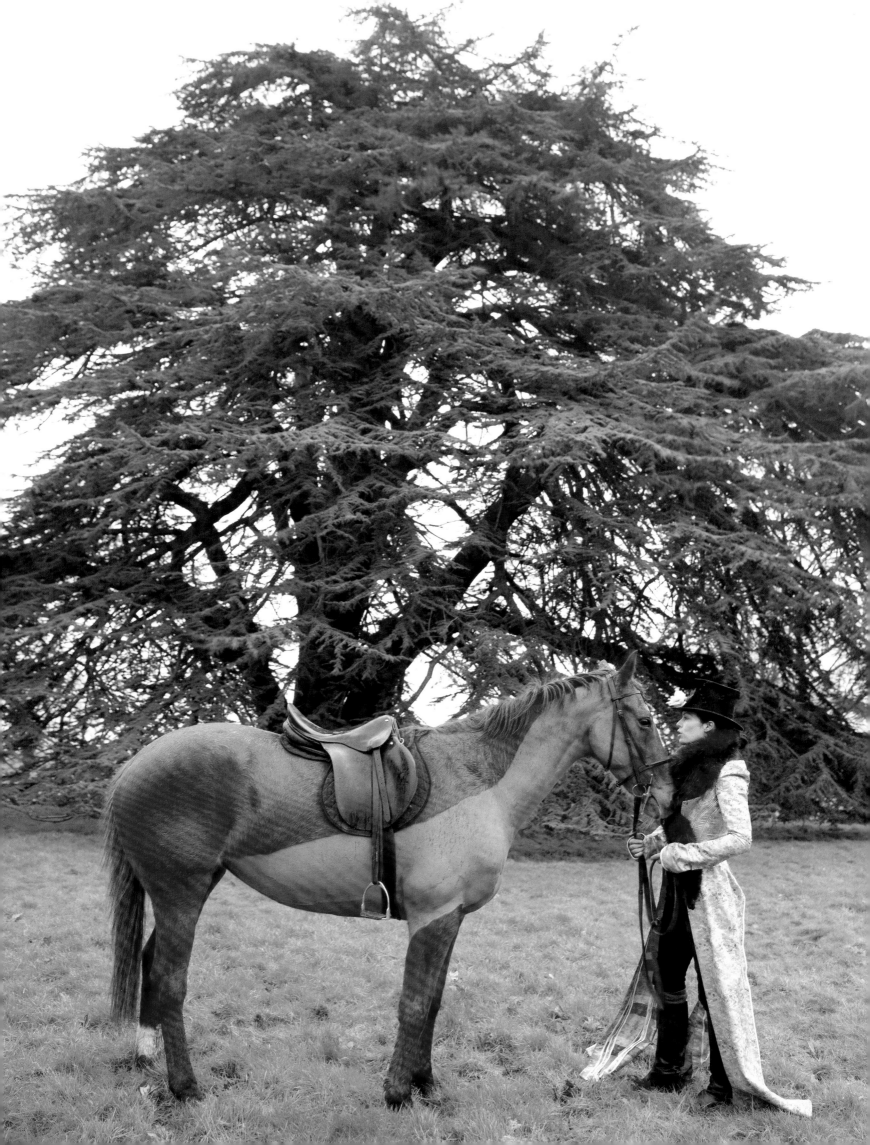

Peter Saville

One of the twentieth and twenty-first centuries' most prolific creative directors, Peter Saville draws a stellar client list from the worlds of art, fashion, and music. But his work of the late 1970s and early 1980s, for the emergent Manchester-based Factory Records label and particularly his album covers for the bands Joy Division and New Order, are icons of modern British popular culture—so much so that his cover art for New Order's 1983 album *Power, Corruption and Lies*, with its playful subversion of a still life by Henri Fantin-Latour, was honored as a Royal Mail postage stamp in 2010.

Alongside his fellow Mancunian, interior designer Ben Kelly (with whom he had worked on the pioneering "postindustrial chic" designs for the Haçienda nightclub in 1982 and the Factory Records headquarters in 1990), Saville was pivotal in creating a "Manchester aesthetic," which it might not be too outlandish to claim triggered a regeneration of the city itself. Fittingly, in 2004, Saville was appointed the city's official creative director.

After a spell in Los Angeles, Saville relocated to London. In 1994 he acquired an apartment in an overlooked section of Mayfair—prompted by fellow creative director Mike Meiré, who thought it was perfect for the sort of "salon-office" that Saville had previously imagined, where Meiré and Saville could open an office together, and Saville would live.

Recently vacated by a businessman, it was decidedly 1970s in look, complete with, as Saville recalls, Verner Panton's exaggerated three-tier light fixture from the Fun series, an acreage of mirrored walls, a bedroom with a black-lacquered bed, and midnight-blue velvet walls. The price was reasonable; the real estate agent had been trying to rent the apartment for a long time and the then-tired, original 1970s interior was deeply unfashionable.

Saville brought Kelly onto the project, too. "We refreshed what needed to be refreshed while keeping the good bits," Saville remembers. White carpeting and new furniture—a black leather sofa from de Sede, a rosewood-and-steel desk, an Eames office chair, and aluminum vertical blinds were installed. Above the desk: Stephen Hepworth's *Simply the Best*, a telephone number rendered in voluptuous pink satin. A plaster bust of Louis XIV, the Sun King—placed in the entrance hall (page 2)—had appeared on the cover of New Order's 1989 single "Round & Round," which was art-directed by Saville and photographed by Trevor Key.

Saville says that he has always been interested in "what you describe as styling—that is actually what I do, from the point of view of the sensibility of the now. In college, I was delighted to discover the word 'zeitgeist,' and 'convergence' became my default sensibility." In the 1990s Saville was fascinated by the 1970s, finding himself reevaluating and reimagining things he'd seen before. Saville admits that the space, which became known as *The Apartment*, "was a self-portrait of me as a bachelor." The mannequins appearing in Bourne's photographs alluded, Saville says, to Roxy Music's 1973 song "In Every Dream Home a Heartache," a quirky, menacing, and futuristic love song to an inflatable doll. Saville notes that *The Apartment* was completed around the same time that Tom Ford began his tenure as creative director of Gucci, giving the fashion house a modern, rather louche sensibility. Artists and rock stars came to visit. Jarvis Cocker asked Saville, along with artist John Currin, to art-direct the cover for Pulp's *This is Hardcore*, which was later photographed at *The Apartment*.

In 1999 the apartment's owner put it up for sale and Saville moved to Berlin, where he met his partner and occasional collaborator, artist Anna Blessmann. They've called London home for more than twenty years now, currently a live-work loft. The furniture from *The Apartment* has been in storage since he left it. "Here," Saville says, "the desks take priority over the sofa." But the couple are "determined to have a late period elsewhere," Saville continues. He cites Picasso's studio in the South of France as inspiration for their next chapter. Going through his extensive archive made him realize that "I still have an enormous amount of work to do," and his future vision is for an atelier-cum-workspace, "and it would be nice if it had a garden and a tree" he says "someplace where the climate is pleasant, and the coffee is good. I want double doors, and a parquet floor." It's not the seventies-meets-nineties bachelor pad of yore, but it certainly sounds like home. After a fashion.

The Apartment, Mayfair, London, 1995, for Meiré und Meiré. Concept by Peter Saville, interior architecture Ben Kelly, project architect Helen Abadie, photographed in 1997.

Pages 48 and 49: Main living area with three-tier Fun lamp, 1963, by Verner Panton and modular leather seating from de Sede.
Pages 50–51: Danish rosewood-and-steel desk by dyrlund, chair by Charles and Ray Eames, and *Simply the Best* by Stephen Hepworth.
Pages 52 and 53: Bedroom with its original 1970s interior. *Pages 54–55*: Main living area with three-tier Fun lamp and *Exotics*, 1997, by Martin McGinn.

Peter Saville

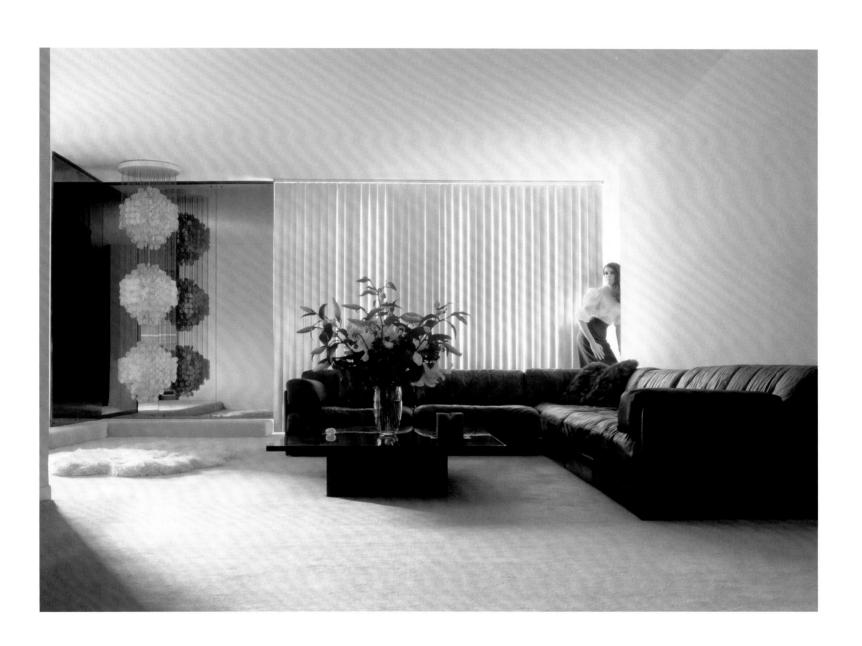

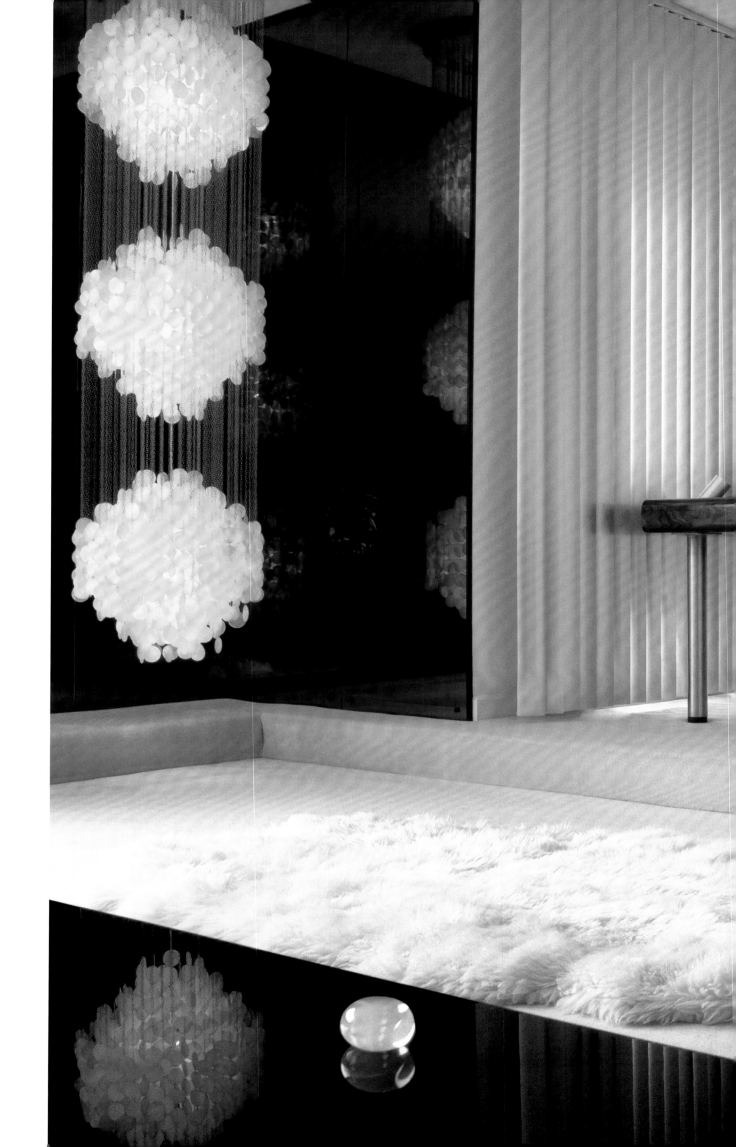

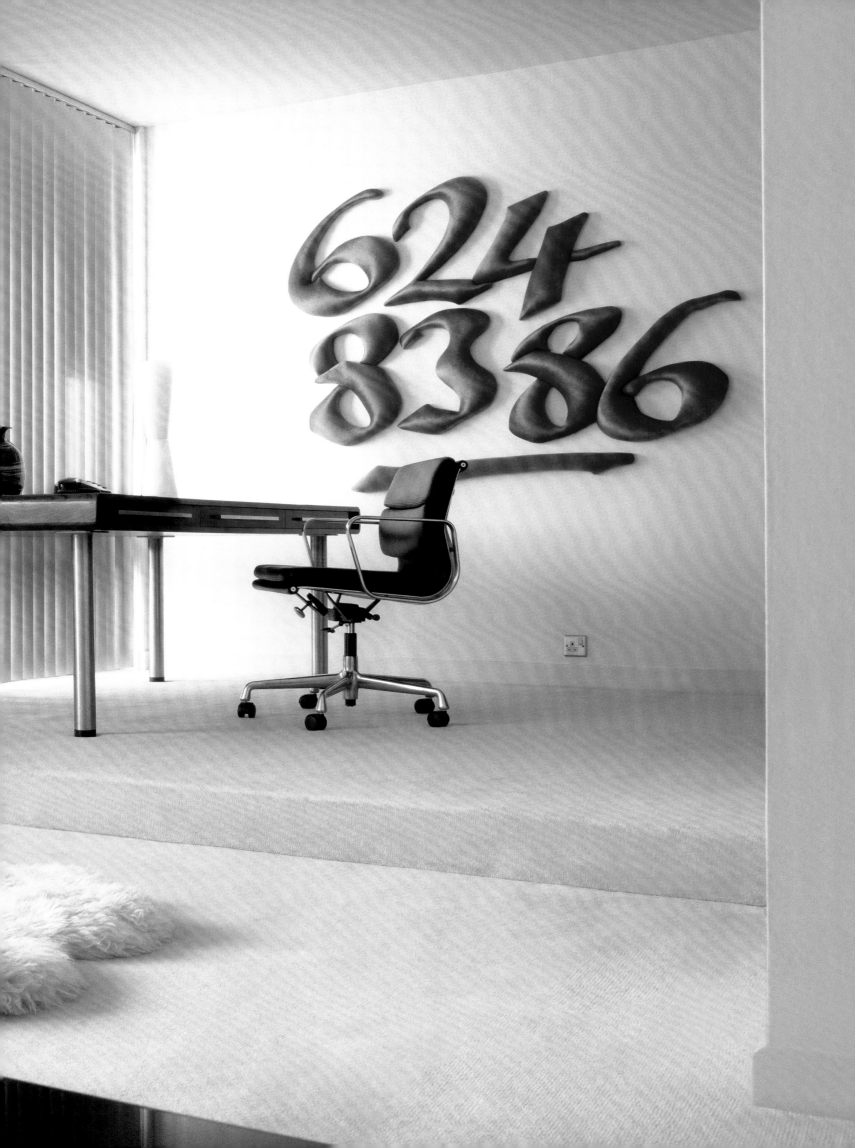

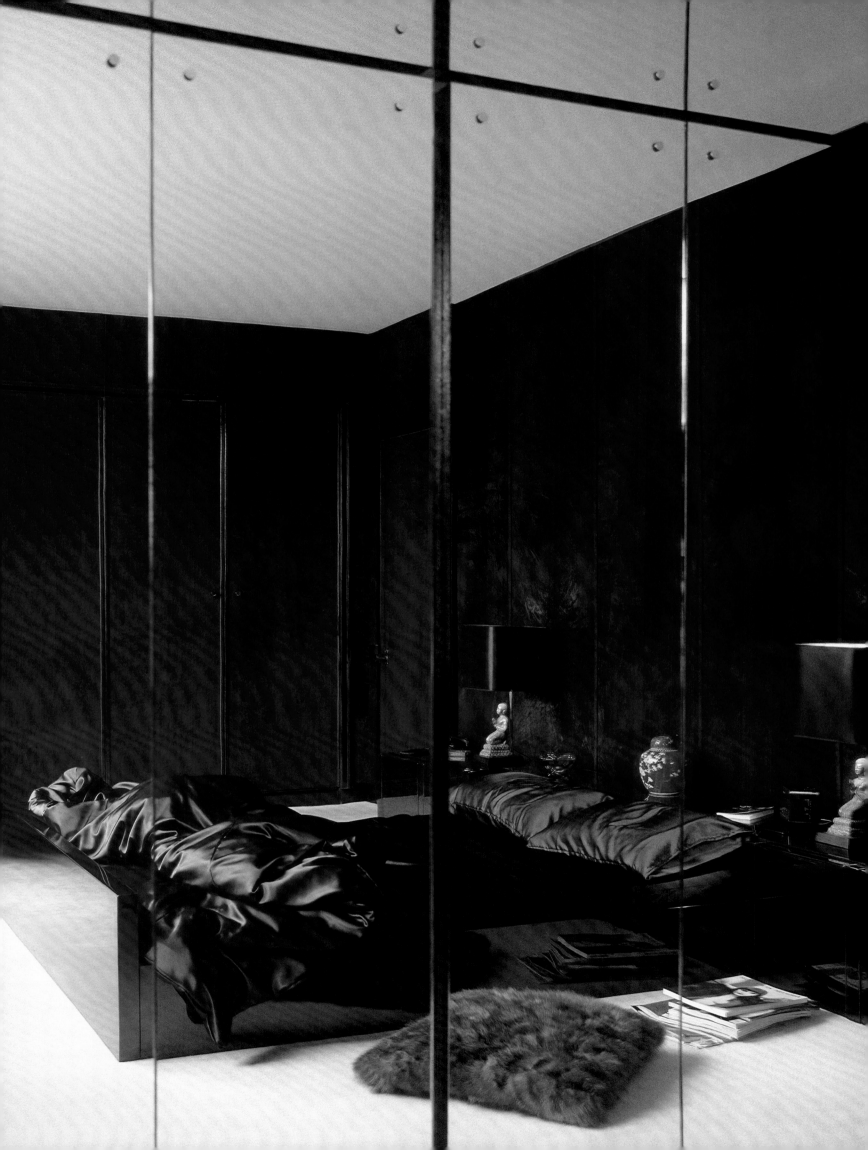

Scott Crolla

In 1981 fashion designer Scott Crolla opened, with Georgina Godley, the eponymous and eccentric store Crolla in Dover Street in London's Mayfair. The space was once part of The Empress, a women-only club and bathhouse inaugurated in 1897 by Queen Victoria for the pleasure of her ladies-in-waiting. Crolla was an unapologetically maximalist, postmodern, New Romantic emporium, selling men's and women's clothing fashioned from extravagant fabrics: mixed-up tartans, decadent damasks, chintzes, velvets in floral wallpaper prints, all skillfully combined with more traditional textiles.

Illustrious creative director Peter Saville (page 46) was an early enthusiast, calling it "the most intelligent clothing shop I'd ever seen, a vanguard of 'convergence culture'—granny took a trip to Savile Row," referring to Granny Takes a Trip, the fabled Swinging Sixties boutique in the Kings Road. Inside the store one might at various times find a green brocade Cathedral Chair designed by Crolla; storage units by Le Corbusier; or a rug designed by Oliver Messel for the Dorchester, salvaged when the hotel was renovated in 1979. The walls in varying shades of pastel were similarly inspired by Messel's Dorchester originals. Crolla was unapologetically the antithesis of the austere, monochromatic creations and spartan stores of the Japanese designers then finding currency.

After a decade of colorful extravagance and extraordinary success, the shop closed in 1991. By then Godley and Crolla had already parted ways, and Godley had set up her own couture house while Crolla worked on independent projects before moving to Paris to design for the Italian fashion label Callaghan. Crolla's apartment there, in a sixteenth-century building off the Place des Vosges, was photographed in 1995. It was incontrovertibly the Crolla aesthetic: a sitting room cloaked in orange hessian, a bedroom in orange velvet, and red carpeting throughout, the warm glow broken only by a light-colored stone fireplace. At first the setting was unexpectedly minimalist—Crolla's hectic schedule afforded little opportunity for combing the flea markets and offbeat hardware stores he knew intimately.

When time finally allowed, Crolla's friends the designer and architect Lionel Bourcelot and his artist wife, Marine Caillé Bourcelot, undertook the renovation. "Scott was the absolute master of taste," recalled Lionel Bourcelot, adding that those tastes ranged from "the Renaissance to Gilbert & George." The photographer Nick Fry, a friend for many years, was in awe of Crolla's sophisticated style and his influence on the fashion world. And it was at a dinner hosted by Fry in London in 1994 that Crolla met fashion designer Vivienne Tam. The two became inseparable in life and in business, with Crolla conceiving and collaborating on Tam's distinctive store designs, and the relationship ending, sadly, with his premature death in 2019.

Scott Crolla's apartment, Paris, photographed in 1995.

Page 59: Scott Crolla.

Scott Crolla

Richard Prince

In the mid 1990s, artist Richard Prince moved upstate from Manhattan, into a quaint clapboard farmhouse in Rensselaerville, a tiny township in the Catskill Mountains. Over the years he has bought up much of the surrounding land and buildings for his Ryder Road Foundation, established to show his work and that of emerging artists. There are large sculptures on display around the property, as is Prince's collection of muscle cars and, in a former bank on the grounds, some of his collection of rare books.

These photographs from 1996, taken just after he had settled in upstate, capture Prince in the snow carrying his painting *Untitled*, 1995, which is shown again hanging on the side of one of the many barns. Prince described the painting as "starting a whole new body of work." It was the first in this new series of Joke paintings, shown to great success in 1995 and considered a breakthrough for him as an artist—perhaps the reason why he still owns it. It represents a departure from his earlier work, those notorious appropriations of American pop culture (such as the infamous Marlboro Man of tobacco advertising, from his early-1980s Cowboys series) and his mid-1980s Joke paintings, monochromatic canvases with one-line jokes. An early example from this series, the acrylic and silk-screen work *Untitled*, 1989, stands a little forlornly here in the snow. The later series of Joke paintings evolved into more abstract canvases layered with paint and scribbled with doodles, but still with a joke and a punchline.

So rooted is Prince in this landscape that in 2005 New York's Solomon R. Guggenheim Museum acquired one of its small wooden structures, itself a work of art. *Second Home*, as the work was called, contained a Joke painting, several pieces from a series of painted sculptures (casts of the hoods from those muscle cars), and some rare books. The museum had committed to opening *Second Home* to the public for at least the following ten years, but in 2007 calamity struck: the little house was struck by lighting and burned to the ground. But it once again belongs to Prince—in due course the museum sold him the ashes.

Richard Prince's studio, Rensselaerville, New York, photographed in 1996.

Page 66: Untitled, 1989, acrylic and silk screen on canvas (75" × 58"). *Page 67:* Polaroids with and without Richard Prince and his *Untitled*, 1995, acrylic and silk screen on canvas (48" × 62"). *Page 68:* Prince with *Untitled*, 1995. *Page 69:* Studio interior with *Untitled*, 1995. *Pages 70–71:* Studio interior.

Richard Prince

1990s

"My brother just married the two-headed lady from the sideshow," says Bozo. "Is she pretty?" asks Cooky. "Well," says Bozo, "yes and no."

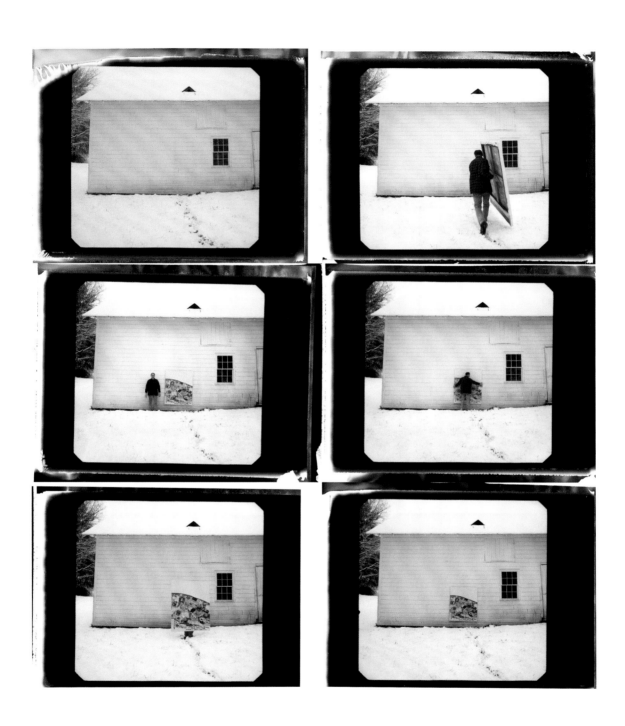

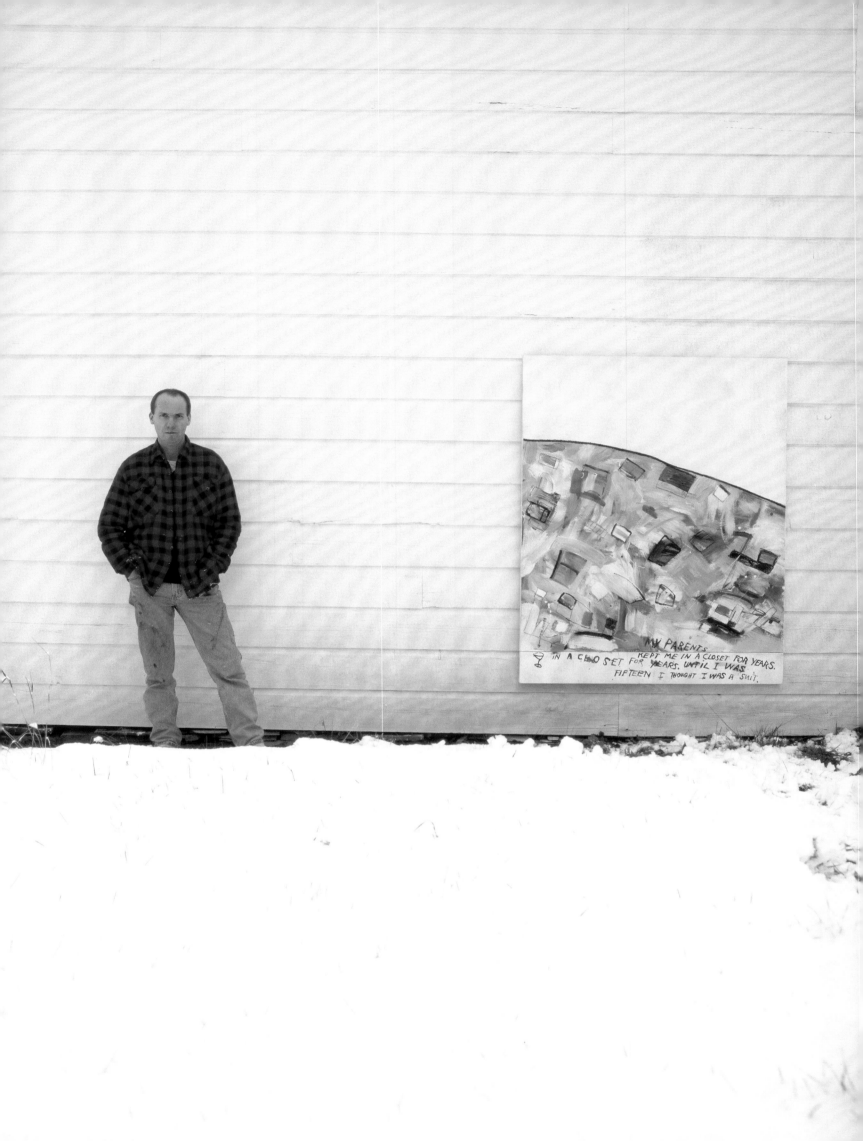

MY PARENTS
KEPT ME IN A CLOSET FOR YEARS.
IN A CLOSET FOR YEARS. UNTIL I WAS
FIFTEEN I THOUGHT I WAS A SUIT.

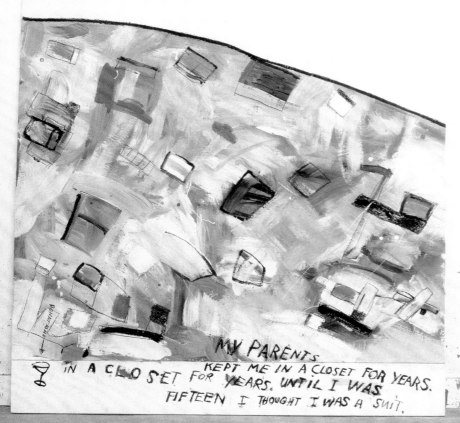

MY PARENTS
KEPT ME IN A CLOSET FOR YEARS.
IN A CLOSET FOR YEARS. UNTIL I WAS
FIFTEEN I THOUGHT I WAS A SUIT.

Pharmacy by Damien Hirst

Pharmacy — which was, as perhaps it sounded it would be, a pharmaceutical-themed restaurant in London's Notting Hill — opened in January 1998 as the creation of Damien Hirst, perhaps the most conspicuous of the Young British Artists (YBAs), who rose to prominence in the mid-1990s. One of the most debated artworks in the Royal Academy's groundbreaking exhibition *Sensation* the year before had been Hirst's *The Physical Impossibility of Death in the Mind of Someone Living* (1991), a fourteen-foot tiger shark suspended in a tank of formaldehyde.

The notion of modern medicine as a "belief system," as well as the iconography of pharmacology, had long intrigued Hirst. As he explained it in a 2001 conversation with Gordon Burn for Tate Modern, "I like the way art works, the way it brightens people's lives up . . . but I was having difficulty convincing the people around me that it was worth believing in. And then I noticed that they were believing in medicine in exactly the same way that I wanted them to believe in art." Perhaps it was inescapable, then, that when Hirst first conceived of a restaurant it should be in the form of a chemist's shop. His collaborators on the venture, which lasted just over five years and was photographed in 1998, were architectural designer Mike Rundell, restaurateurs Jonathan Kennedy and Liam Carson, and co-owner Matthew Freud.

The theme was all-pervading. The downstairs bar was lined with cabinets stocked with pharmaceutical packaging, the staff uniforms were surgical gowns designed by Prada, and the cocktails had drug-inflected names. Meanwhile, in the upstairs dining room a striking sculpture by Hirst, *The Molecular Structure*, 1997, as well as his iconic spot and monochromatic butterfly paintings. The silver wallpaper, with shades of Andy Warhol's Factory, was decorated with images of pills and assorted medicine bottles and packaging; the seats of the barstools, designed by Hirst with Jasper Morrison, were shaped like pills; while behind the glass wall of the urinals was a space stuffed with latex gloves, alcohol pads, and other medical equipment.

Pharmacy was contentious from the start. The Royal Pharmaceutical Society threatened legal action since it remains illegal to use the term "pharmacy" for anything other than an actual pharmacy. Misspellings of the word, puns, and anagrams were used as temporary signage to alleviate a potentially tricky situation. (Ironically, when a diner asked Hirst for an aspirin, he was obliged to reply that *Pharmacy* operated a strict no-drugs policy). Eventually the thrill was gone, and *Pharmacy* closed in 2003. Hirst mothballed the fittings and fixtures, and a year later, in 2004, they were auctioned off at Sotheby's, bringing in an impressive $20,063,528 (£11.1 million) — two cabinet works achieved the highest prices at around $1.8 million each, while a pair of martini glasses sold at almost one hundred times their estimate. As an enterprise *Pharmacy* may have been relatively short-lived, but as an emblem of fast-paced fin-de-siècle London life it was all but unrivaled.

Pharmacy by Damien Hirst, Notting Hill Gate, London, photographed in 1998.

Pages 74 and 75: Facade of *Pharmacy* with *The Molecular Structure*, 1997, and *Earth, Air, Fire, Water*, 1998, both by Damien Hirst. *Pages 76–77:* The ground-floor bar, with cabinets by Damien Hirst. *Page 78, top:* Spot painting by Damien Hirst and Hirst's silver wallpaper. *Page 78, bottom:* The men's-room urinal. *Page 79:* Pill stool designed by Damien Hirst and Jasper Morrison.

Pharmacy
by Damien Hirst

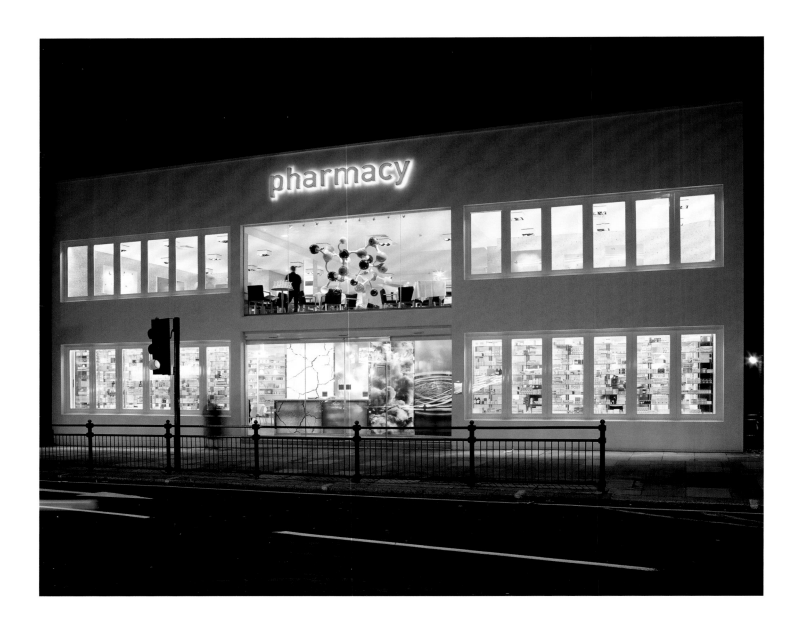

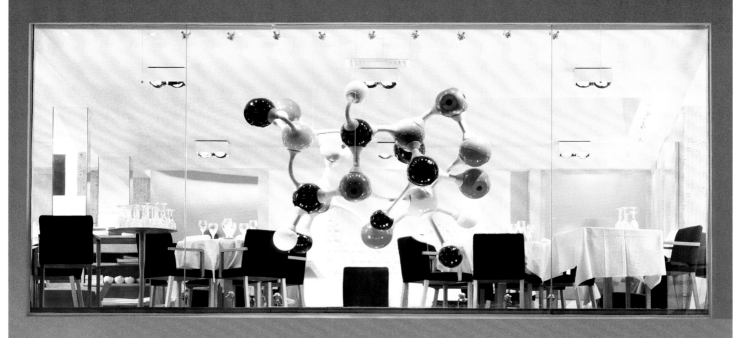
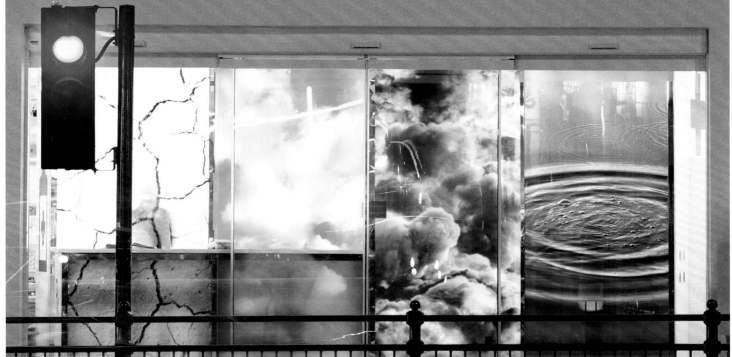

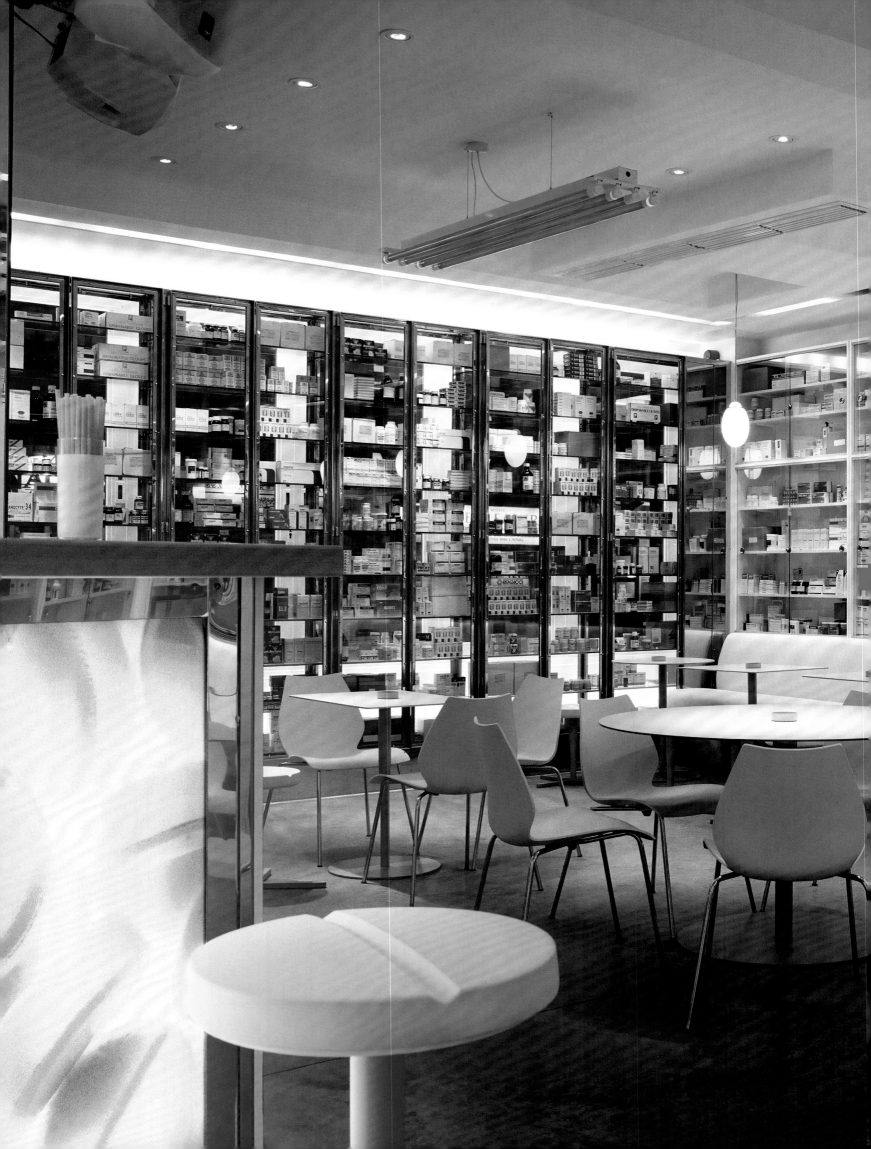

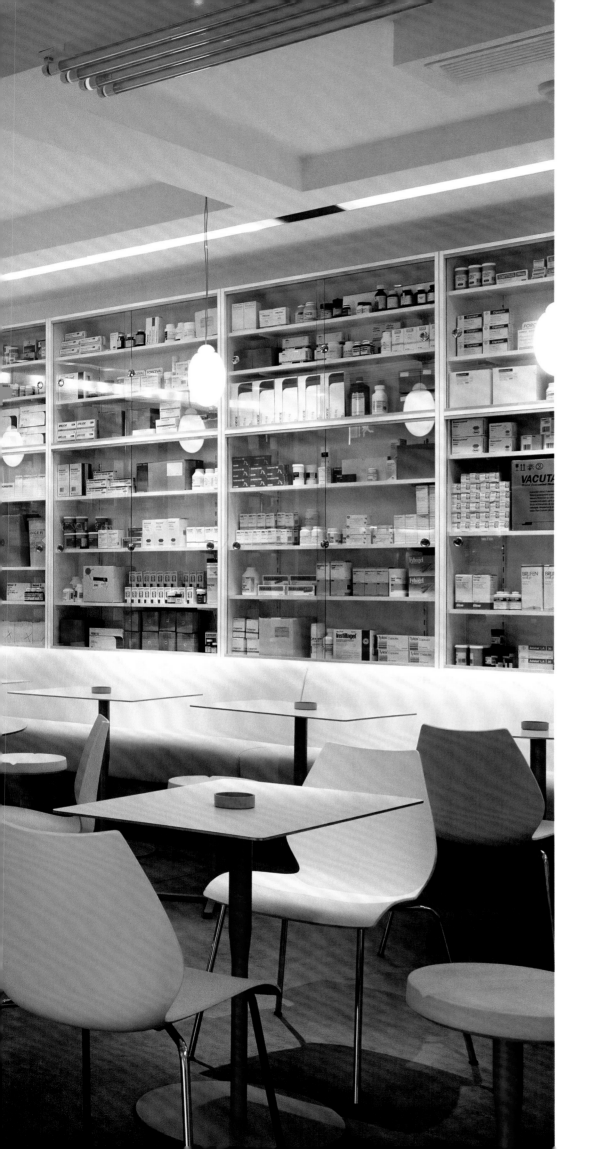

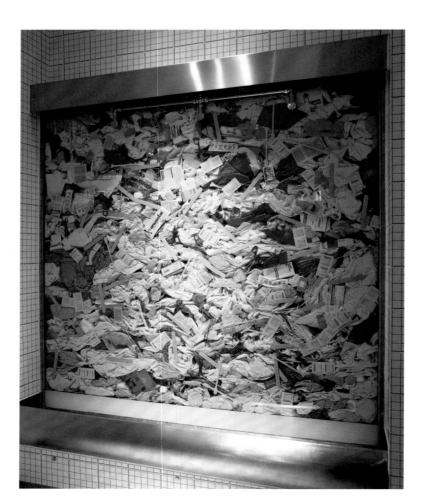

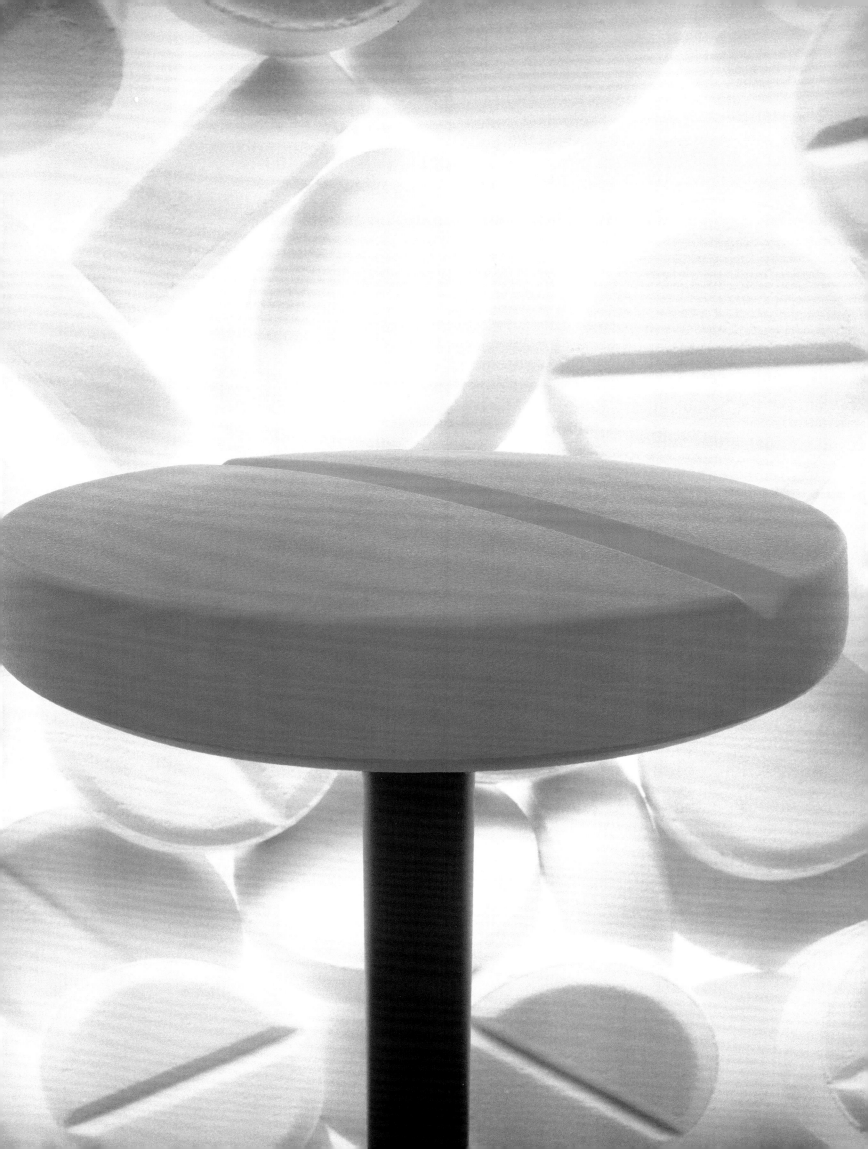

Cholmeley Dene

In January 1989 a loose-knit collective of artists moved into a derelict house, Cholmeley Dene, in Highgate, North London. Built in the late nineteenth century for a doctor and his family, the house was later acquired by the local health authority and carved up into dormitories for male nurses. By 1989 it was abandoned and deteriorating, and ripe for squatting artists. Writer and features editor Elspeth Thompson chanced upon the house and its new uninvited inhabitants and wrote it up for *The World of Interiors*.

Immediately recognizing that the house with its history and faded grandeur was more than just a free place to live and work, the collective—called the Cholmeley Dene Artists— set about transforming the building, photographed here in 1990, into an artwork in its own right. The disintegrating rooms became blank canvases: fallen plasterwork was replaced at random, and the walls were layered haphazardly with found items—pages torn from magazines, scrap metal, pieces of stained glass, hubcaps, discarded birdcages. Every available space appeared to be stacked high with random detritus.

One member of the collective, David Miles, recalls the house as "magical, constantly changing and growing. Everything was made from materials found on the street—refuse in an age of regeneration. . . . Each evening a celebration, with storytelling and music, took place in the Nest room." There was no working electricity in the house; instead, he says, "we had the luxury of natural light. It felt as though we were in the country. Time simply slowed down." He proudly adds that this was "the only squat that ever appeared in *The World of Interiors*."

Miles still adheres to the anticommercial philosophy that drove the group: "Last year," he says, "five people tried to buy my art, but none succeeded." He still covers his walls with newspapers and CDs, and he continues to make art "because I like to make art. The possibilities of art are endless, but they become toxic when people use it for profit."

After only a year at Cholmeley Dene, the artists were ordered to vacate by the local council, which wanted to redevelop the property. When they left, they took away everything they had made. Some of the artists, known as the Arc Collective, relocated to an abandoned, rubbish-filled Quaker chapel in London's Dalston. They partially cleared the refuse in the new space, and the remainder was put to constructive and creative use as a fifty-two-foot boat fashioned out of paper and discarded plastic sheeting—and christened *The Ark*.

A few months later, the council handed over the building to the Sikh community. "So, we went abroad," one of the artists, Nicola Pellegrini, recalls, "to Prague and Italy, and our squatting story ended there." Pellegrini now works in Berlin with Ottonella Mocelli, another member of the group. And the chapel, like the old house, is gone, both replaced by luxury apartments.

Cholmeley Dene House, Highgate, London, photographed in 1990.

Page 82: Hallway. *Page 83:* Cholmeley Dene Artists' studio. Pages *84–85:* Cholmeley Dene Artists in the Nest room. *Pages 86 and 87:* Bedrooms at Cholmeley Dene House.

The Ark by the Arc Collective, Dalston, London, photographed in 1991.

Page 89: The Ark by the Arc Collective. *Pages 90–91:* Detail of *The Ark.*

Cholmeley Dene

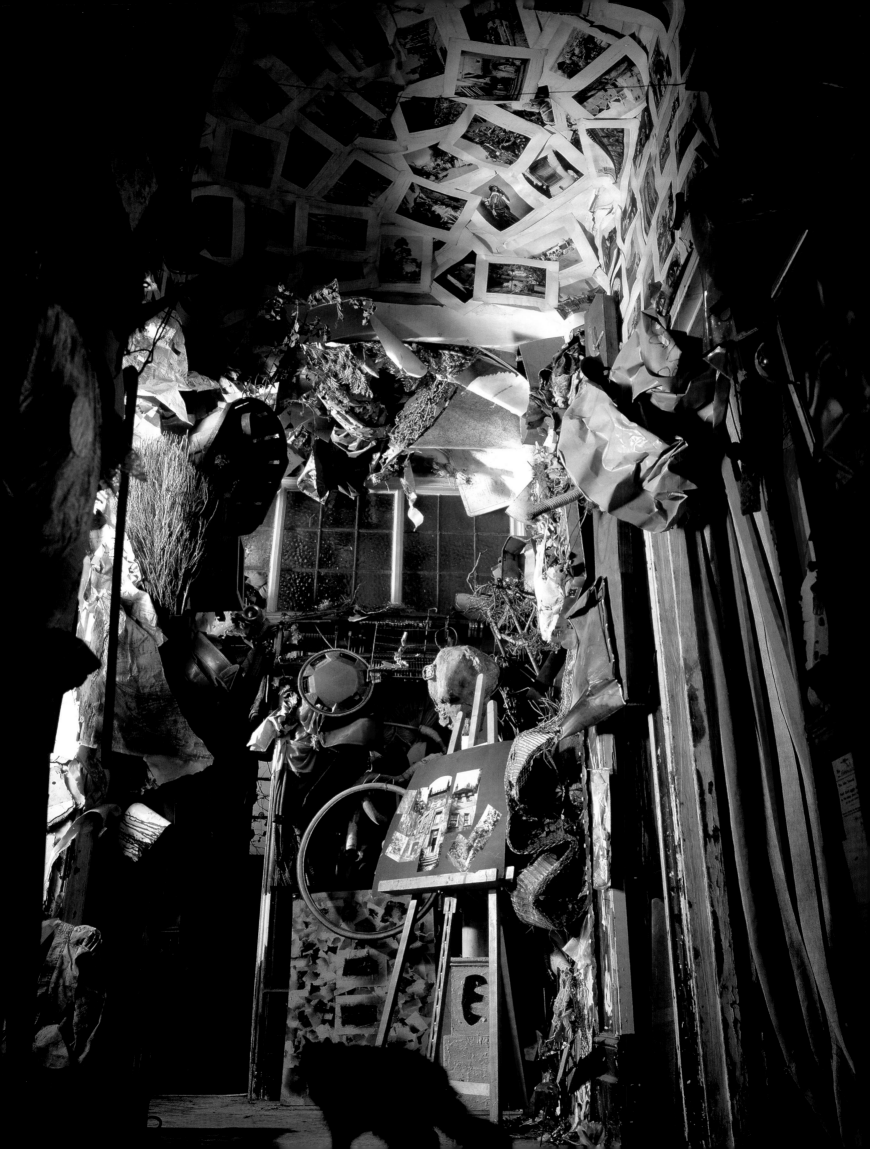

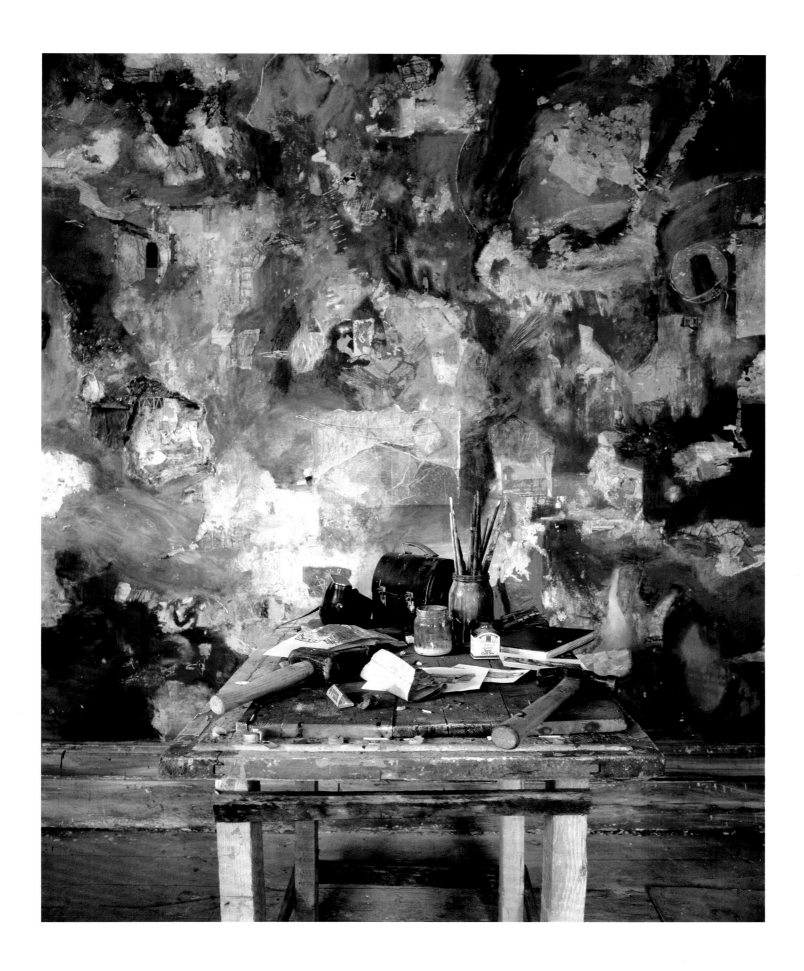

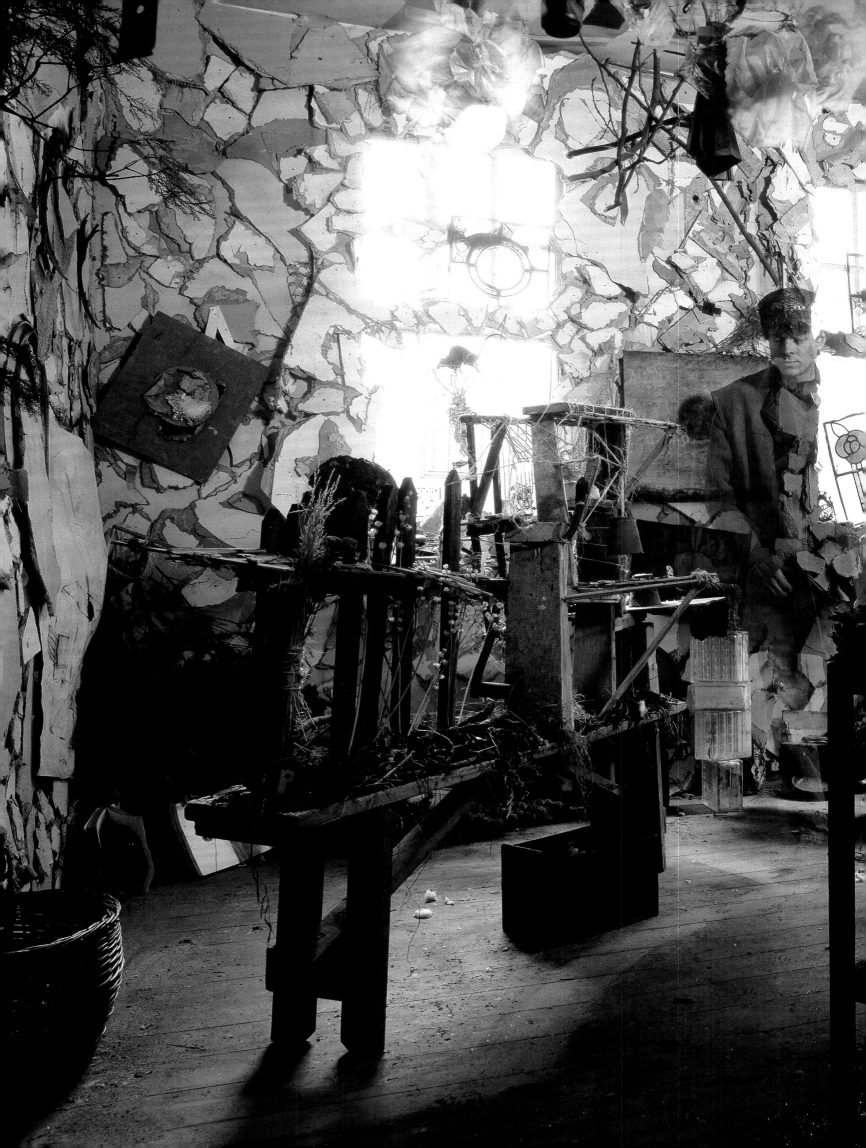

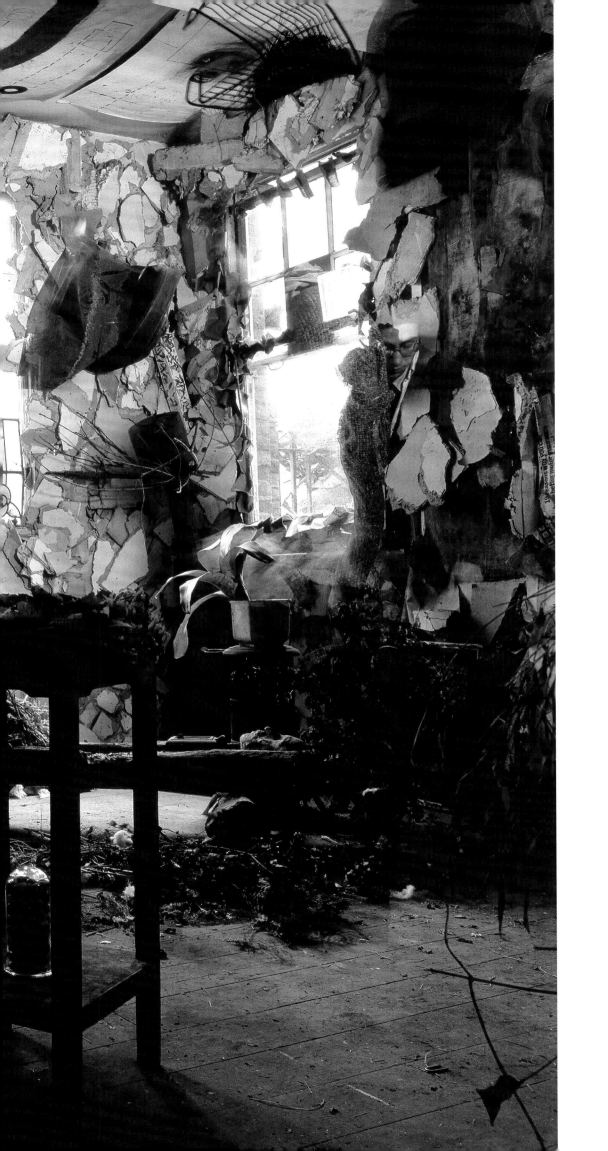

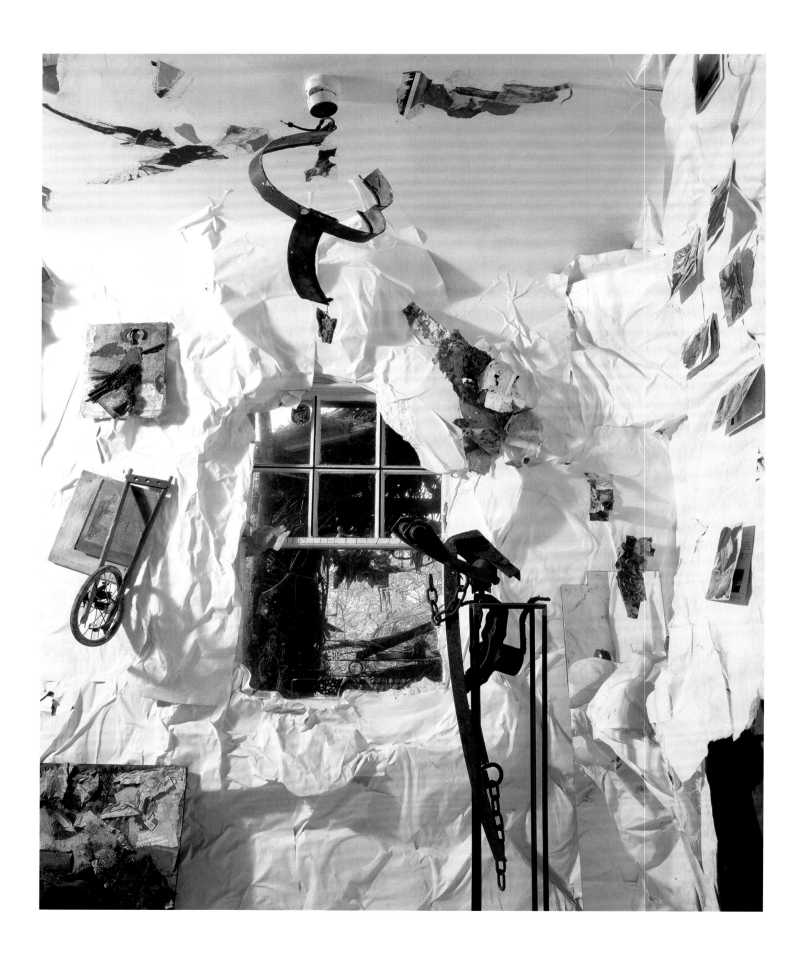

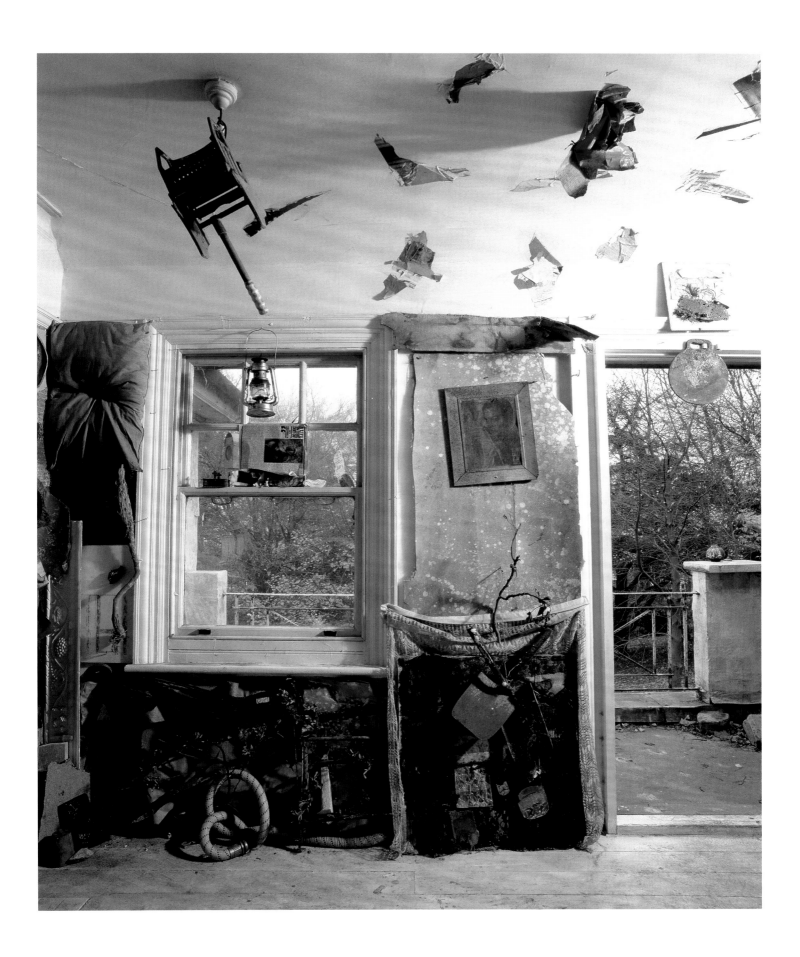

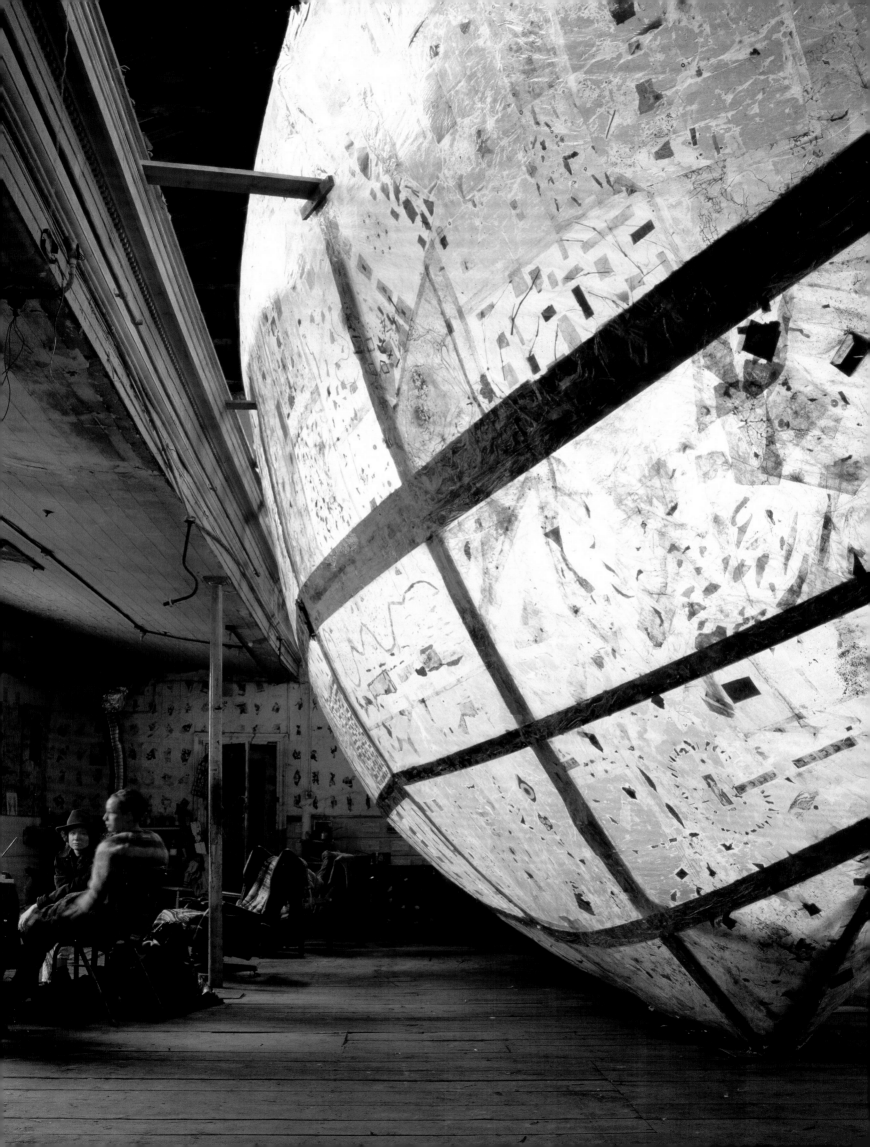

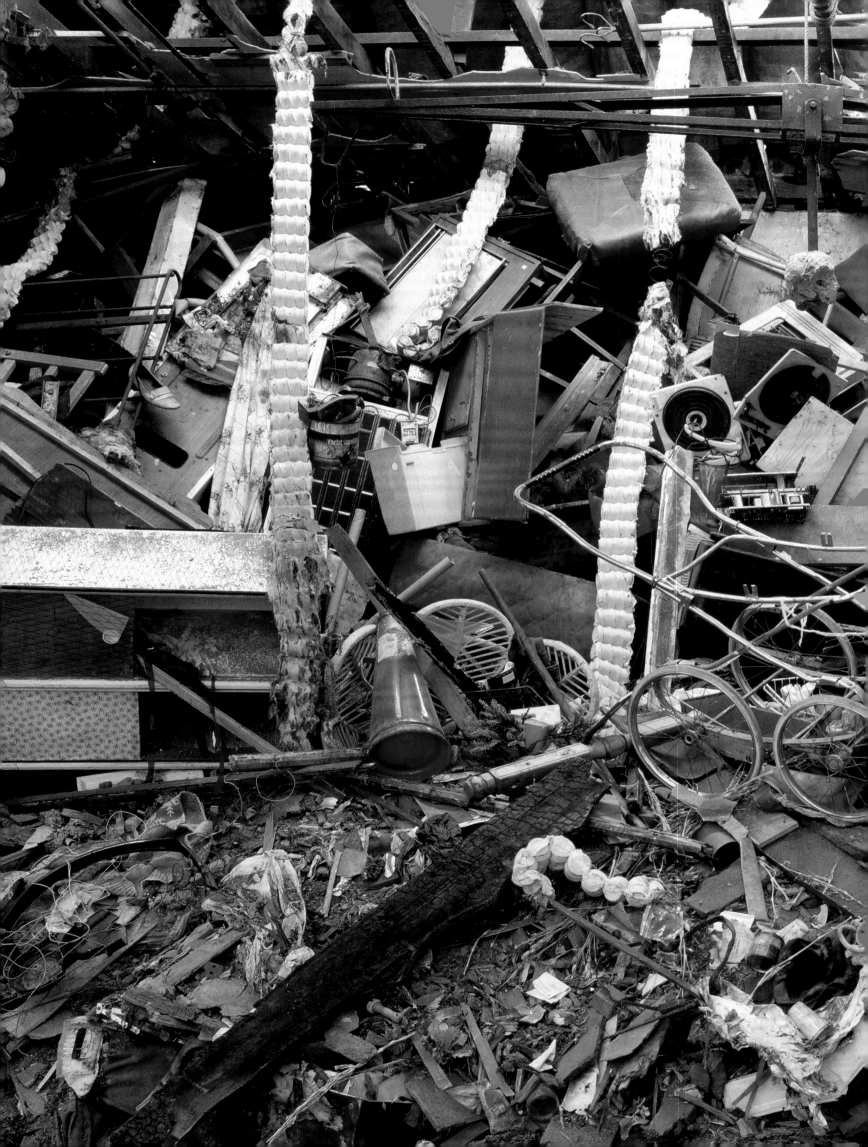

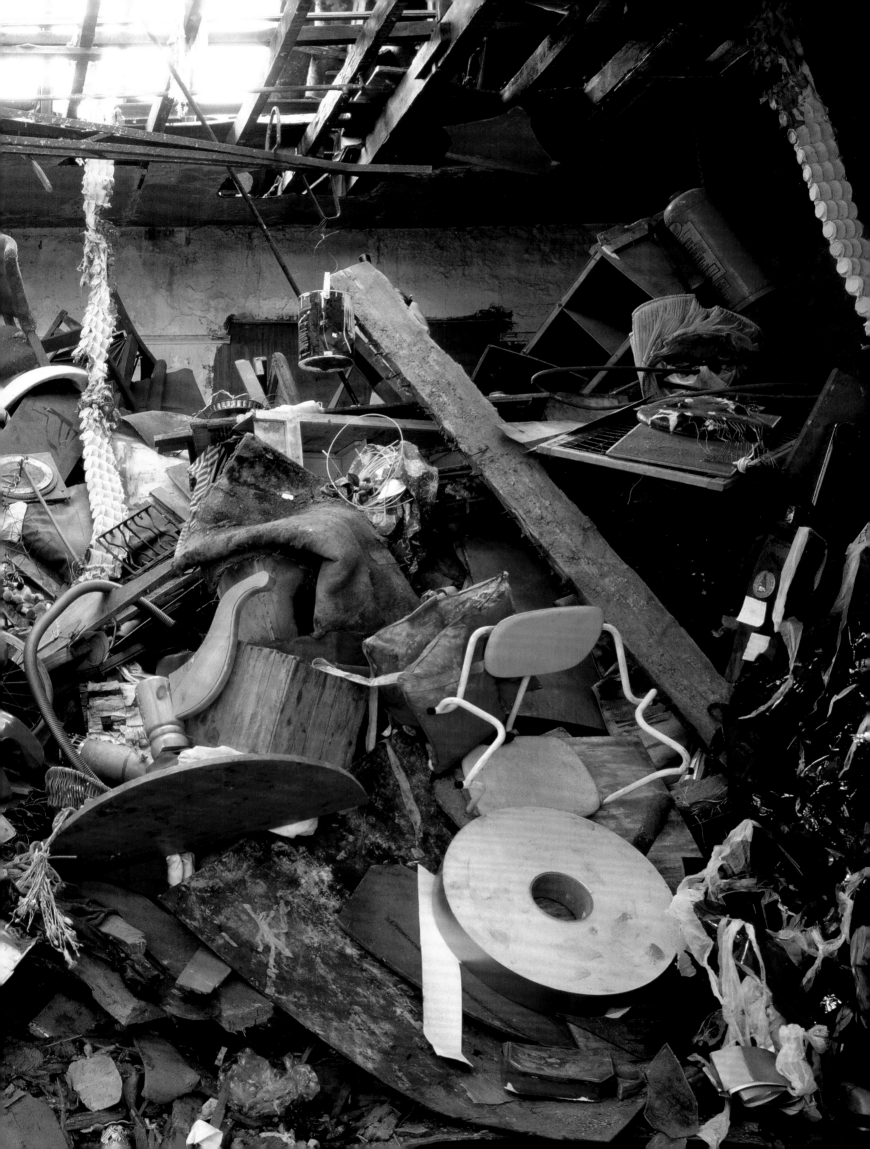

Marc Newson

Born and raised in Australia, Marc Newson, a longtime London resident, is known around the world as one of the best industrial designers of his generation. As multifaceted as he is prolific and inventive, Newson has conceived luggage for Louis Vuitton, a sterling-silver tea set for Georg Jensen, furniture for Knoll and Cappellini, clocks for Jaeger-LeCoultre, kitchen appliances for SMEG, the cabin interiors of Qantas's Airbus A380, the Aquariva motorboat for Riva, two concept vehicles—the Kelvin40 jet-powered aircraft for Fondation Cartier and the 021C car for Ford—as well as a limited-edition bottle for Hennessy XO cognac and a public toilet for the city of Tokyo, commissioned for the 2020 Summer Olympics. Since 2014 he has worked on special projects for Apple and co-founded, with Sir Jonathan Ive and Peter Saville, the creative collective LoveFrom,.

It was likely the Lockheed Lounge, a chaise longue launched in 1988, that catapulted him to recognition within the design field and, beyond it, to international fame. The sinuous, almost amorphic silhouette is covered by rectangular aluminum panels that are riveted together, evoking an airplane fuselage. Its status as an icon of contemporary design was ensured when an edition fetched $3.7 million at auction in 2015, a record for a living designer.

If a Newson signature can be distilled from this eclectic repertoire, it is perhaps a sleek, modern, functional aesthetic combined with cutting-edge technology. It has secured him an enviable reputation; he is, for example, represented worldwide by Gagosian, the only industrial designer on its roster of A-list artists.

Newson had recently moved into this newly converted west London apartment when it was photographed in 1999. He had stripped it of all ornament and painted it a stark white, adding accents of color like the sitting room's acid-green cupboards. Two of Newson's furniture designs— the 1988 Wood Chair and 1993 Felt Chair—shared space amicably with such classics as Achille and Pier Giacomo Castiglioni's Toio floor lamp, their celebrated Arco floor lamp (both 1962), and the Brionvega Radiofonografo, an enchanting yet minimalist sound system they created in 1965.

For the indefatigable, peripatetic Newson, it was important to have a rigorously designed home to return to, in his own words, "a deluxe crash pad."

Marc Newson's apartment, Notting Hill, London, photographed in 1999.

Page 94: Marc Newson. *Page 95:* Sitting room with Wood chair, 1988, by Newson and a Brionvega Radiofonografo stereo system, 1965, by Achille and Pier Giacomo Castiglioni. *Page 96:* Fireplace designed by Newson. *Page 97:* Bedroom with drawing of Flaminio Bertoni's Citroën DS 19 and Toio floor lamp, 1962, by Achille and Pier Giacomo Castiglioni. *Page 98:* Sitting room with Felt chair, 1989, by Newson and Arco floor lamp, 1962, by Achille and Pier Giacomo Castiglioni. *Page 99:* Bedroom with the Rock Doorstop, 1999, by Newson.

Marc Newson

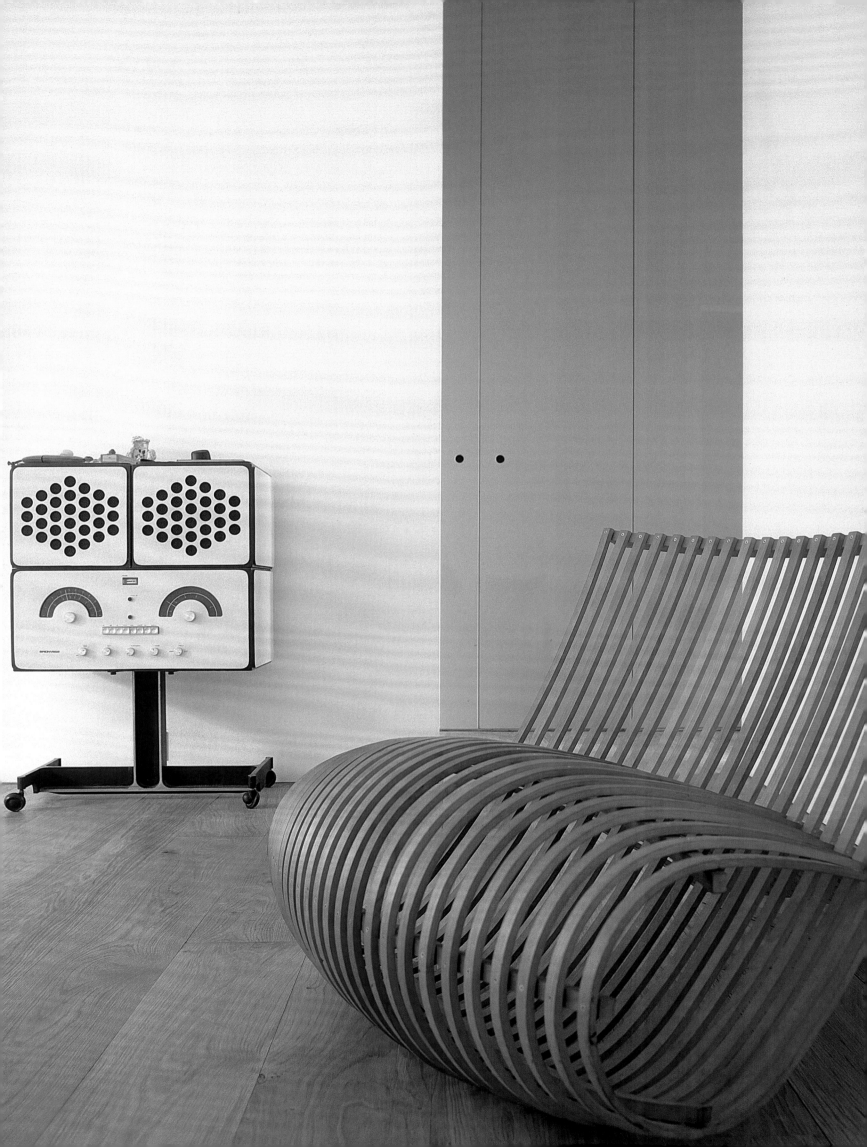

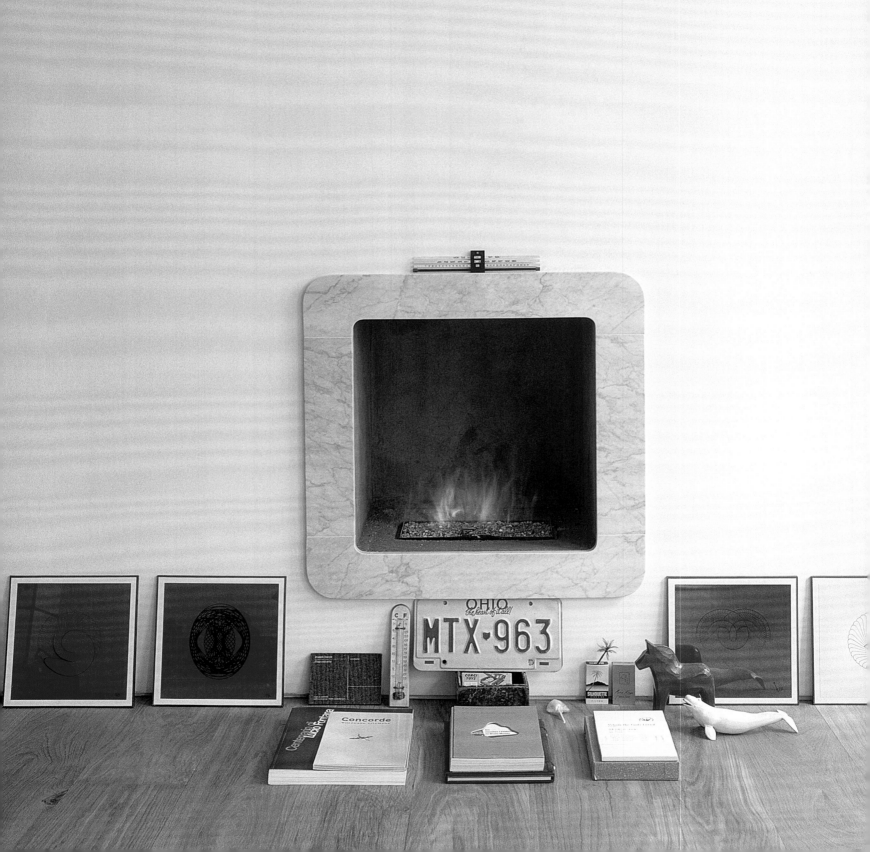

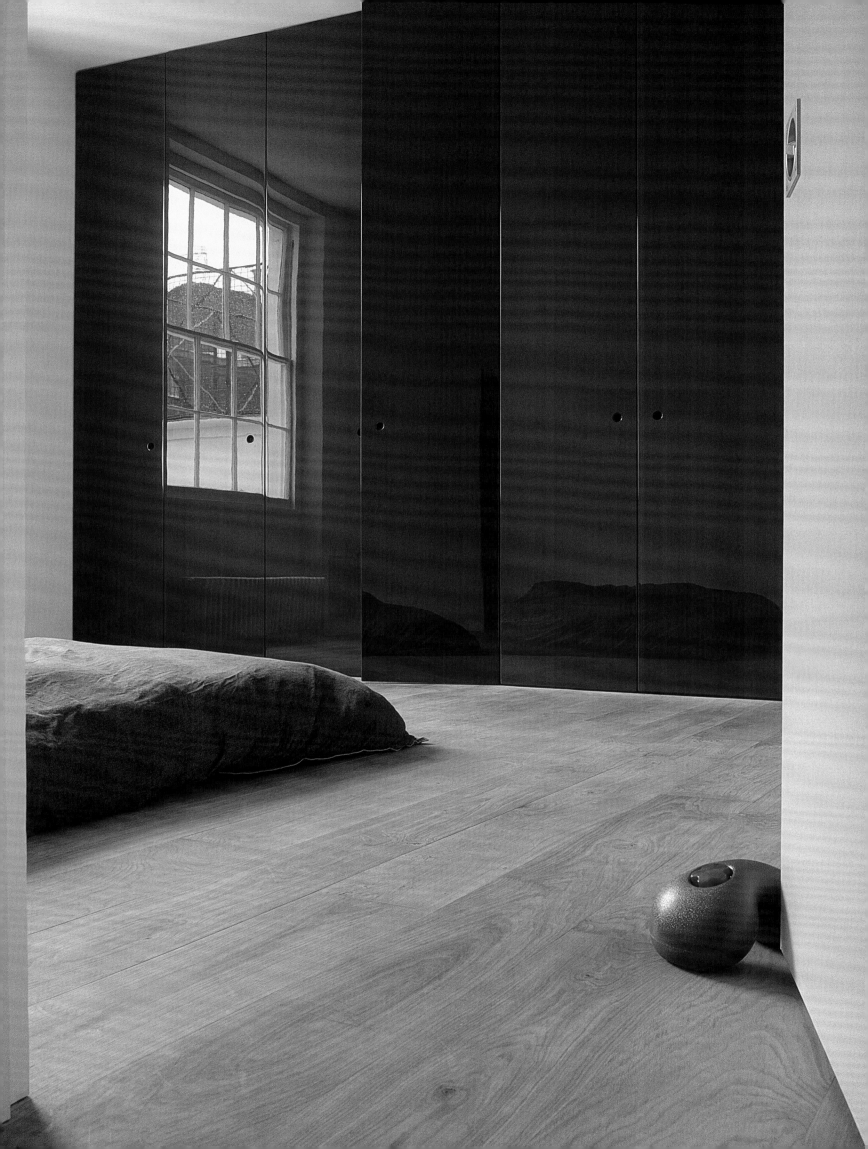

John Pawson

John Pawson is arguably the world's best-known practitioner of minimalist architecture. He has designed everything from houses, apartments, and hotels to a Cistercian abbey in the Czech Republic and Calvin Klein's flagship store in New York, and led the design team tasked with reclaiming the former Commonwealth Institute into a new home for the Design Museum in London. What these diverse projects have in common are precise lines, fine materials, and calm, sculptural spaces free of superfluous ornamentation. That approach guided his design for his family home, a house in London's Notting Hill, completed in 1999 and photographed the following year.

From the street, the house shares the same Georgian facade as its neighbors, but inside it's pure Pawson. To create an interior that appears seamless, he concentrated on the cumulative sequence of rooms rather than the individual spaces. The ornament, if it could be called that, is a vocabulary of large windows, a staircase that runs straight up two stories between white plaster walls, a shower with a view of the sky, rooms that have long benches (anything but sofas), and expansive kitchen counters clad in Italian stone and interrupted only by the stovetop or an occasional vase of flowers.

John's wife, Catherine, is herself an interior designer who has worked for Colefax and Fowler, a traditional English decorating firm founded in the 1930s. Perhaps understandably, she and her husband don't see eye to eye about room design, but her husband's aesthetic prevails at home on apparently consensual and harmonious terms, as they still live there happily.

Nearly a quarter of a century later, the London house remains largely unchanged, almost as a matter of principle. Pawson says, "My design process is very front-loaded—reflect for an eternity and refine exhaustively." He is fond of a maxim of the late Japanese designer Shiro Kuramata: "Everything can be changed until the first nail." And Pawson still believes that "the choreography of a place has a profound impact on how comfortable it feels to be there. I particularly like the vertical narrative of the London house—the upward vista through the stairwell that rises two floors, up to the skylight."

In what may be the ultimate compliment, the Pawsons' elder son, Caius, raised in this minimalist household, asked his father to design a home and workplace for him. As Pawson père says with evident delight, "I love that the philosophy that shaped the places he grew up in still makes sense to him."

John and Catherine Pawson's house, Notting Hill, London, photographed in 2000.

Page 102: Reception room with bronze table designed by Pawson. *Page 103:* Bedroom with white-cedar bed by Pawson. *Page 104:* Benedict Pawson in the "sky shower." *Page 105:* Bathroom with stone bathtub. *Page 106:* Kitchen with Italian limestone worktops, Hans Wegner chairs, and white-cedar dining table by Pawson. *Page 107:* John Pawson. *Page 108:* Double-height Italian limestone stairwell. *Page 109:* John Pawson.

2000s

John Pawson

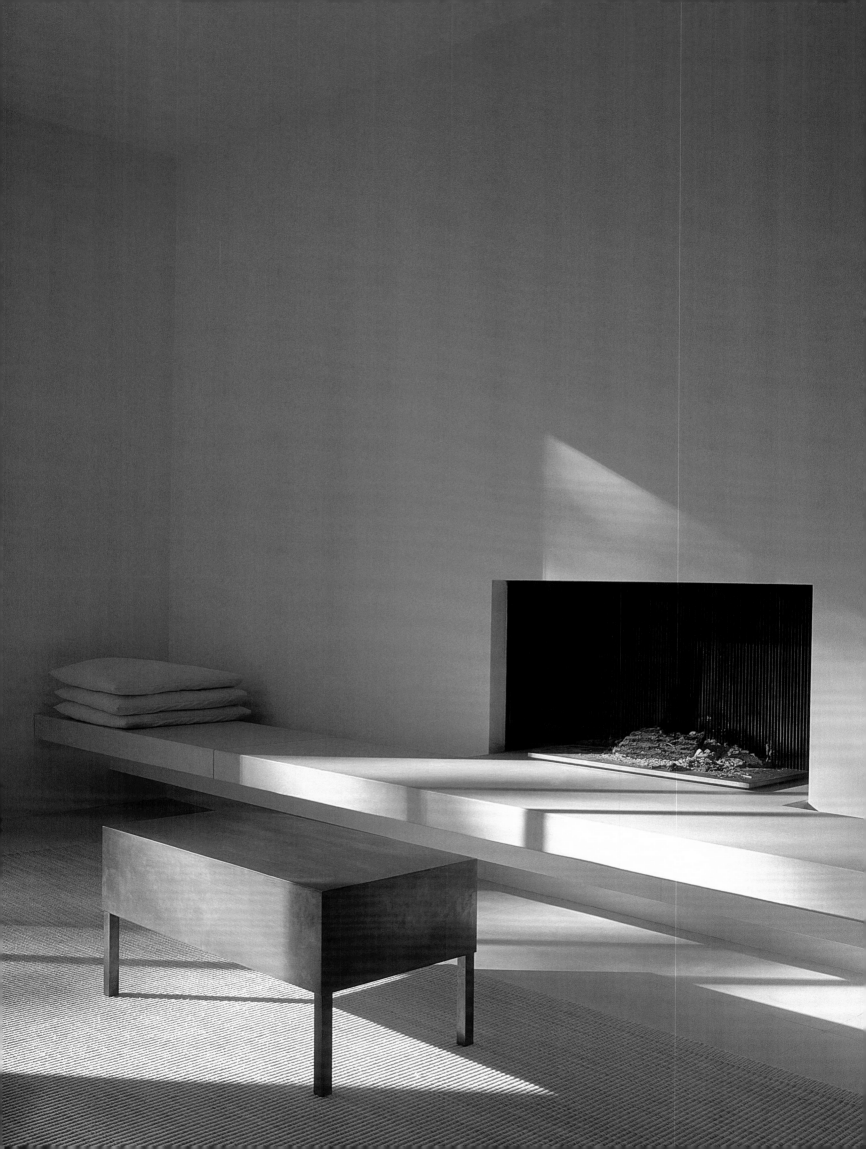

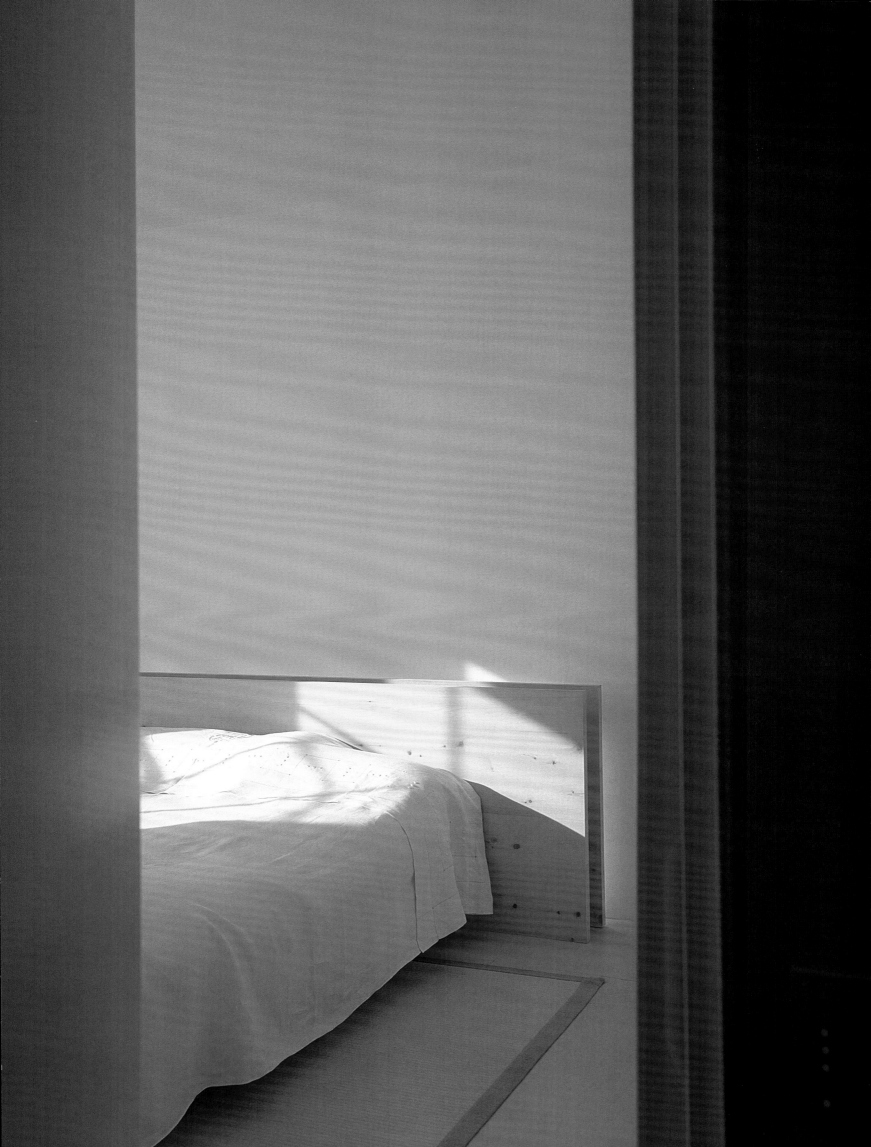

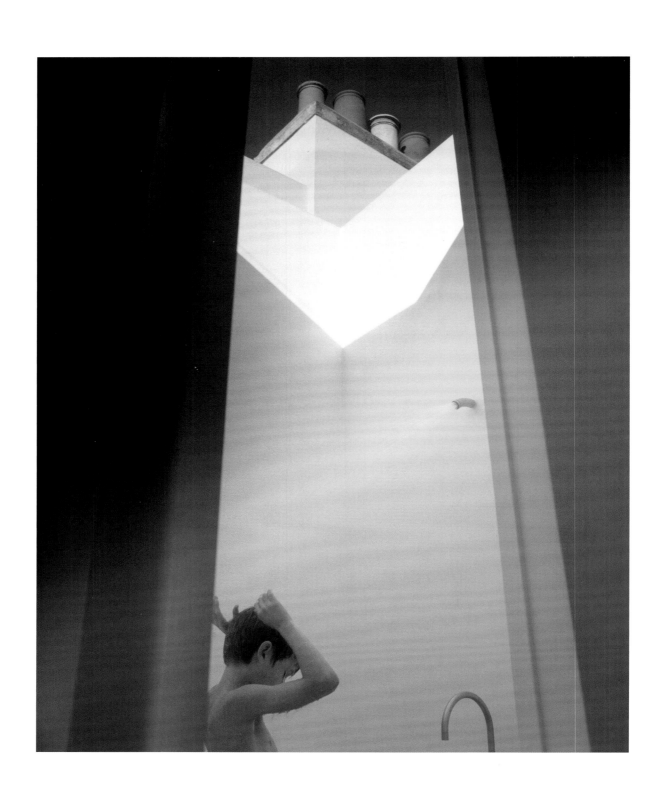

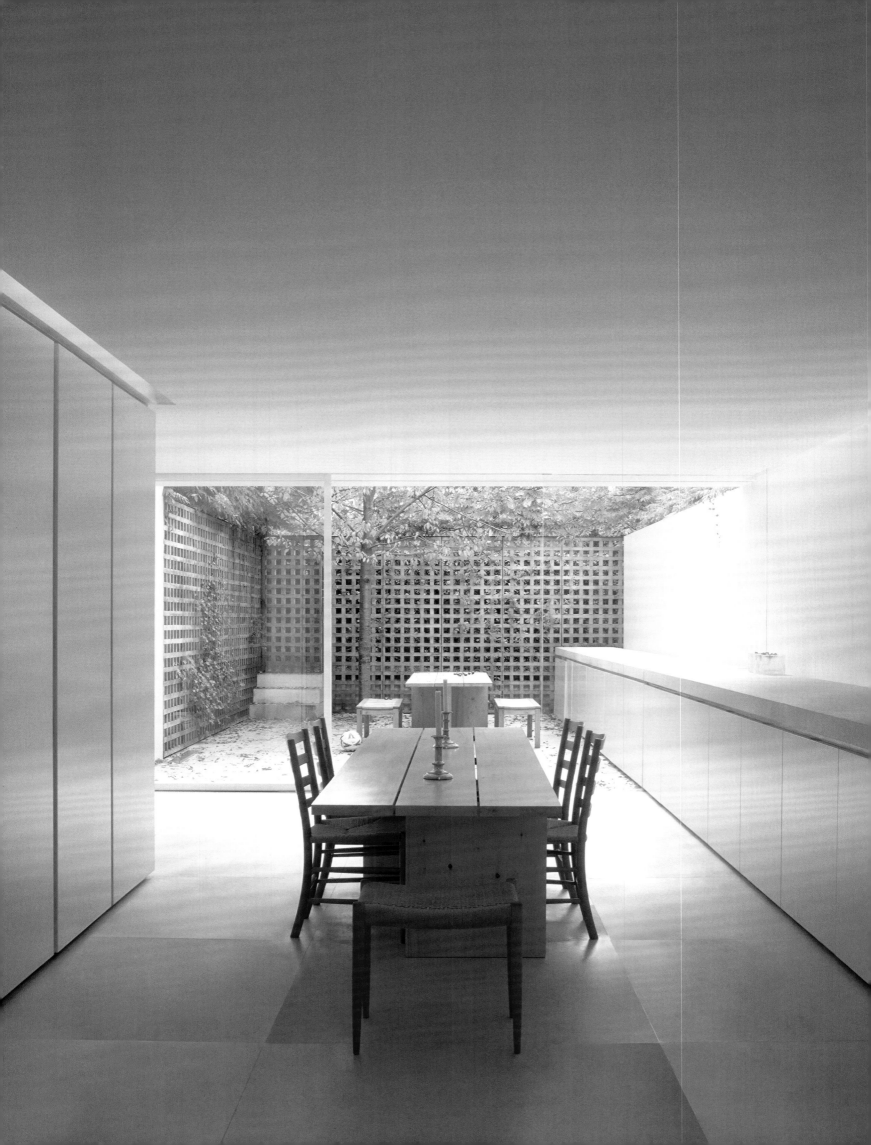

Tim Noble & Sue Webster

The name of London's fashionable Shoreditch district possibly derives, as might be guessed, from a ditch on the shore of the nearby River Thames or, more likely, from its lord, the fourteenth-century nobleman Sir John de Sordich. What's certain is that the neighborhood evolved after the City of London's population nearly tripled in the sixteenth century and Shoreditch, outside the City's walls, became one of London's earliest suburbs. By the early nineteenth century it devolved into one of London's poorest slums. The local furniture-making industry partially improved conditions and spawned a spate of industrial buildings and warehouses, and a century later, when Shoreditch had once again slid into disrepair, those cavernous buildings had become uncommonly affordable to rent or buy—at least by central London standards— and therefore ideal for young artists to live and work in.

Tim Noble and Sue Webster first moved to Shoreditch in the early 1990s because, Webster frankly points out, "it was cheap." Their first home was a tiny two-story building that housed their studio on the ground floor and living quarters upstairs. Both levels were, in the grand tradition of the struggling artist, "freezing cold," Webster recalls. Their work began to attract attention (they were of the generation of artists that became widely known as the Post–Young British Artists), and in 1998 they were able to buy a vast former furniture warehouse nearby, in need of extensive renovation.

Before they embarked on the protracted remodeling, they encountered Henry Bourne, who lived conveniently nearby, and invited him to document the building, now functioning as the couple's new studio. Later that year, Noble and Webster commissioned David Adjaye to transform the building into a voluminous double-height studio with a light-suffused living space on the upper floor. Four years later, the couple moved in, and the building was christened the *Dirty House*, and Bourne returned to photograph the newly completed live-work space.

The exterior was painted a bronze-like shade of brown—the effect was almost black—and punctuated with half-silvered mirrored windows that glowed at night. While the studio space reflected the often-messy process of artmaking, the glass-walled, white-painted residential area was spare, serene, and graced with a panoramic view of the London skyline. In the dining area, Adjaye's white-lacquered table was surrounded by Philippe Starck's transparent plastic chairs in multiple colors.

The gentrification of Shoreditch has accelerated over the past few years, drawing high-end coffee shops, boutiques, galleries, hotels, and restaurants. And, inevitably, exploding property prices. "Shoreditch became a victim of its own success," Webster says. "It became too unbearable to live here. And so, I chose the polar opposite." Webster moved out in 2018, and when she and Noble separated, they sold the Dirty House. (They continue to work together.) The building is now, with some inevitability, a popup store for high-end fashion brands and a venue for glamorous events.

Unsettling as it may be, this unique and particular district of London insists on reinventing itself and serves as a record of the city's urban history and evolving culture. In a way it also reflects the art Noble and Webster made there—they once described their early Shadow projections, those detritus-strewn sculptures that secured their reputations, as "emblematic of transformative art. The process of transformation, from discarded waste and scrap metal into a recognizable image."

Tim Noble and Sue Webster's apartment and studio, Shoreditch, London, photographed in 2001 and 2003.

Page 112: The warehouse in London's East End in its original state, with *The Whole Year Inn*, 1998, by Tim Noble and Sue Webster. *Page 113:* The Dirty House after being rebuilt by David Adjaye, with white-lacquered table by Adjaye and chairs by Philippe Starck. *Page 114:* Noble and Webster photographed in the kitchen. *Page 115:* The Dirty House. *Page 116*: Noble with *Falling Apart*, 2001, by Tim Noble and Sue Webster. *Page 117:* Webster and Noble with *YE$*, 2001, by Tim Noble and Sue Webster. *Page 118:* The Dirty House studio with *Little Peter*, 2002, by Tim Noble and Sue Webster. *Page 119:* Details and artworks by Noble and Webster, 2001.

Tim Noble & Sue Webster

2000s

2000s — TIM NOBLE & SUE WEBSTER

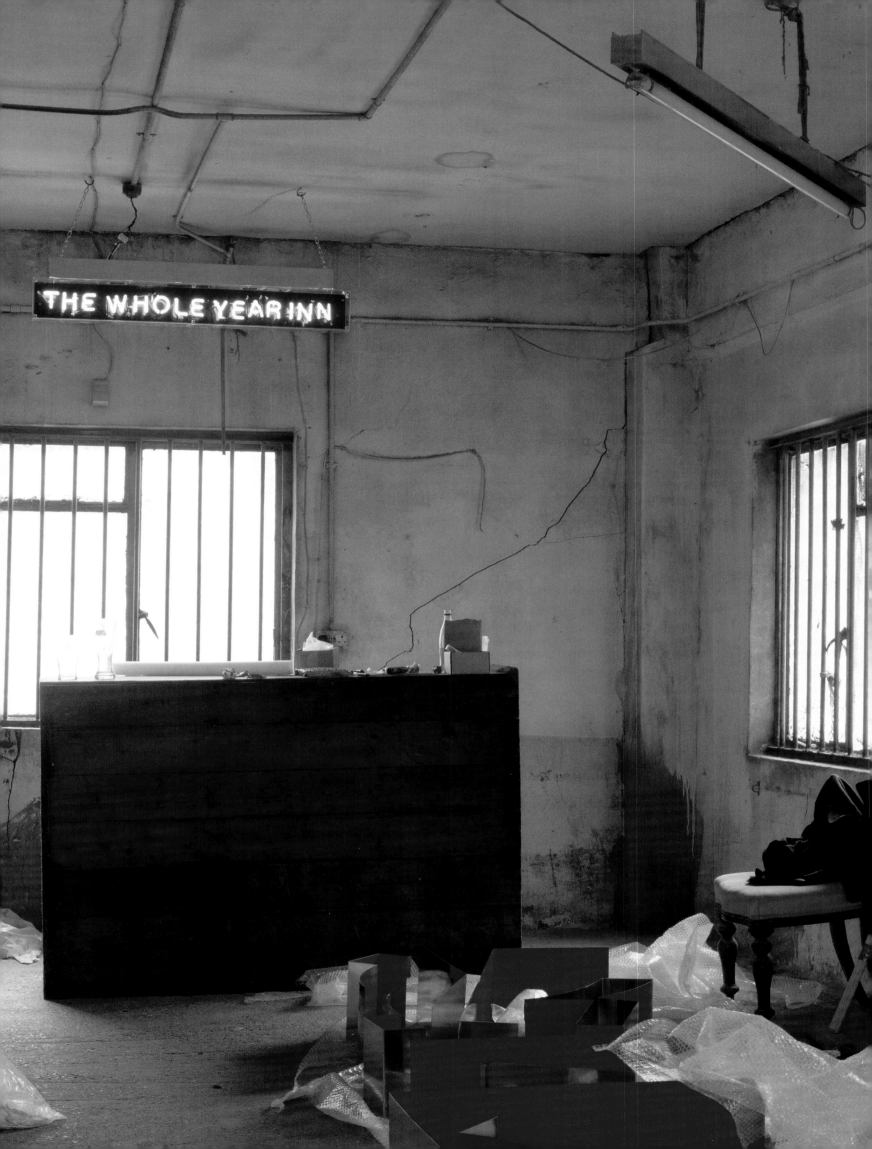

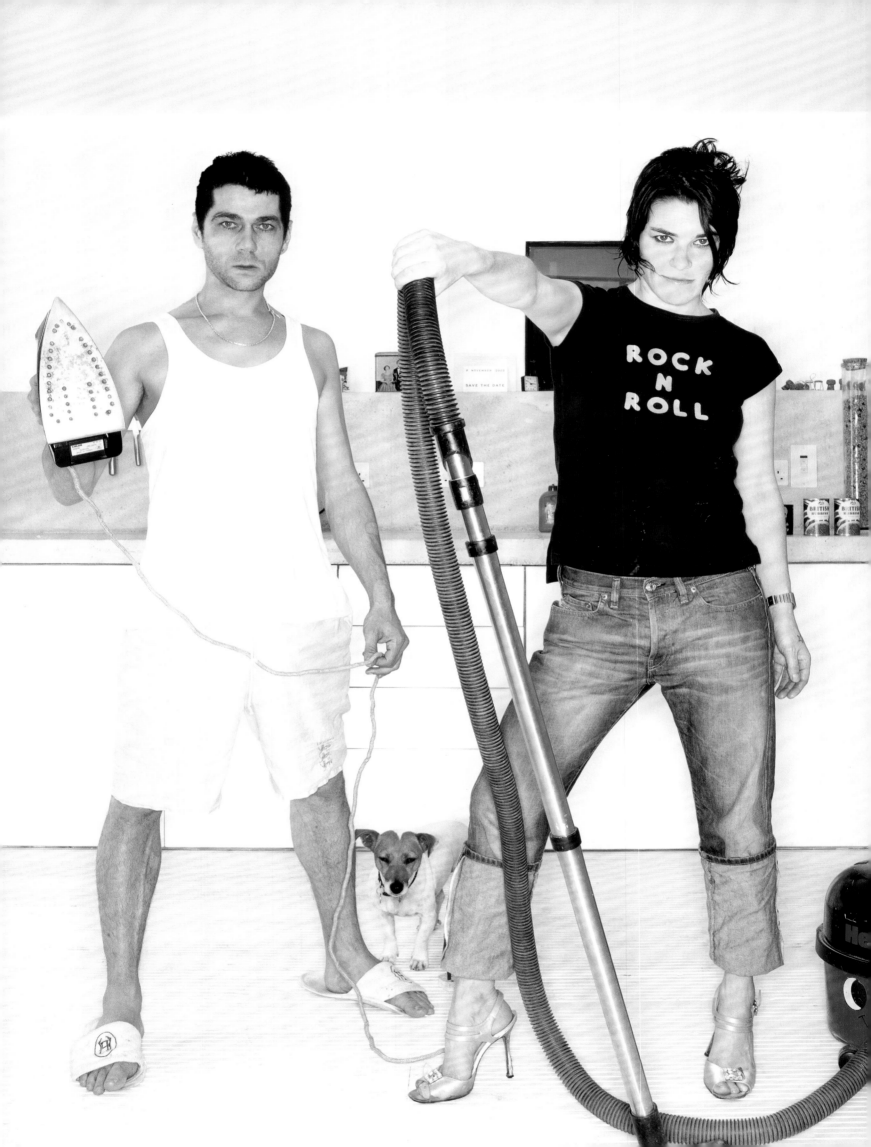

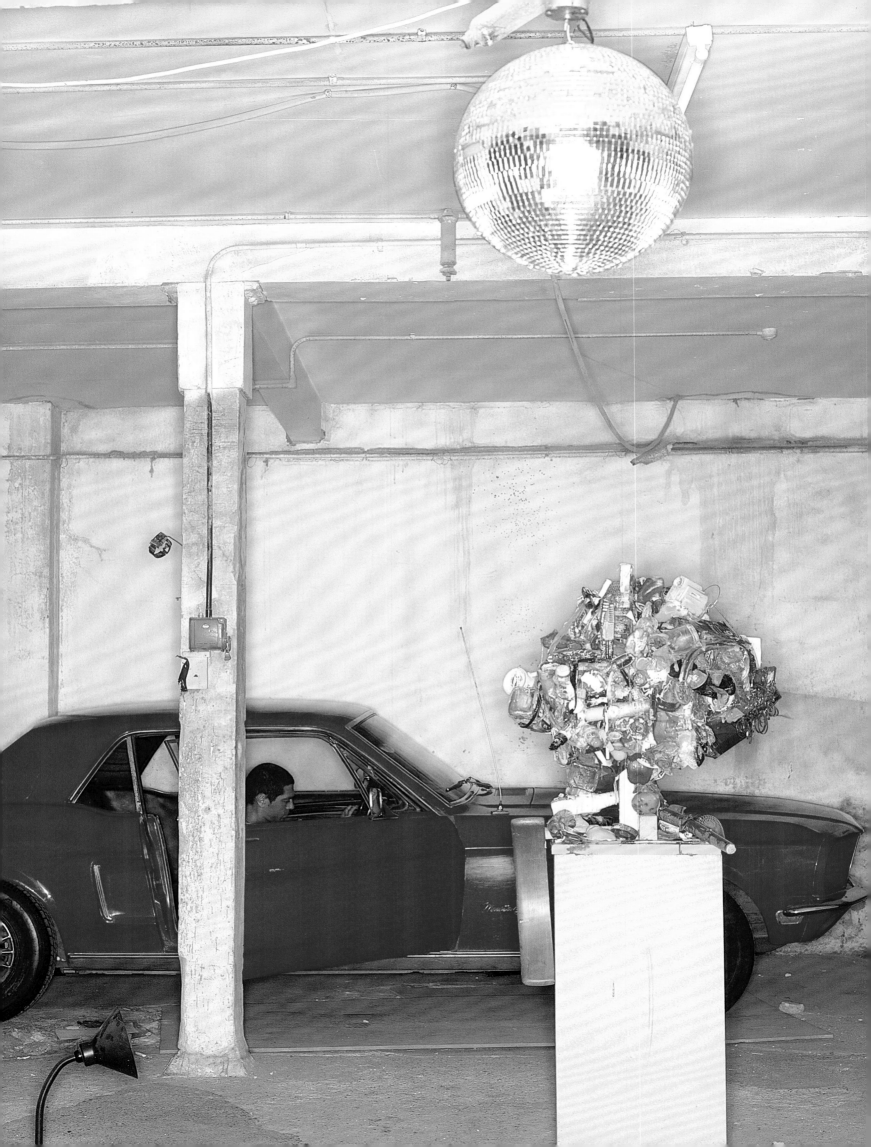

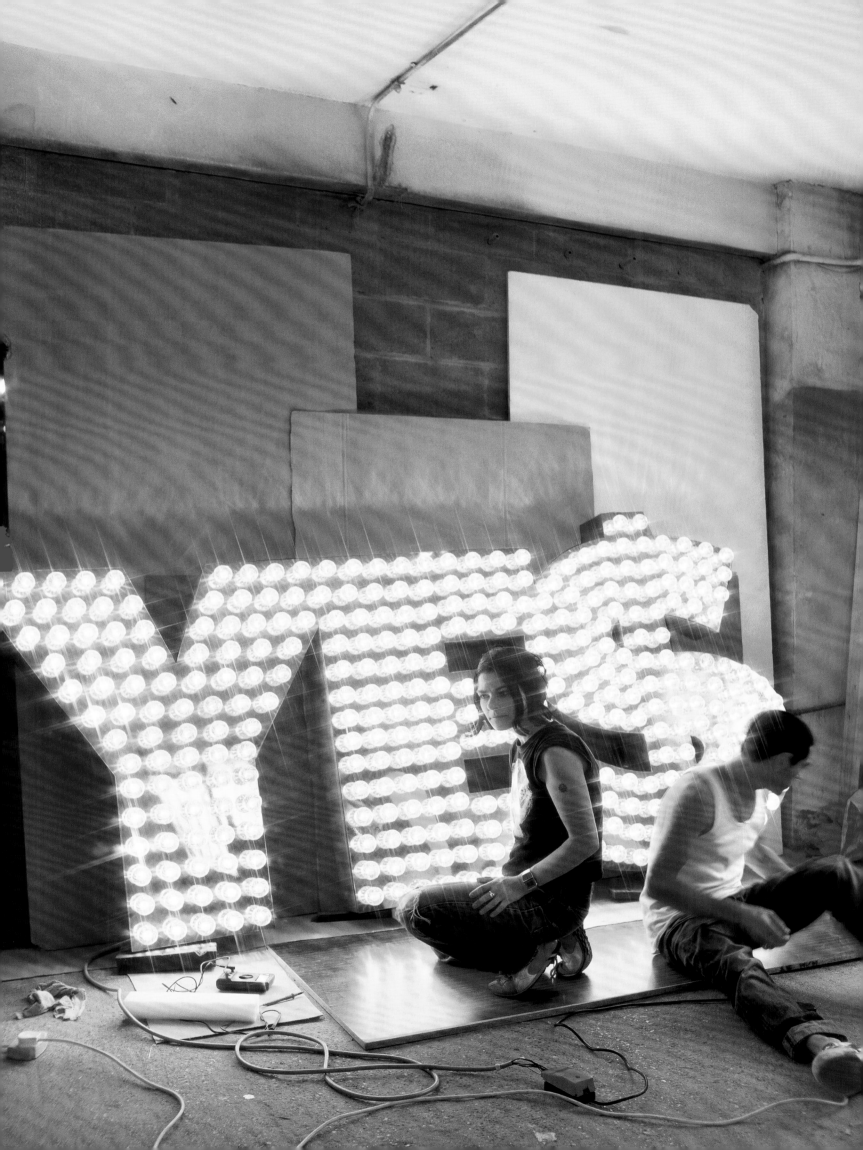

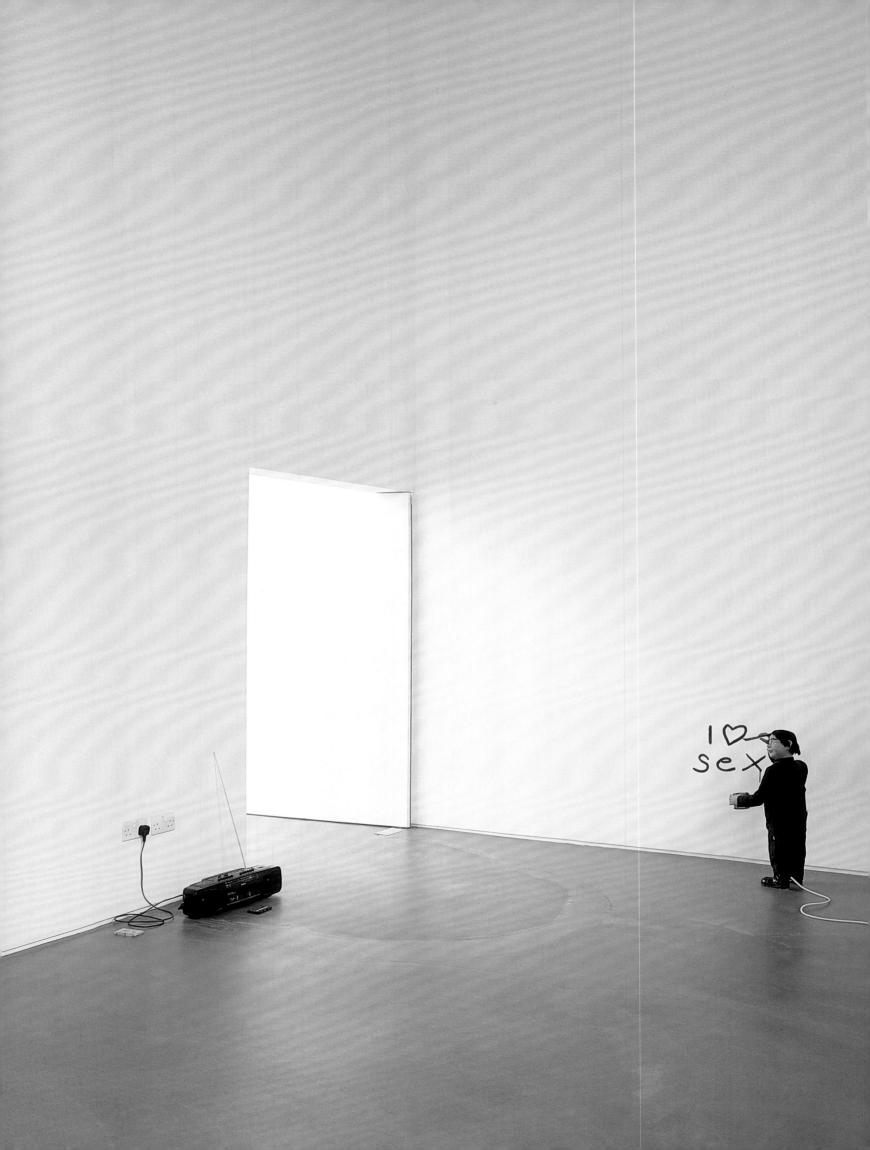

Andrée Putman

The 1984 opening of the elegant, monochromatic Morgans Hotel in Manhattan, widely credited as the first boutique hotel, was a pivotal moment in Andrée Putman's decades-long career. She subsequently worked on hotels in France, Japan, and Germany and designed the office of the French minister of culture, Jack Lang, and many other residential and retail commissions—projects as diverse as a redesign of the interior of the Concorde aircraft in 1994 and the sets for Peter Greenaway's ravishing 1996 erotic melodrama *The Pillow Book*.

The rooftop apartment in San Sebastián, Spain, that she designed for Gabriel Calparsoro and his partner, Jose Gorritxo, was photographed in 2005. Calparsoro, who works with his family's real estate firm, was a longtime admirer of Putman's work and followed her career closely. The duo commissioned Putman to come up with the concept and the design, while Gorritxo, an architect, supervised the practical renovation. "The first thing that comes to mind of our experience of working with Andrée Putman on this project is how much fun we had together," Calparsoro remembers. "We were on the same wavelength. We wanted visual comfort over physical comfort, and strong architecture. Her interiors might look classical and timeless, but they are profoundly unconventional."

The residence originated from three small studio apartments that were joined together. Putman connected the dining area (complete with Putman-designed dining table) at one end to the living room and bedrooms at the other via a hundred-foot hallway that serves as the apartment's main thoroughfare. A series of French doors open onto the terrace, providing views across the River Urumea to the skyline of San Sebastián beyond. Folding doors separate the dining area from the kitchen, while sliding doors close off a room with a desk and a wall of recessed cupboards that Putman designed with a nod to Piet Mondrian. A curved glass-block wall was built around an existing light well to enhance the daylight that floods the living room, with its custom-made sofa and chairs designed by modernist pioneer Finn Juhl. In the larger of the two bedrooms, an alcove lined in Macassar ebony creates a self-contained sleeping pod. And in the main bathroom are tiles reminiscent of a swimming pool, with a bathtub set on Putman's signature oversize ball feet.

Calparsoro and Gorritxo still live in the unchanged apartment. "Over the years, it's become a place about rituals," Calparsoro says. "Breakfast in the kitchen with the beautiful morning light, surrendering to the hedonistic bathroom, and reading at night in bed, within the beautiful dark wooden box. When I come home from my travels, I am happy to find a strong connection to the space. I'm home." Putman died at age eighty-seven in 2013, leaving a distinguished and ongoing legacy in the world of design.

Gabriel Calparsoro and Jose Gorritxo's apartment by Andrée Putman, San Sebastian, photographed in 2005.

Page 122: Andrée Putman. *Page 123*: Corridor with cupboards by Putman. *Page 124*: Bathroom with bathtub by Putman. *Page 125*: Living room with chair by Finn Juhl and custom-made sofa. *Page 126*: Bedroom sleeping alcove. *Page 127*: Kitchen with folding doors and, in the foreground, a dining table by Putman.

Andrée Putman

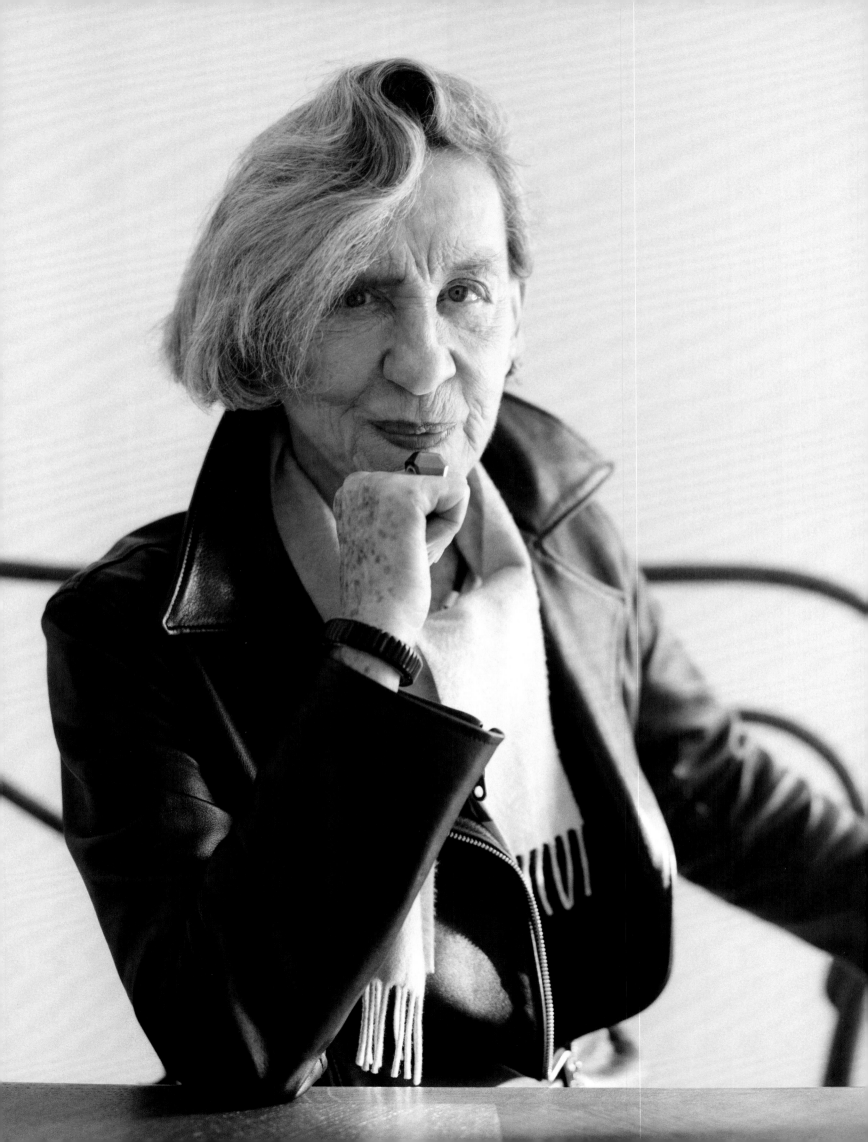

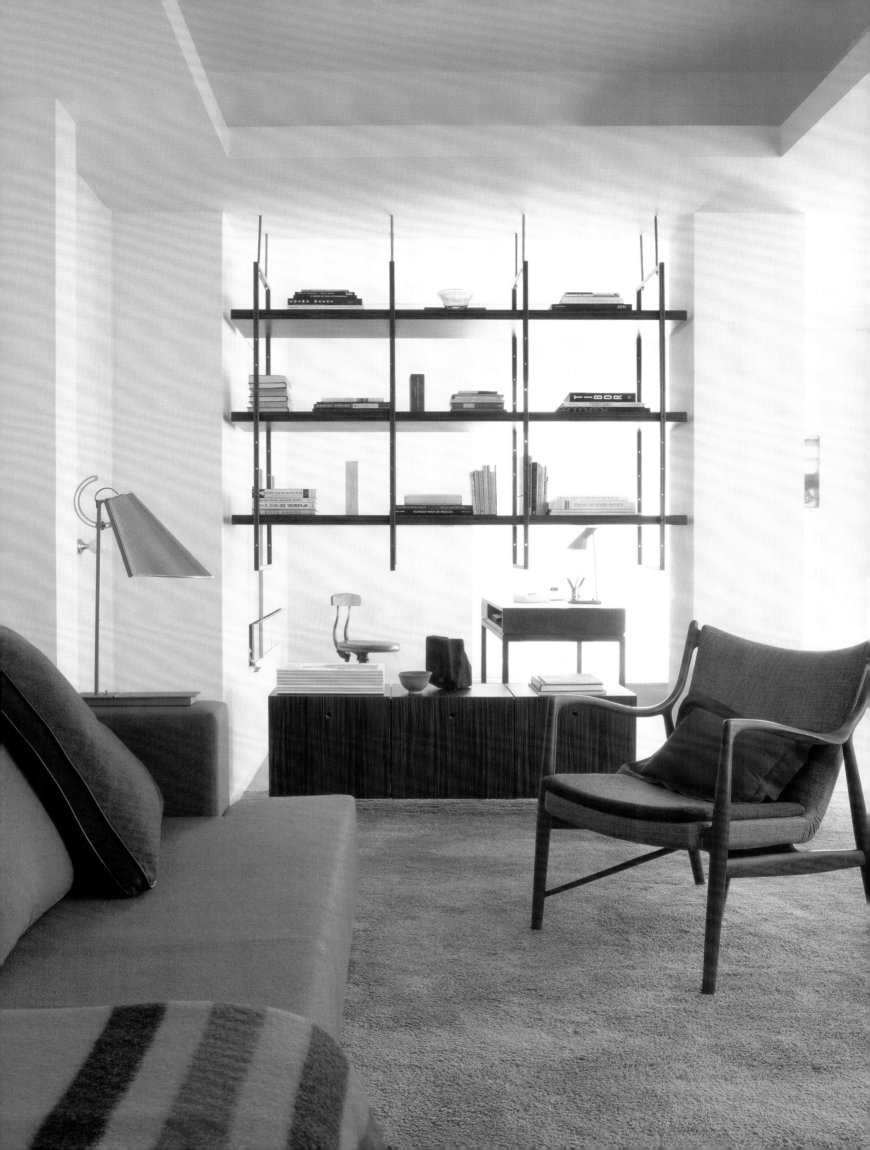

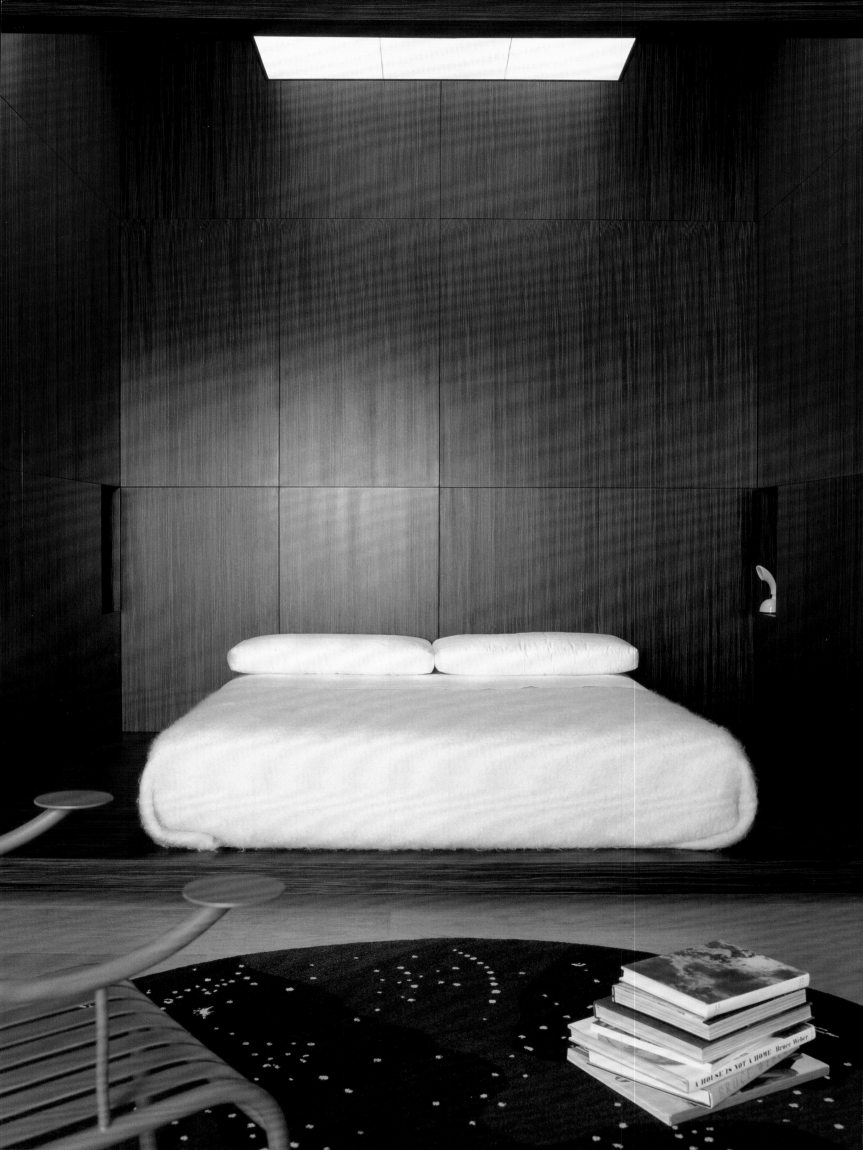

Seizure by Roger Hiorns

In 2008 Artangel, a London-based arts organization, and the Jerwood Charitable Foundation invited British artist Roger Hiorns to create an installation in an abandoned public-housing apartment in South London. The commission resulted in the extraordinary *Seizure*, the transformation of a boarded-up apartment into a deep-cerulean-blue cavern encrusted with glittering copper sulfate crystals.

Hiorns was intrigued by copper sulfate as a medium because, as a reactive chemical, it would respond to nature in its own time, however the results might manifest. He pumped tens of thousands of liters of heated liquid copper sulfate through the apartment's roof, then left it to cool and develop over a few weeks. When the liquid was drained away and the plastic coverings dismantled, a breathtaking, otherworldly interior came into view — walls, ceilings, and floors covered in a crystalline iridescent blue growth, an effect more like sorcery than like chemistry.

An instant success with the public, *Seizure* — photographed in 2008 in its original London location — was on view until late 2010. The fact that the crystals were dangerously sharp and the floors treacherously damp did not deter visitors, who were advised to wear protective clothing. *Seizure* was always intended to be transient, not least because the buildings were scheduled for demolition, but in 2011 Hiorns donated it to the Arts Council Collection for preservation, and the thirty-ton installation was carefully removed. In 2013 *Seizure* was loaned to the Yorkshire Sculpture Park in northern England, and is now housed within an award-winning concrete structure, purpose-built by Adam Khan Architects in collaboration with Hiorns, where it remains proudly on display to the public.

Seizure by Roger Hiorns, Harper Road, London SE1, 2008–2009. Commissioned by Artangel and the Jerwood Charitable Foundation, photographed in 2008.

Page 130: Exterior entrance. *Pages 132 and 133–134:* Interior of *Seizure*.

Seizure
by Roger Hiorns

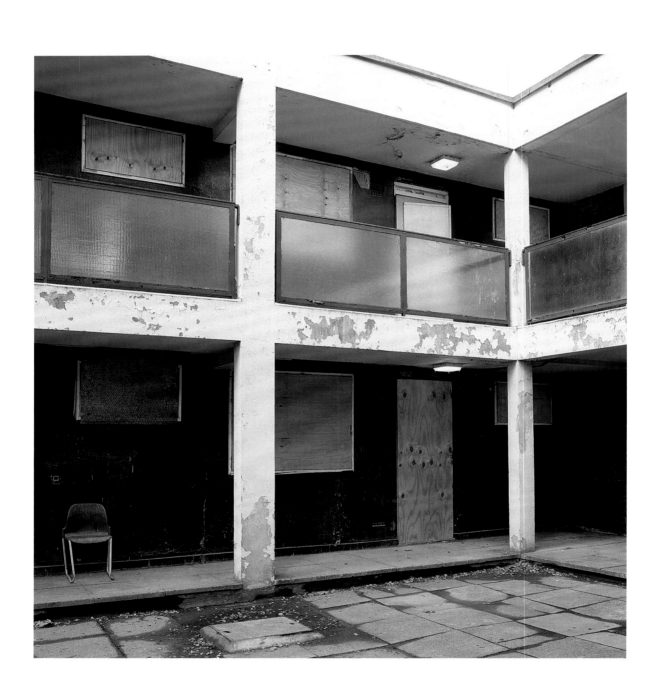

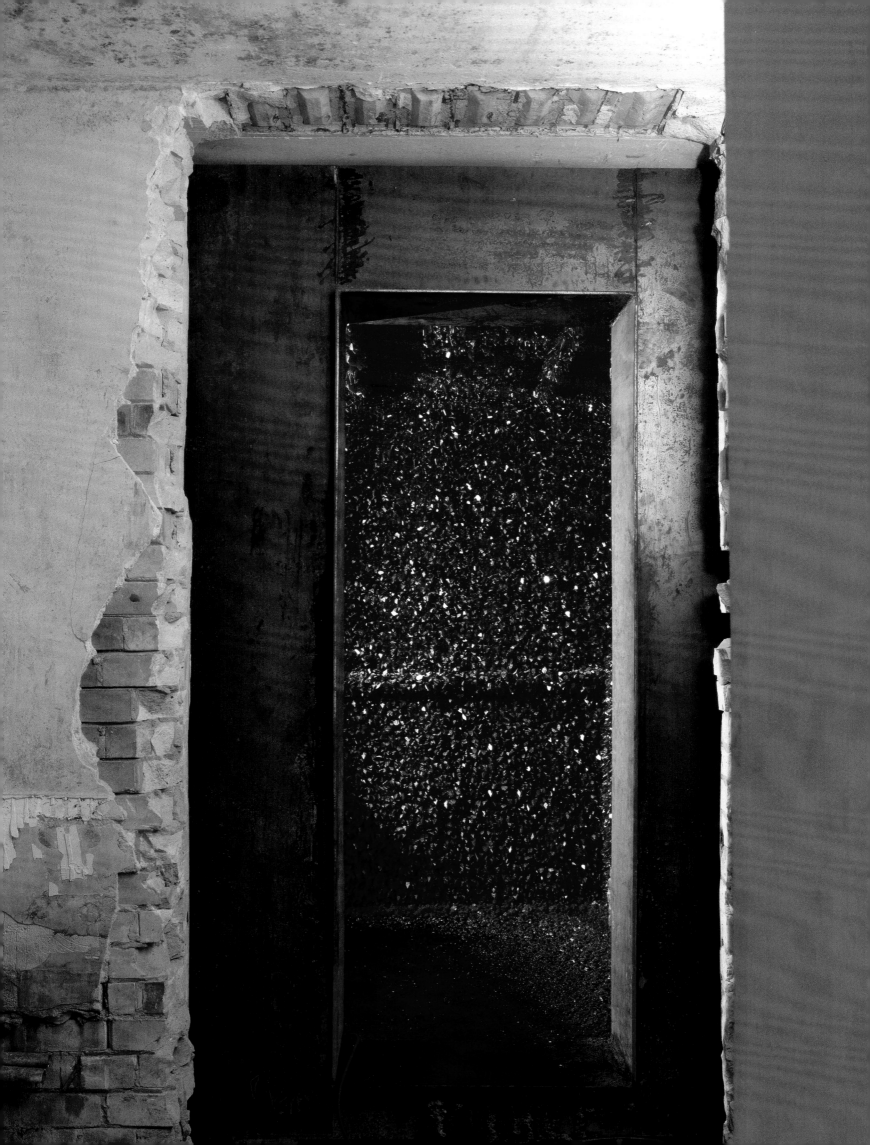

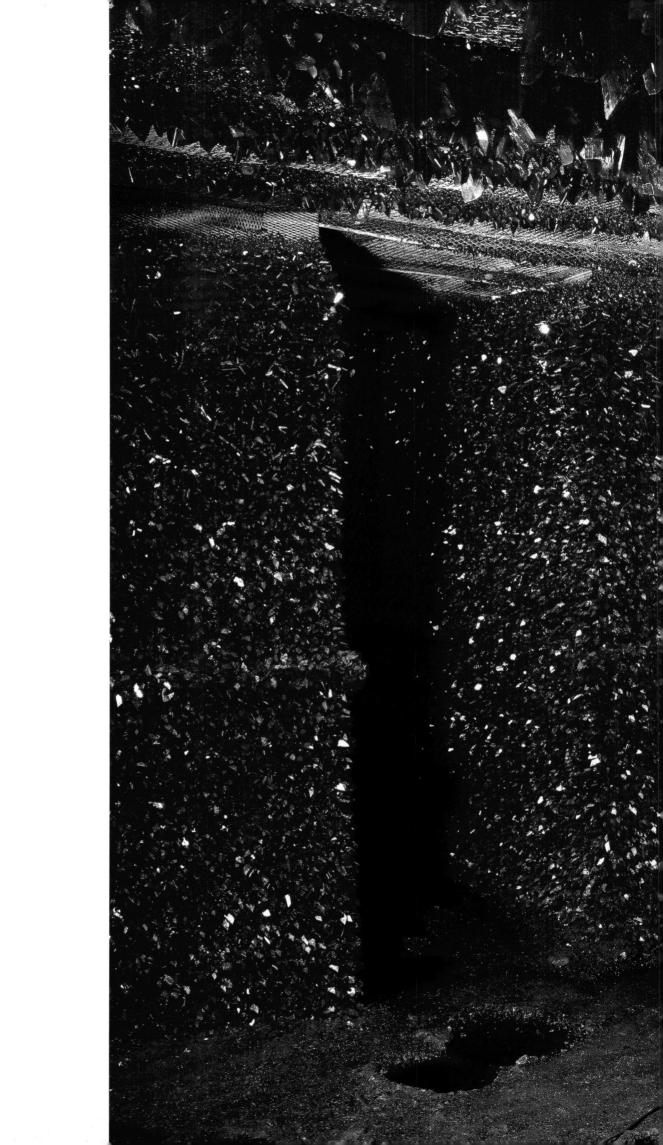

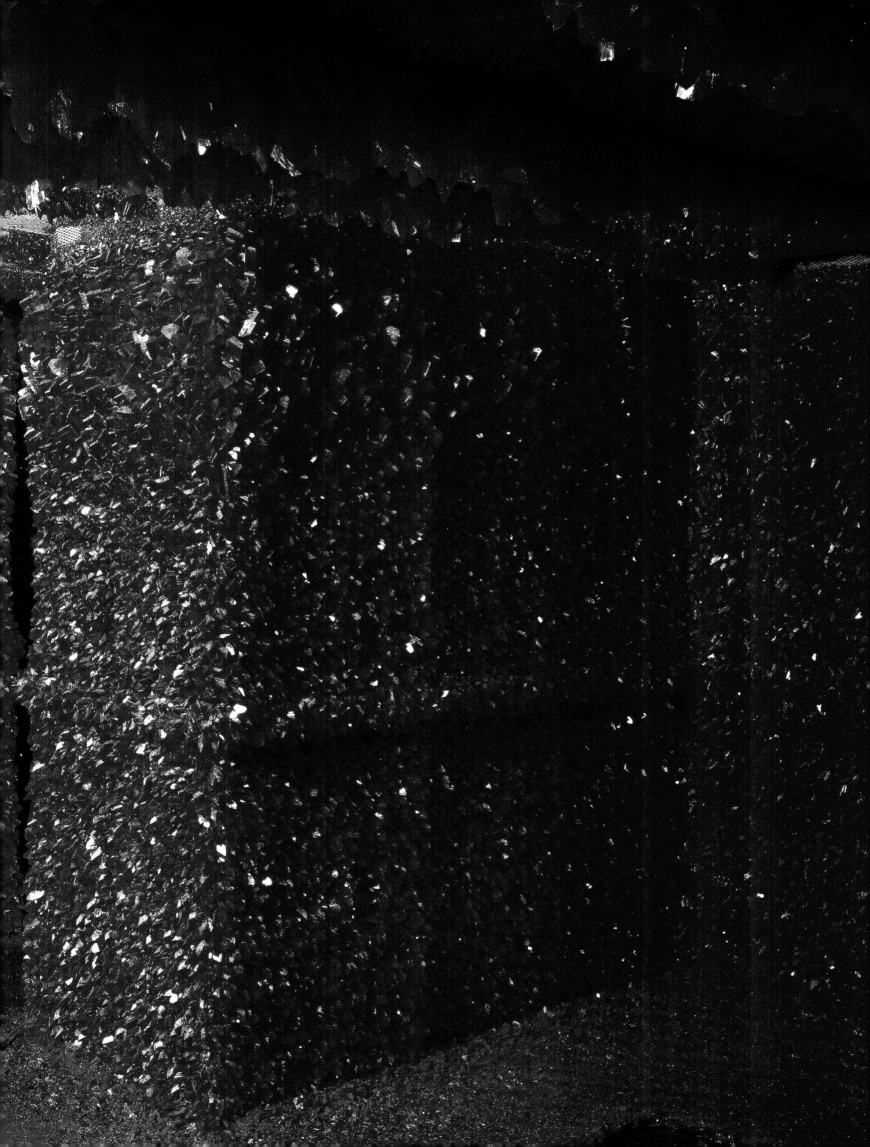

Zaha Hadid

After establishing her practice in London in 1980, architect Zaha Hadid proceeded to upend and in many ways redefine the world of contemporary architecture. With her bold geometric forms, sharp angles, and a scorn for compromise, she radically reignited discussion on what might be achieved in three dimensions. In 2004 she was the first female recipient of the prestigious Pritzker Architecture Prize, and her realized works include a fire station on the campus of the furniture company Vitra, a BMW car factory in Germany, the MAXXI museum in Rome, the Guangzhou Opera House in China, and the London Aquatics Centre for the 2012 Summer Olympics.

Hadid lived in a converted warehouse apartment in London's Clerkenwell. Although she had not been the architect behind the space, it was unquestionably hers, filled with furniture of her own design as well as those of twentieth-century masters George Nelson and Shiro Kuramata. A prototype of her undulating Aqua Table stood in front of her monumental painting *Malevich's Tektonik,* created for her Architectural Association (A.A.) graduation thesis—a concept for a hotel on a bridge over the River Thames, inspired by the work of Russian avant-garde artist and self-styled Suprematist Kazimir Malevich. Hadid would go on to teach at the A.A. school until 1987.

Surprisingly—or perhaps not—Hadid's radical work was polarizing; only two residential projects she designed were actually constructed, one in London's Belgravia and one in Russia, in a forest outside Moscow. Perhaps the constraints of time were a determining factor, as Hadid's concepts demanded a flexible approach to "dimension," conceivably better suited to far larger projects. She was also vocal about her adopted hometown's often reactionary approach to contemporary architecture; while she designed over fifty fully realized projects across the world, only four can be found in London.

Hadid died unexpectedly in 2016, but her office, run by Patrik Schumacher, her longstanding partner in the firm, carries on her pioneering approach to architecture.

Zaha Hadid's apartment, London, photographed in 2008.

Page 136: Main living space with a prototype of Hadid's Aqua Table, 2006, for Established & Sons and Hadid's painting *Malevich's Tektonik,* 1976–77. *Page 137:* Hadid with her Iceberg sofa, 2003, for Sawaya & Moroni. *Page 138:* Hadid's collection of Murano glass; a Marshmallow sofa, 1956, by George Nelson; and lacquered stacking trays by Shiro Kuramata. *Page 139:* Hadid's Iceberg sofa. *Pages 140–141:* Detail of the prototype for Hadid's Aqua Table.

2000s

Zaha Hadid

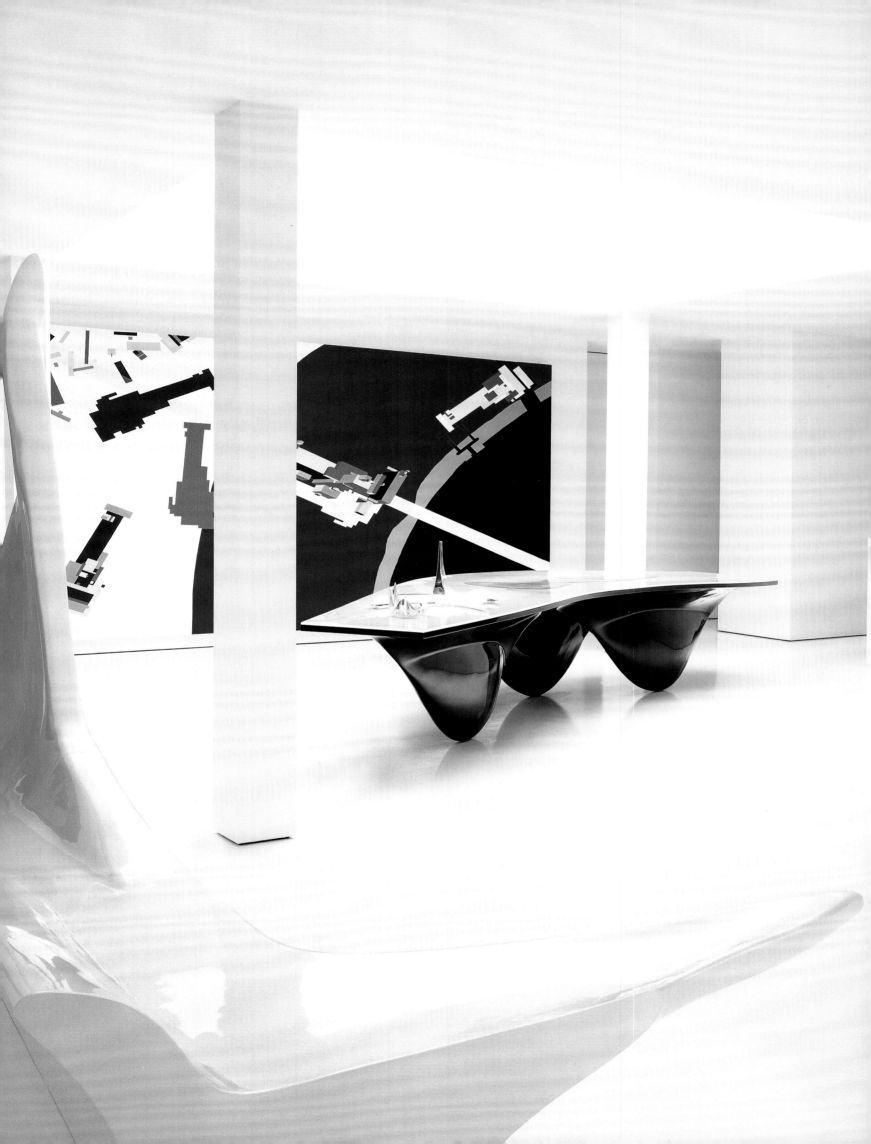

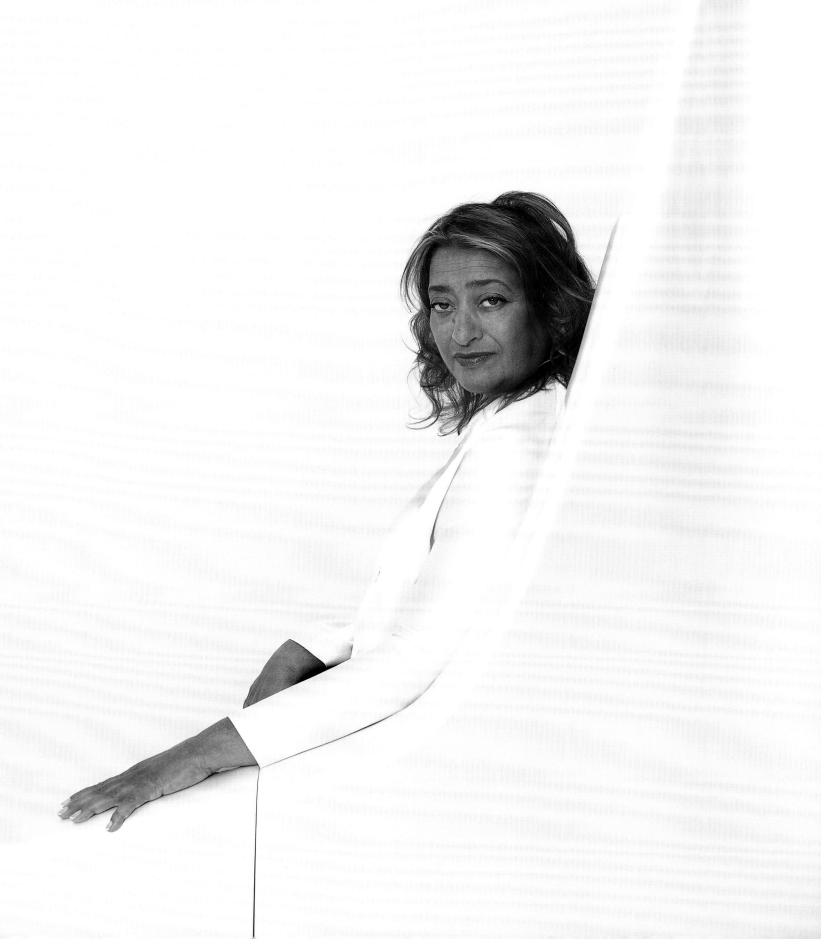

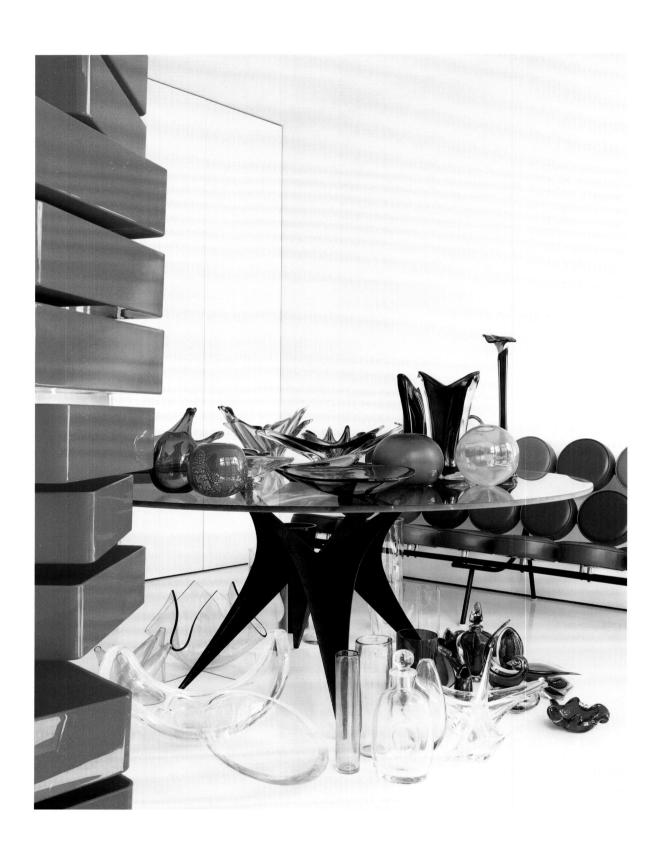

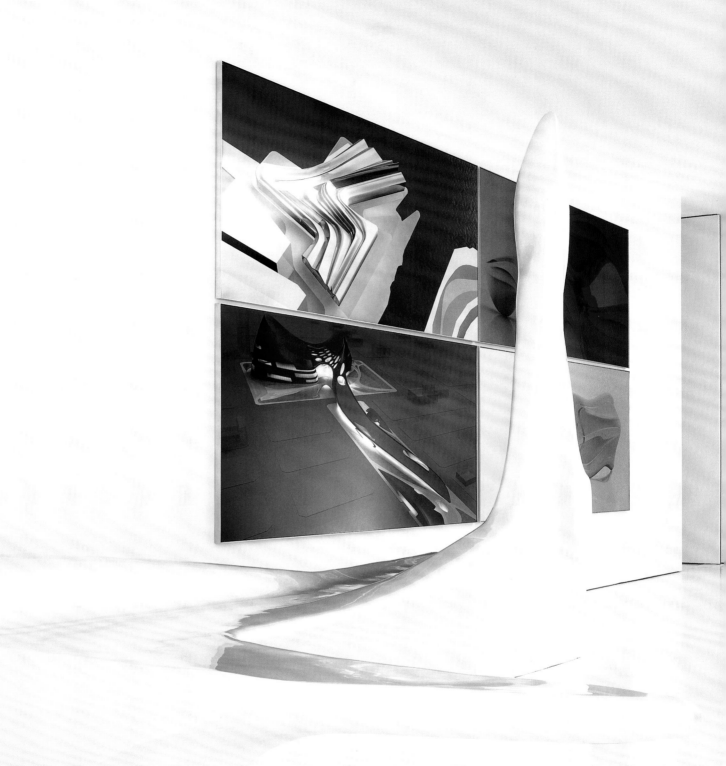

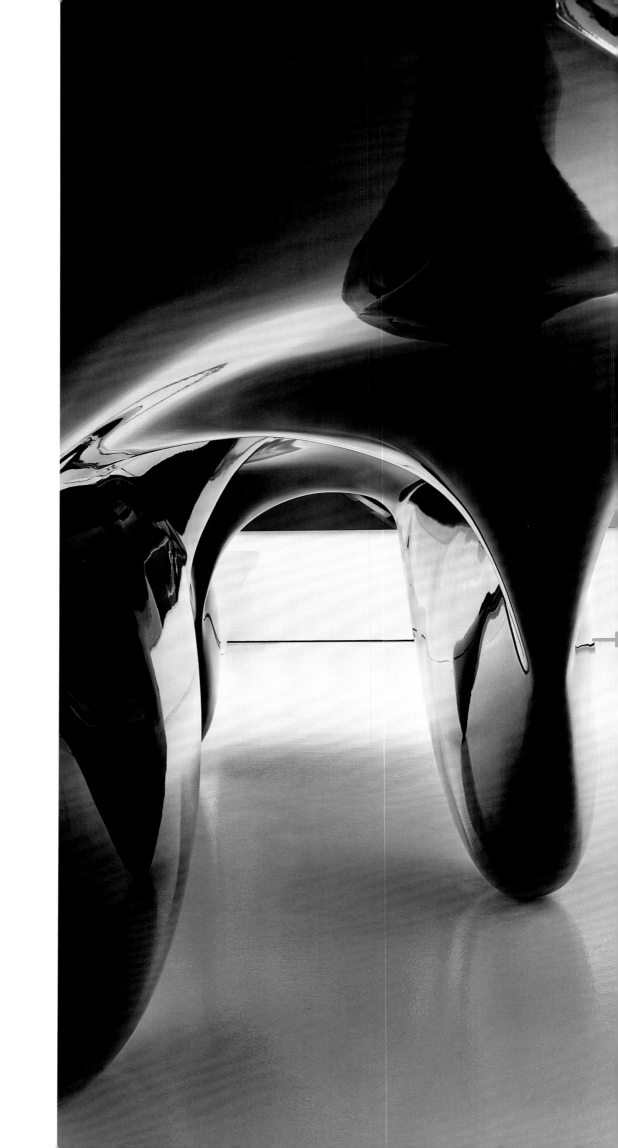

Marc Newson & Charlotte Stockdale

When industrial designer Marc Newson married fashion consultant Charlotte Stockdale in 2008, each of them held on to the London homes they already owned—Newson to his sleek, spartan bachelor-era apartment (page 92), Stockdale to her traditional, feminine five-floored Victorian house. With the arrival of children, they embarked on a search for their first shared home, one with space for a growing family, a new office for Newson, and a design that met in the middle. They agreed, it seems quite quickly, on a 4,000-square-foot flat in a former Royal Mail sorting office in London's Victoria, dating from 1894 and ripe for redevelopment. In 2009 they moved in.

The couple share a dislike of what might still best be termed "loft living," and Stockdale was happy to let her husband take the lead on the design, with one condition: that he provide her with a library. Newson set about redesigning the apartment, photographed in 2010. Working with architect Sébastien Segers, he added smooth, round-edged plaster walls, a Swiss chalet–inspired stone wall in the double-height living room, and floor-to-ceiling green-lacquered cupboards in the downstairs kitchen.

In the kitchen and living room, the sense of scale is enhanced by unglazed windows on the second floor that overlook the space below. Two sofas from by Svenskt Tenn, covered in a leaf-strewn green-and-white fabric by Josef Frank, face the living room's open fireplace. Newson took over an adjacent space for his office and, as promised, provided his wife with a library—a traditional English oak-paneled inner sanctum.

The second-floor rooms are single-height, but Newson's application of colors, textures, and patterns give them an intimate, welcoming feel. Devoid of corners and lined in white-striped Italian marble, a bathroom between the library and main bedroom lends a sparse and unexpectedly serene contrast—a happy marriage of aesthetic viewpoints.

Marc Newson and Charlotte Stockdale's apartment, Victoria, London, photographed in 2010.

Page 144: Kitchen with Lathed table, Coast chairs, and Diode lamp, all by Newson. *Page 145:* Living room with Micarta chairs, 2007, by Newson and a ballpoint-ink artwork by Alighiero Boetti. *Page 146:* Kitchen with a Dish Doctor dish rack by Newson. *Page 147:* Kitchen. *Page 148:* Living room with Svenskt Tenn sofa upholstered in a Josef Frank print. *Page 149:* Marc Newson and Charlotte Stockdale. *Page 150:* View into the library, with sofa upholstered in Colefax and Fowler tweed. *Page 151:* Hallway leading to the library. *Page 152:* Library, with view to a Wood chair, 1988, by Newson. *Page 153:* White-striped Italian marble bathroom.

Marc Newson & Charlotte Stockdale

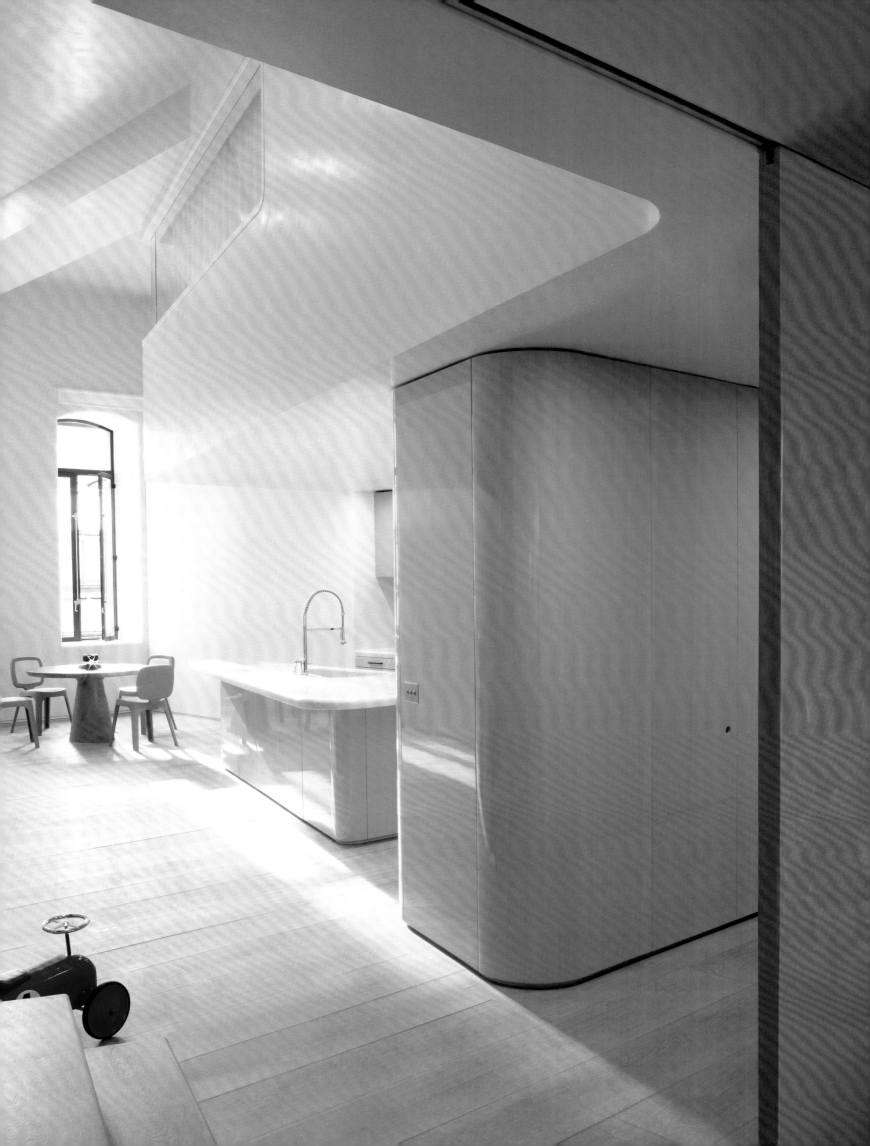

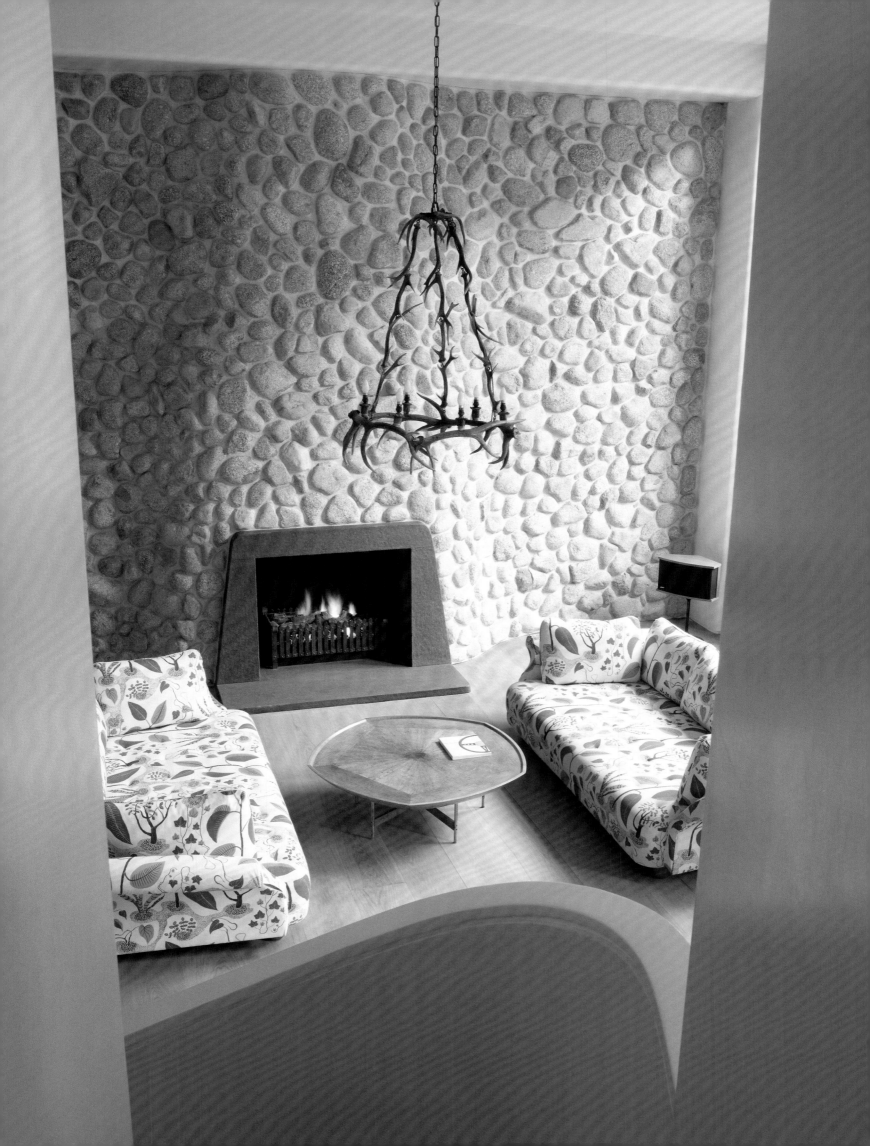

Britt Moran & Emiliano Salci

Milan-based Britt Moran and Emiliano Salci, founders of the architecture and design firm Dimorestudio, share an aesthetic that is subtle and contemporary but acknowledges the influence of twentieth-century Italian modernist masters such as Gio Ponti, Marco Zanuso, and Ignazio Gardella. Moran, a graphic designer from North Carolina, and Salci, once art director for the revered Italian furniture company Cappellini, established their firm in 2003, and over the last two decades they've brought their inimitable style to international residential, retail, and hospitality projects, as well as to furniture, lighting, wonderfully patterned and textured fabrics, and accessories created under the name Dimoremilano.

The Italian word *dimore* translates to "dwelling," but in the vernacular it conjures blowsy villas etched with a palimpsest of Italy's aristocratic past. As the pair explain, "It lends the name a sense of nostalgia. It's in our DNA: we take a historical approach to a project to give it some roots, and then we inject it with more of a contemporary feel."

So, it's fitting that early in the Dimore story, Moran and Salci shared an apartment in a seventeenth-century building on the Via Solferino, in Milan's Brera district. These photographs from 2013 show walls painted in strong but low-key colors and rooms beautifully installed with antique furniture expertly placed alongside twentieth-century items and custom pieces. With characteristic diligence, the pair researched the provenance of each historical object they acquired, and every year during the Milan Furniture Fair, when they opened up their apartment, it was a destination for writers, fellow designers, and design enthusiasts. Visitors might admire the mixture of periods and styles the couple effortlessly achieved: a contemporary kitchen island, say, clad in exquisite polished brass alongside a late eighteenth-century Gustavian daybed.

On the company's tenth anniversary, Moran and Salci reconfigured the apartment into Dimoregallery, a studio-cum-exhibition space. (Their original office, in the same building as the apartment, is now the permanent showroom for Dimoremilano.) What makes the apartment so different as a commercial showcase, Moran explains, is that it is not a gallery but a private home. And its original architectural features are never an obstacle in creating a contemporary feeling; rather, they are harmoniously integrated into each installation.

At Dimoregallery, nothing is left to chance; there is always, as observers have pointed out, a narrative and a purpose to every action. A 2021 installation resembled nothing so much as an apartment abandoned for some urgent but unknown reason—a perfectly set table, but accented with flower arrangements wilting and dying. Or rooms that could only be viewed through holes in the walls, as in an installation at Dimorecentrale, a new office and exhibition space near Milan's central train station. "They keep taking risks," says the acclaimed design writer Tom Delavan. "They're artists, really."

Britt Moran and Emiliano Salci's apartment, Milan, photographed in 2013.

Page 156: Hall with Venini chandelier and Stilnovo hexagonal wall lights. *Page 157:* Britt Moran (seated) and Emiliano Salci (standing) with pendant Fun lamp, 1963, by Verner Panton and armchairs covered in Jim Thompson fabric. *Page 158:* Bedroom with Dimorestudio bench and Azucena sconces. *Page 159:* Bedroom with Marco Zanuso chair, 1951. *Page 160:* Living room with pendant lamp by Panton. *Page 161:* Main living room with Oushak rug and velvet chairs by Zanuso. *Page 162:* Kitchen with vintage Kartell lamp, Saarinen table, a late eighteenth-century Gustavian daybed, and reproduction Chiavari chairs. *Page 163:* Bathroom with an antique map of Italy and Fiberglass Armchair DAR, 1950, by Charles and Ray Eames.

Britt Moran & Emiliano Salci

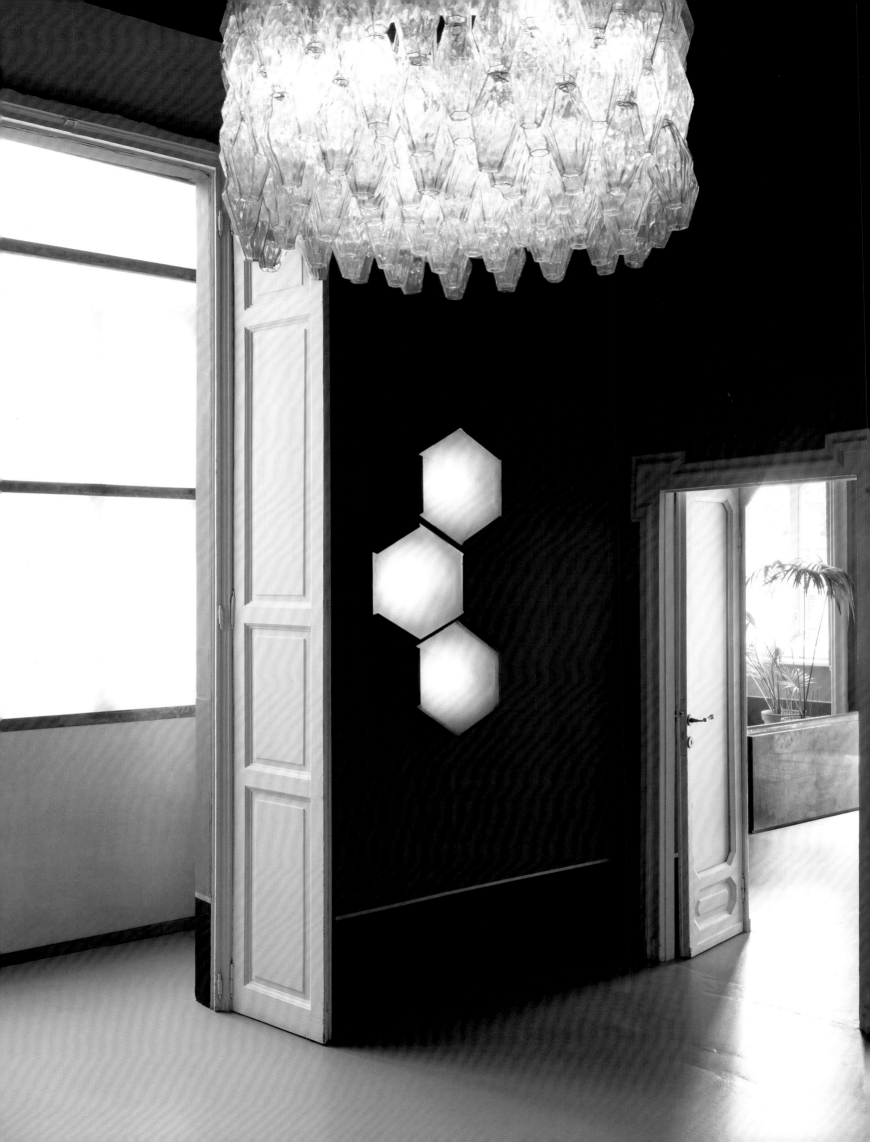

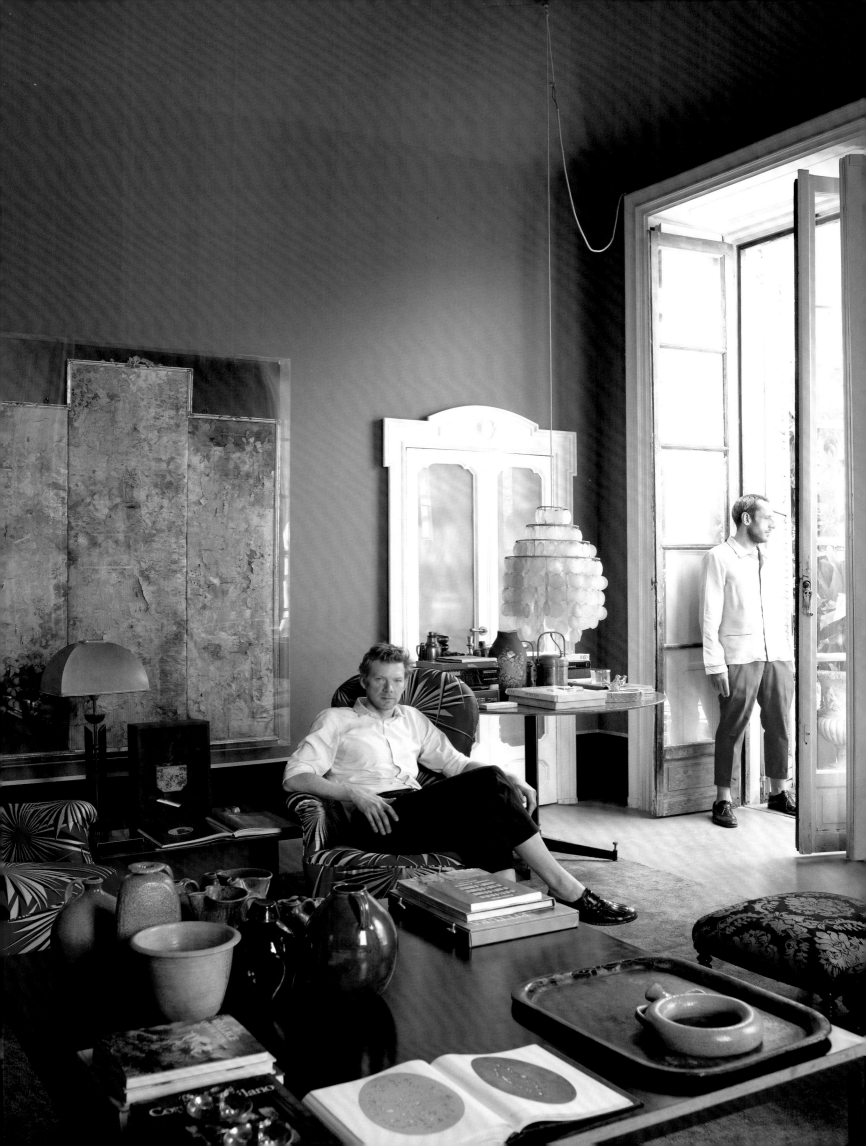

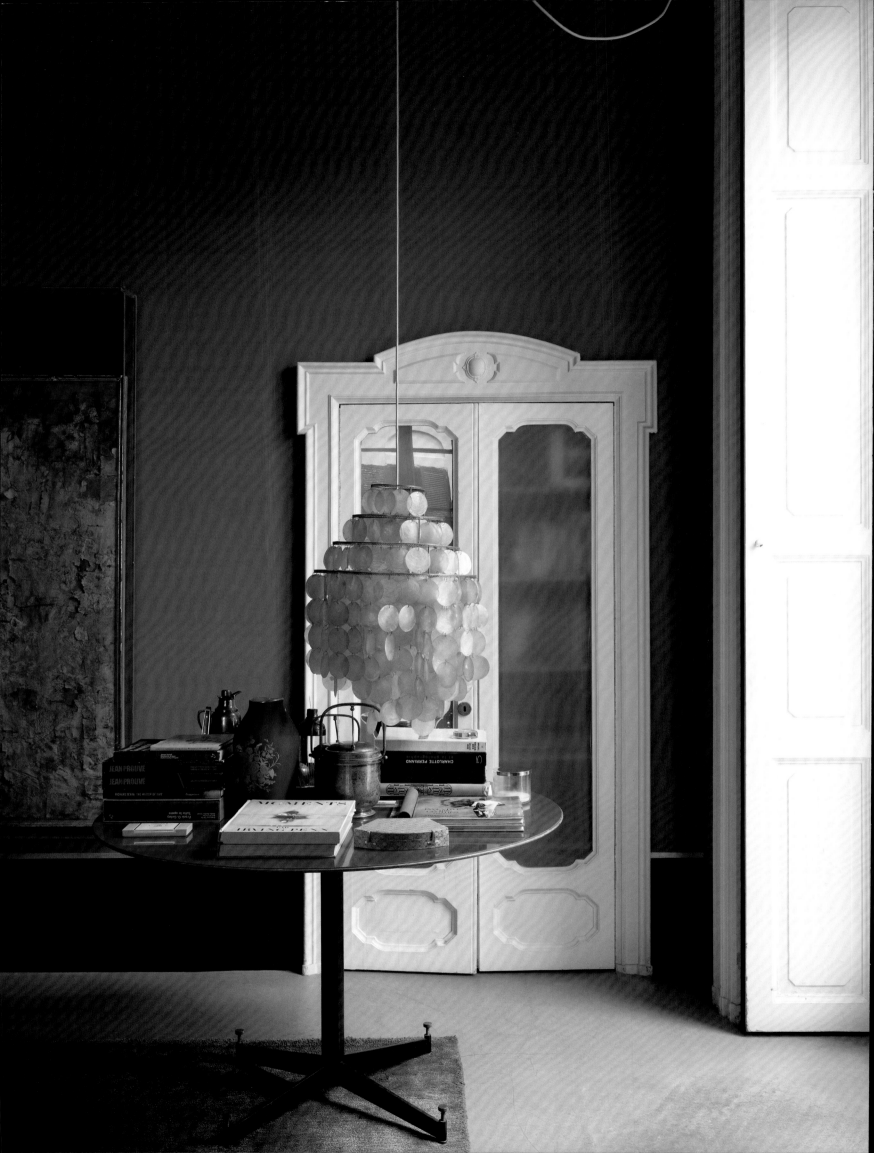

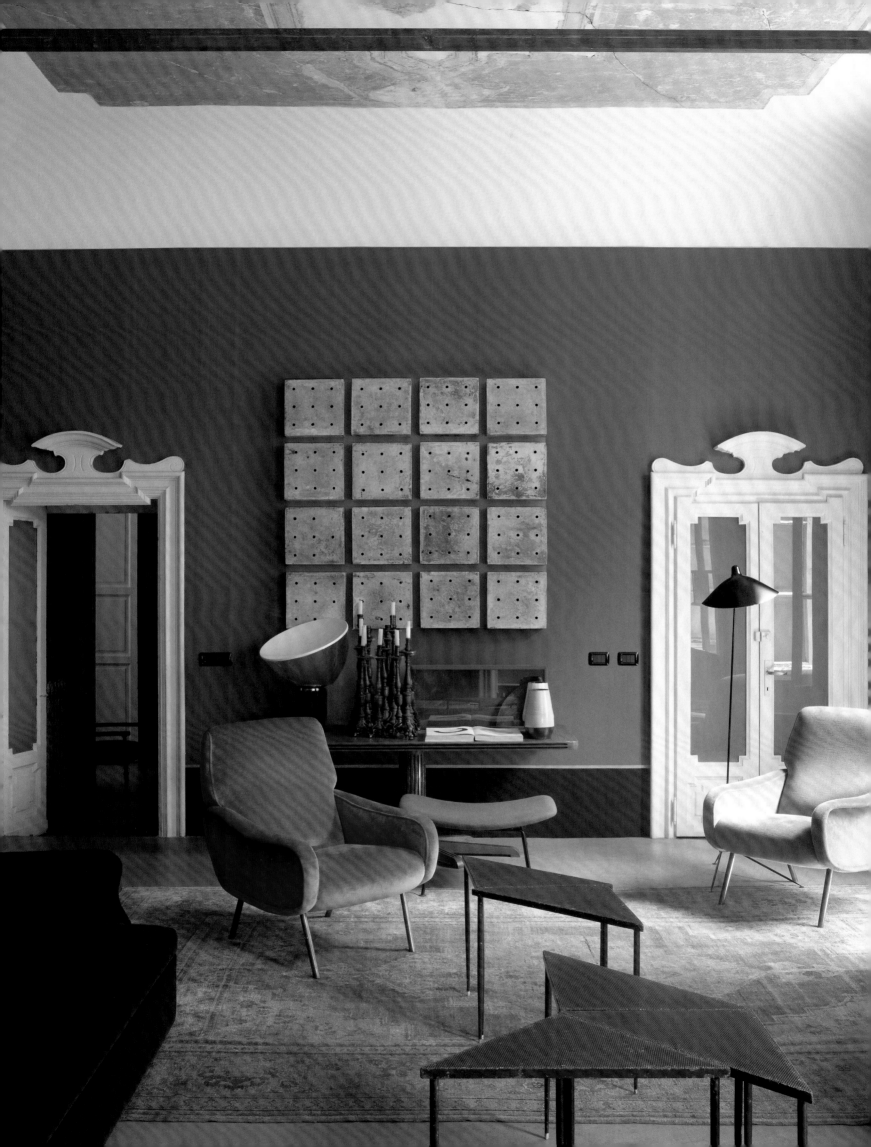

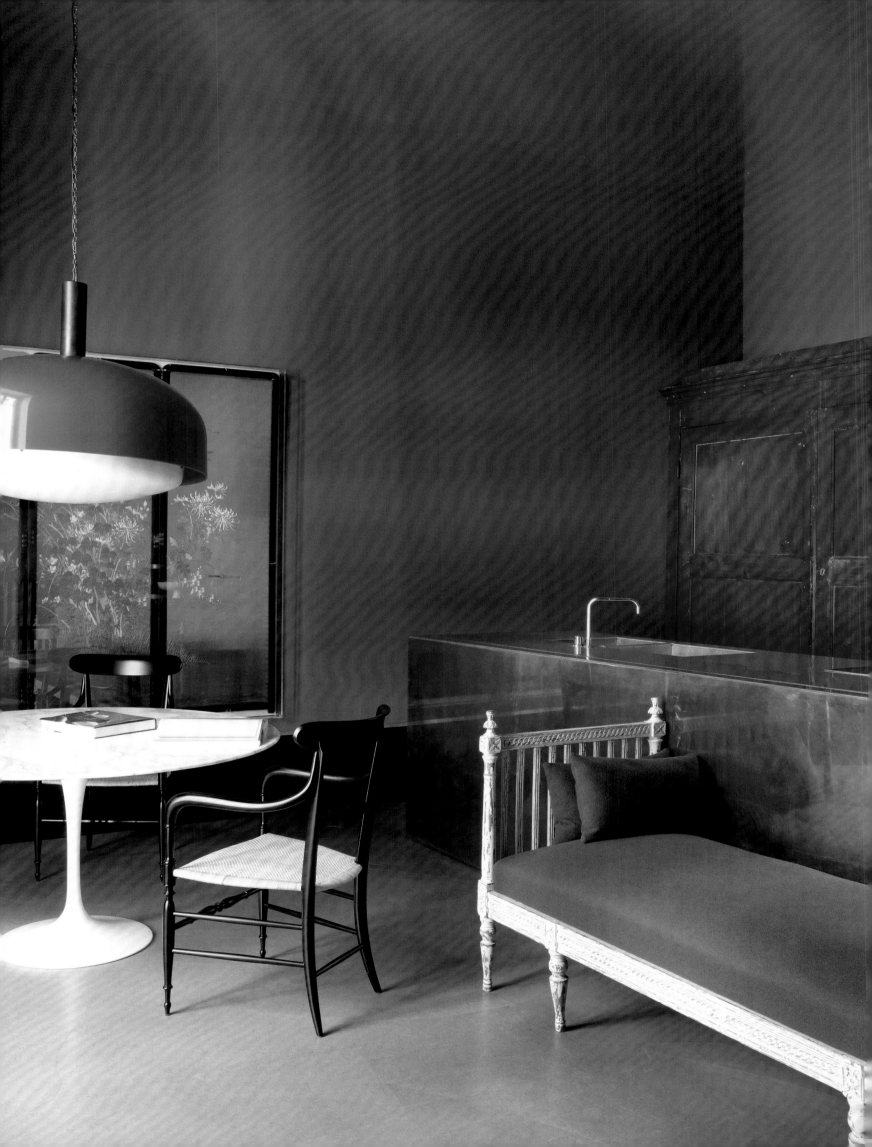

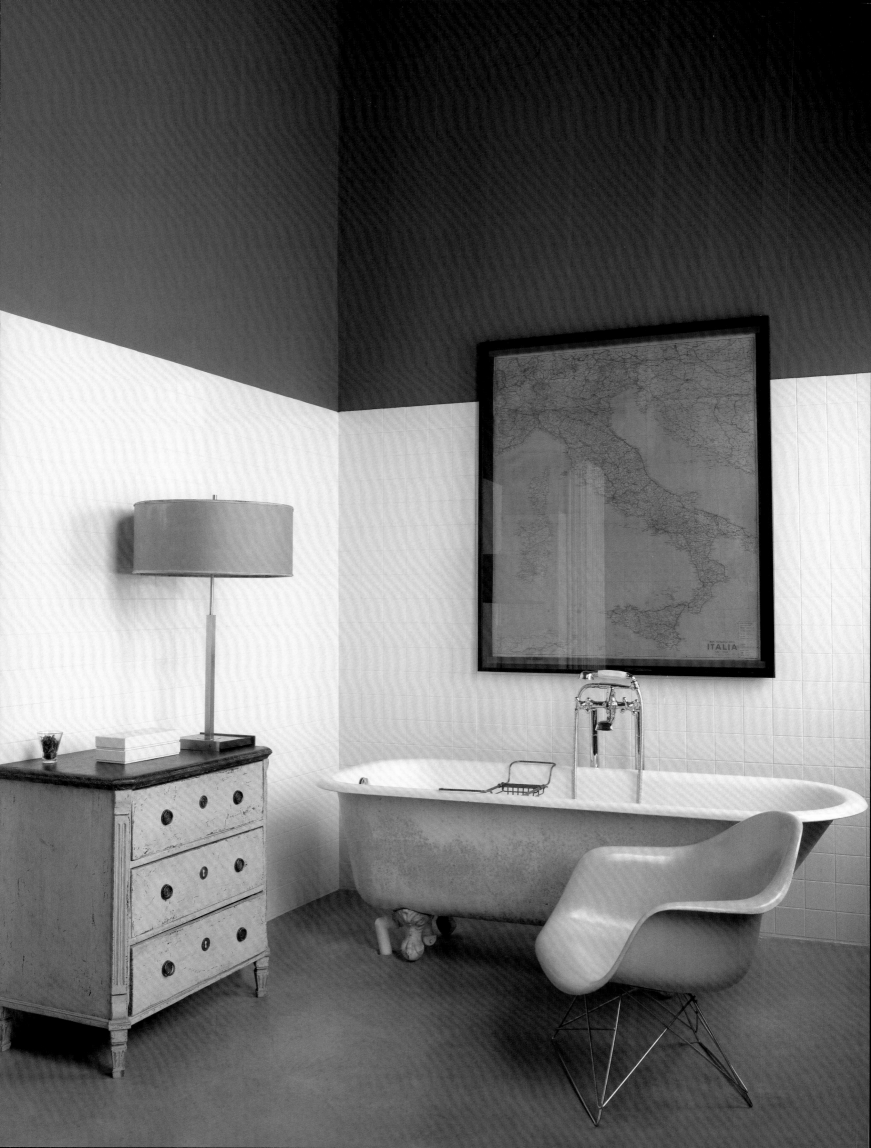

Daniel & Juliet Chadwick

Sculptor Lynn Chadwick bought Lypiatt Park in 1958, two years after becoming the youngest ever winner of the International Sculpture Prize at the Venice Biennale. The sprawling manor house, dating back to at least 1220, was, as might be expected, extended and modified significantly over the following centuries. It's said that Lynn acquired Lypiatt for the same price as he might a three-bedroom cottage—few desiring a home of such scale in an era of falling incomes and rising costs.

　　The house was in a state of some disrepair, but Lynn, who had once trained as an architectural draftsman, stripped back the gloomy Gothic Revival interiors, whitewashing over all the walls, the dark oak paneling, and ornate cornicing to create a new space, which, reconfigured and freed of the superfluous, became an ideal backdrop for his angular, figurative—and sizeable—cast-bronze sculptures.

　　Daniel, the youngest of Lynn's four children, who would in time take over stewardship of Lypiatt, studied engineering in London. At twenty-one and still a student, he was hired part-time by architect Zaha Hadid (page 134). As he recalled it, "I saw that she hated conventional drawings and cardboard models. She was, after all, an artist. I happened to have a talent for working with acrylic, so I made her little sculptures, and she loved them. To the extent that we ended up working, one to one, at the concept stage of her projects." This process proved so harmonious, Daniel says, that Hadid forbade him from returning to his studies, and this relationship saw her very first building completed. After five years Daniel left to pursue his own career as an artist.

　　Lynn died in 2003, and Daniel and his wife, Juliet, also an artist, took over Lypiatt Park. Being the scion of a world-renowned figure comes with its own set of disadvantages, and Daniel was initially hesitant about taking on the house, gallery, and workshops, so identifiably his father's. And had he not after all aspired to something original for himself? In the end, throwing aside any misgivings, he and Juliet embraced Lypiatt Park head-on. They would preserve Lynn's artistic legacy (and his original vision for the house) and add to it their own work. Though the house may have endured new practicalities—Lypiatt, photographed in 2014, now has central heating—the most compelling dialogue is clearly that between two generations of artists.

　　In the grandly proportioned dining room stands a stove designed by Lynn, perched on a platform in view of Daniel's shocking-pink sculpture *Landscape* from 1998 and a huge white mobile, part of his 2006 Galaxy series. Alongside it is an angular terrazzo dining table made in the 1960s by Lynn, while his 1967 sculpture *Dancers* faces Daniel's White Landscape piece, *Paradise* from 2005, and a site-specific spot painting by Damien Hirst, a friend from Daniel's early London days. (In something of a cultural exchange, Daniel's sculptures were prominently displayed at Hirst's *Pharmacy* restaurant (page 72).)

　　Much of Lynn's work remains on display, though on fresh terms. The unequivocal *High Hat Man and High Hat Woman*, 1968, stand guard in the large hallway—with Daniel's 1995 acrylic *Black and Cream* mobile hanging high above. At which Daniel remarks: "They say you are always in your father's shadow. Well, I suppose you could say my father's work is now in my shadow."

　　And the romance continues outdoors. Within this improbably arcadian landscape, Lypiatt's sculpture park contains thirty, maybe more, of Lynn's artworks, carefully positioned to watch over the flocks of sheep contentedly keeping 250 acres of rolling Gloucestershire parkland in check.

Daniel and Juliet Chadwick's home, Lypiatt Park, Gloucestershire, photographed in 2014.

Pages 166–167: Daniel and Juliet Chadwick in the dining room with *Landscape*, a pink sculpture, 1998, and white mobile from the Galaxy series, 2006, both by Daniel Chadwick, and a stove designed by Lynn Chadwick. *Page 168:* Dining room with terrazzo table by Lynn Chadwick; his sculpture *Dancers*, 1967, a White Landscape piece; *Paradise*, 2005, by Daniel Chadwick; and spot painting by Damien Hirst. *Page 169:* Hallway with *Statue of David* by Cockings & Hodge, 2005, and painting by Terry Ilott, 1967. *Page 170:* Through the archway, *Teddy Boy and Girl II*, 1955, by Lynn Chadwick. *Page 171:* Bedroom, with bathroom by Lynn Chadwick in the distance. *Page 172:* Hall with *High Hat Man and High Hat Woman*, 1968, by Lynn Chadwick and *Black and Cream* mobile, 1995, by Daniel Chadwick. *Page 173:* The Sculpture Park with *Encounter V*, 1956, by Lynn Chadwick in the foreground. *Page 174:* A series of mobiles and solar-powered works in progress by Daniel Chadwick. *Page 175:* Daniel Chadwick alongside his mobiles.

Daniel & Juliet Chadwick

2010s

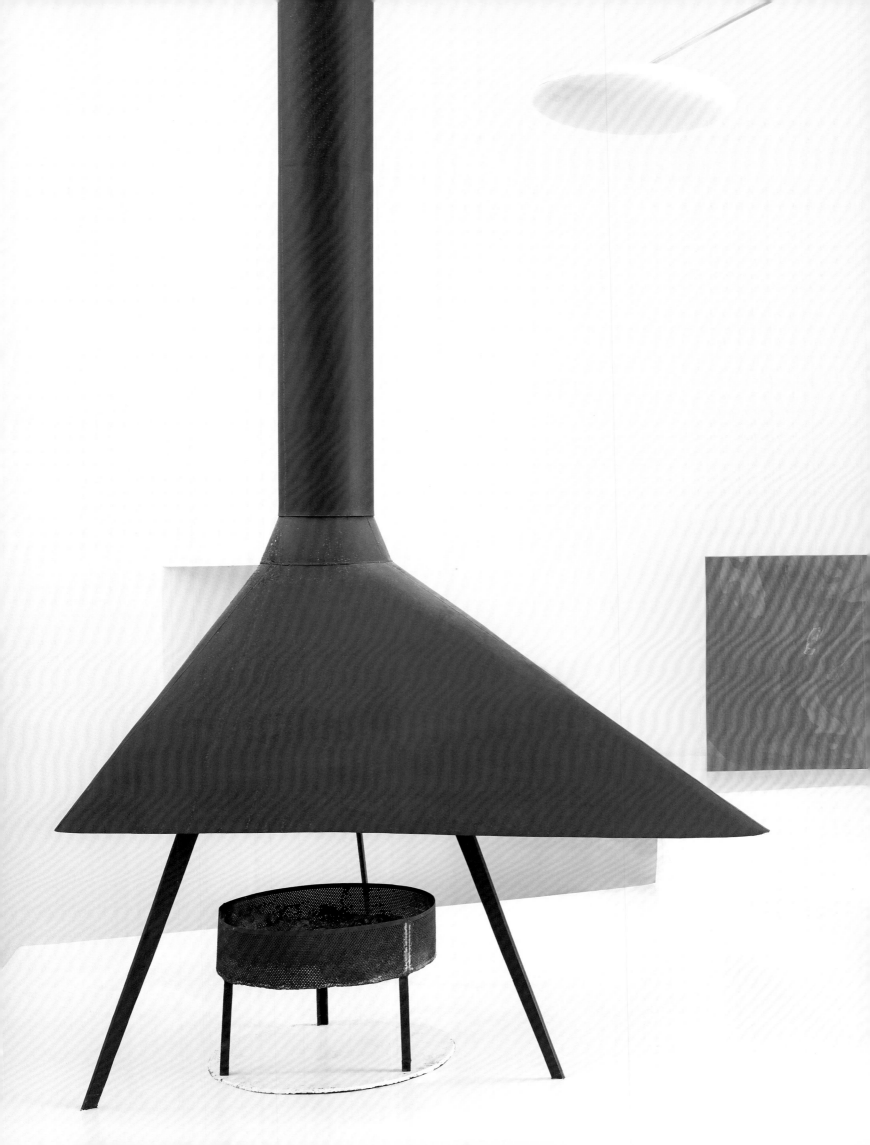

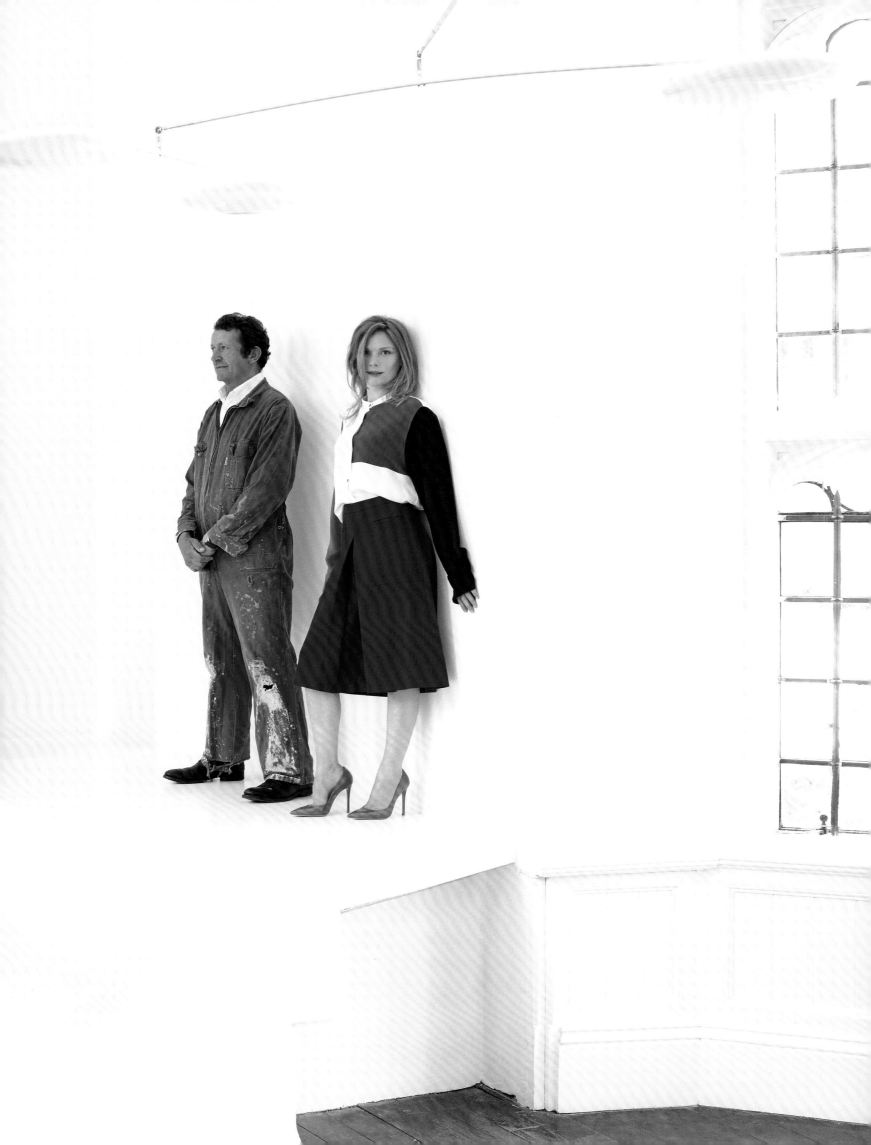

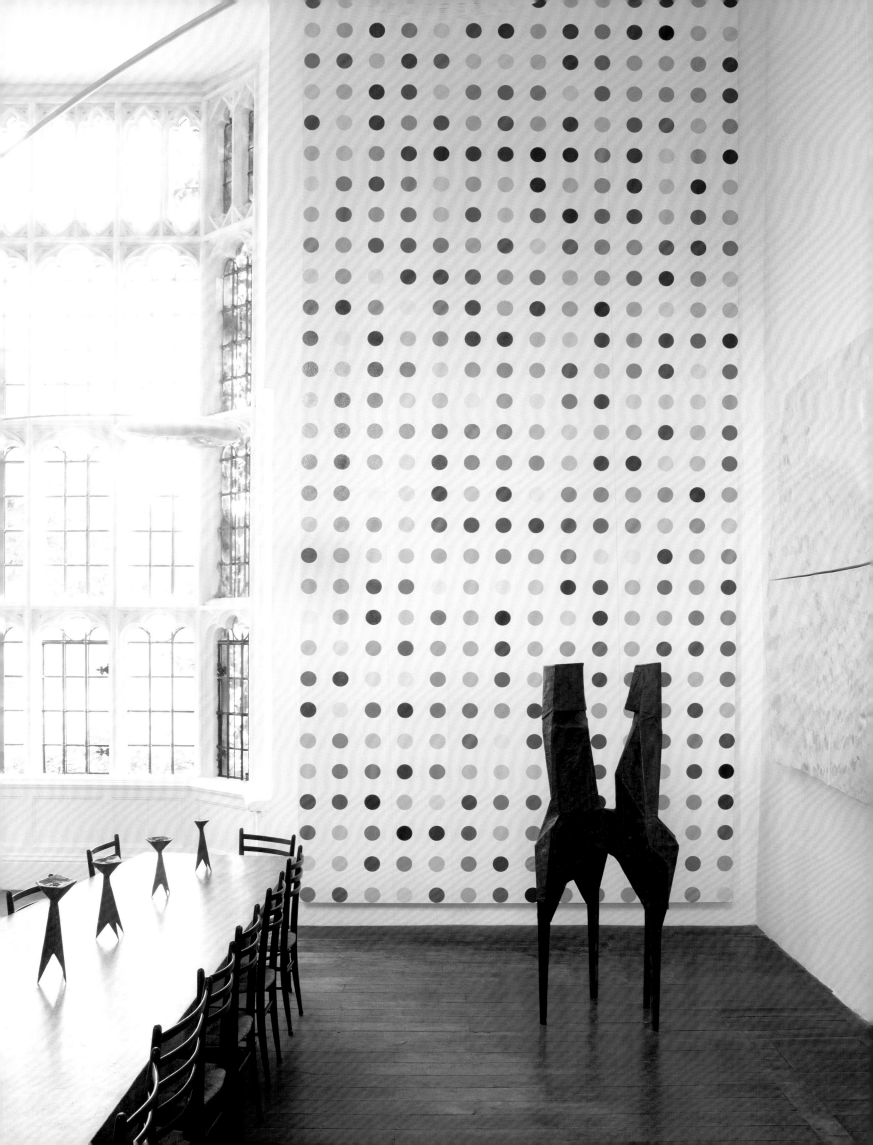

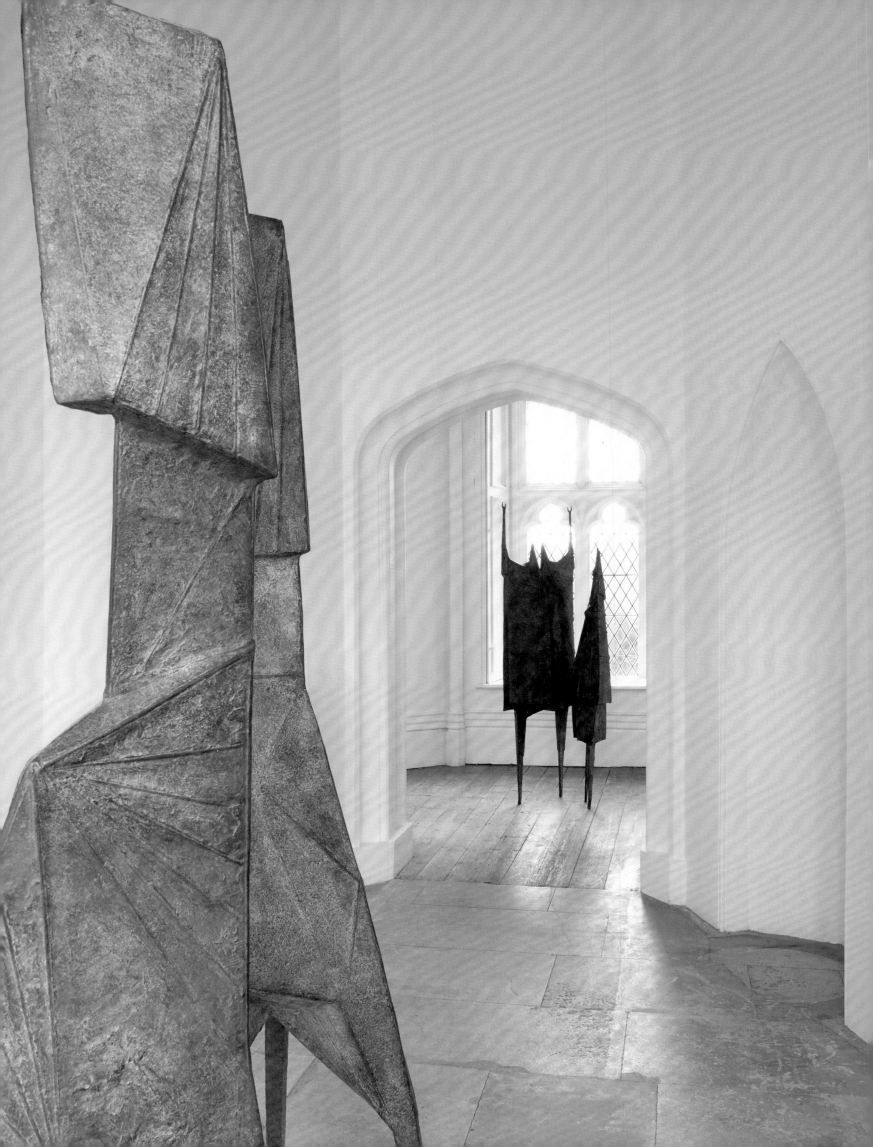

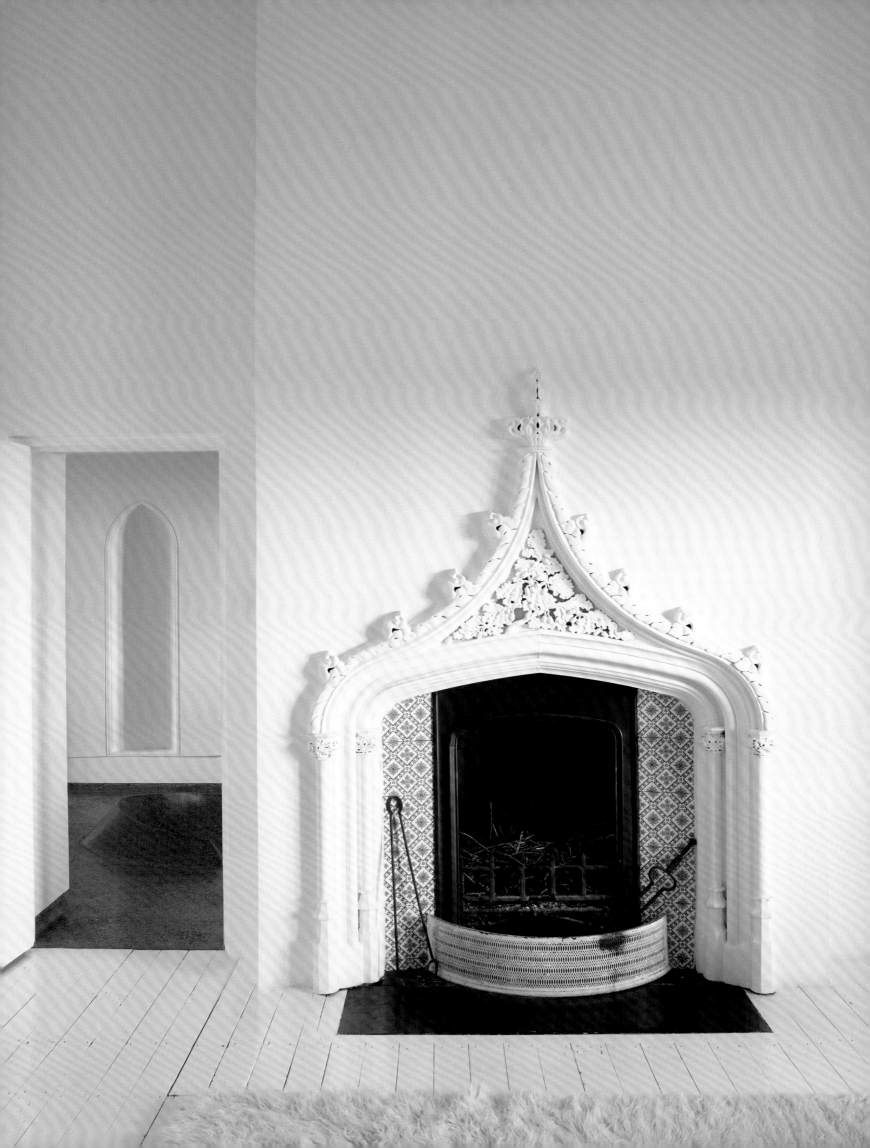

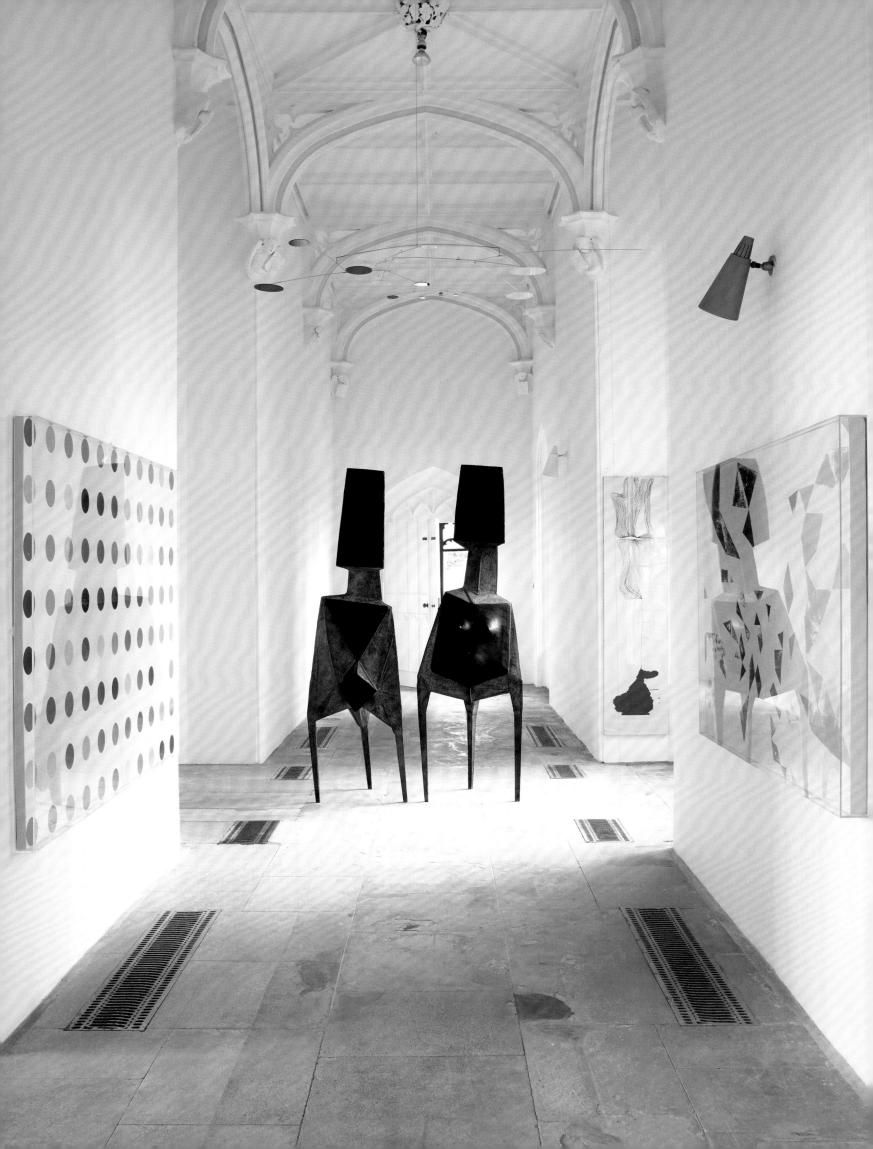

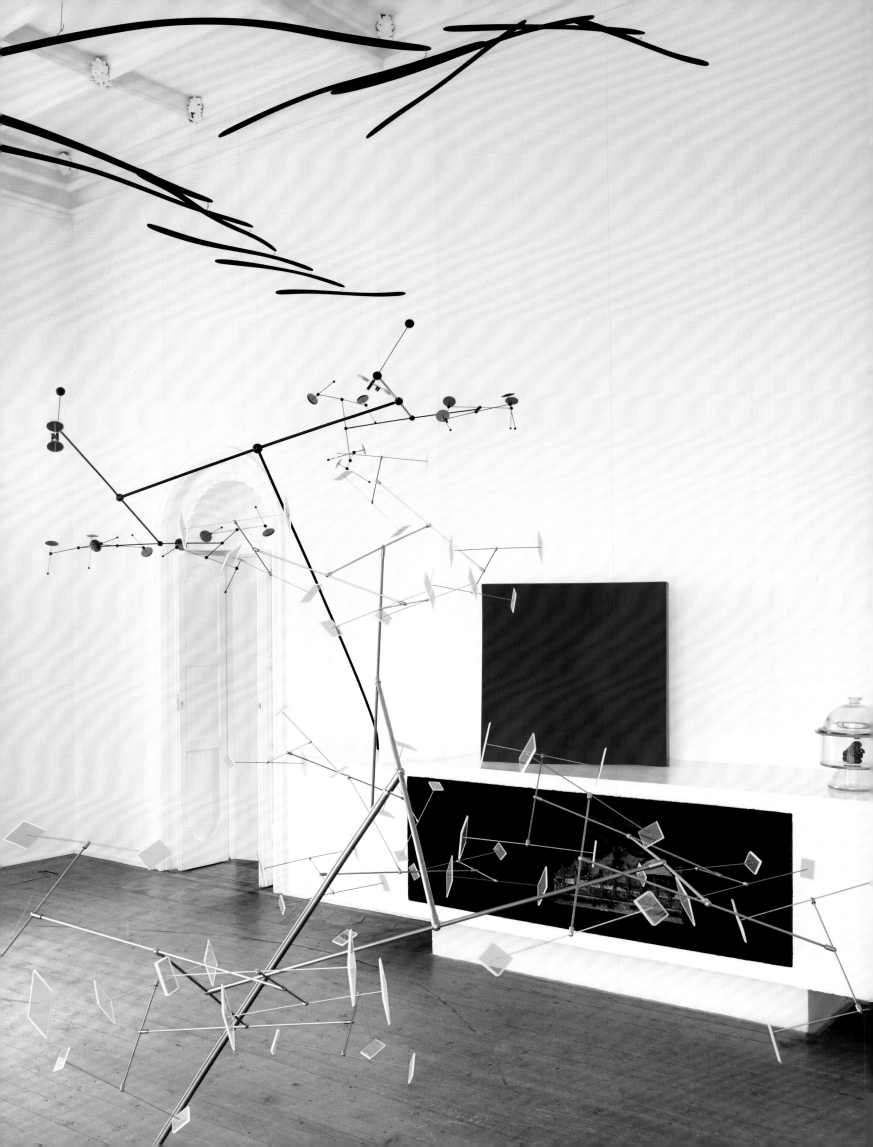

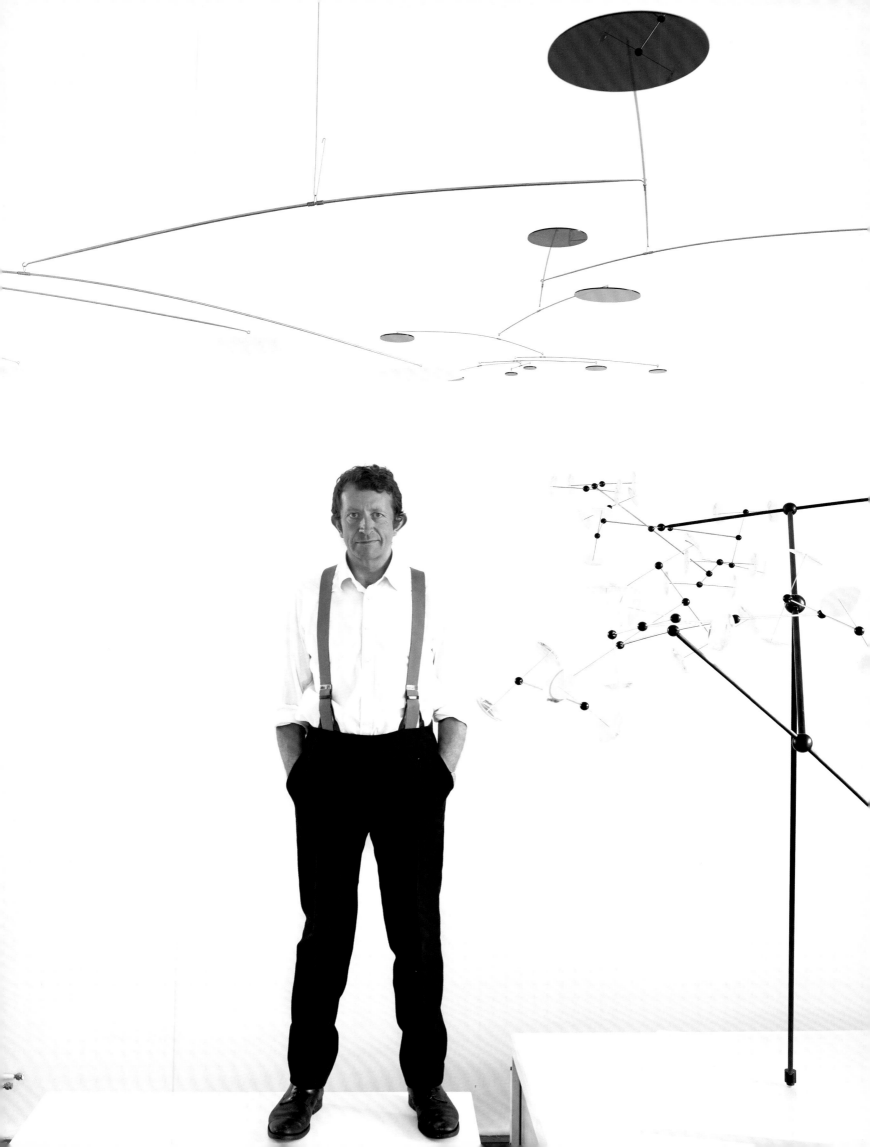

Matt Gibberd & Faye Toogood

Faye Toogood and Matt Gibberd met when they were working for Min Hogg, legendary editor in chief of *The World of Interiors*. As the magazine's interiors editor, Toogood conceived and styled the most imaginative still-life shoots; Gibberd was a staff writer, mainly covering architecture, with a prestigious provenance: his father is an architect, and his grandfather Sir Frederick Gibberd was an influential modernist architect and landscape designer.

Gibberd is still a working writer; he also cofounded in 2004 The Modern House, a successful real-estate agency for contemporary and modern houses, and in 2021 Inigo, which focuses on the sale of more traditional and historic houses. Toogood's multidisciplined design studio encompasses everything from furniture, interiors, and objects to installations for companies such as Hermès, Mulberry, and Tom Dixon. Her furniture sculptures, made of Purbeck marble and stone, were recently exhibited at the Chapel at Chatsworth, and she has created the fashion label Toogood in partnership with her sister, Erica.

Gibberd and Toogood's late-Georgian house in Islington, photographed in 2013, was a series of welcoming rooms in largely neutral colors, with the glorious exception of a bathroom clad in deep-blue Moroccan tiles. The couple are adept at playing off furniture to great effect—juxtaposing, say, a nineteenth-century sofa with a 1950s Italianate marble table, or a pair of midcentury Italian chairs with a table of Toogood's design. Traditional fireplace mantels acted as "canvases" for Toogood's tableaux of carefully placed ceramics, chunks of iron pyrite, deer skulls, and antlers, combining both the raw and the precious.

A few years ago, the couple moved to a modernist house in Highgate, designed in the 1960s by Swiss architect Walter Segal, known chiefly for the Segal Method of self-building—in essence a modular timber-frame system that allows for ease of construction, minimal foundations, and blissfully little maintenance. Segal was an early champion of eco-friendly, low-cost, sustainable building methods, and his pioneering work is increasingly gaining belated recognition.

The house had a courtyard with a profusion of greenery, prompting Gibberd to remark that it looked "like a garden with a house attached." Both house and garden needed considerable work. Inside, for example, the original acoustic-board ceilings, pine paneling, and pale brick walls were all in dire need of restoration. The vernacular of this new living space was a striking departure from the couple's previous residence.

"Faye and I agreed that the earliest vision for the house was likely one of simplicity," Gibberd explains. Toogood adds, "When we moved to the Segal house our furniture looked totally wrong—like a granny's waiting room." Photographs from 2019 capture how the couple maintained and complemented the original aesthetic, carefully mixing twentieth-century furniture with newer pieces, most notably Toogood's Roly-Poly chairs and table in the dining room, and judiciously chosen contemporary art, including a tapestry, also by Toogood, that hung above the sofa. In the kitchen, aluminum cabinets were painted in glossy white car paint while large cupboard doors were covered in an off-white felt. Although the formal vocabulary couldn't have been more different from that of their Islington house, both spaces looked supremely serene.

After a few happy years in Highgate, Gibberd and Toogood, who already had a young daughter, found out that twins were on the way. Cue a bigger home, this time a rambling Victorian house in Hampshire. "It's got lots of color and pattern, which suits it perfectly," Toogood notes. For Gibberd, who, as we have learned, loves modernist architecture, the new house was . . . fine by him. "I'm a fan of great buildings," he says, noting that he grew up in a Georgian town house. "Simply: proportion, materials, and context are the most important things." And on that, this unflappable couple unequivocally agrees.

Matt Gibberd and Faye Toogood's house, Islington, London, photographed in 2013.

Page 178: Bedroom. *Page 179:* Faye Toogood. *Page 180:* Living room with Element coffee table by Toogood and photograph by Tom Mannion. *Page 181:* Dining room with door handle designed by Toogood for Izé; photograph by Tobias Harvey; Madea dining chairs, 1955, by Vittorio Nobili; and, in the foreground, Wassily Lounge Chair, 1925, by Marcel Breuer. *Page 182:* Bathroom with Moroccan tiles. *Page 183:* Faye Toogood.

Matt Gibberd and Faye Toogood's Walter Segal House, Highgate, London, photographed in 2019.

Page 184: Dining room and kitchen with Roly-Poly dining table and chairs by Toogood. *Page 185:* Living room with tambour unit by Toogood. *Page 186:* Matt Gibberd and Faye Toogood. *Page 187:* Living room with Ghost sofa by Paola Navone; Wassily Lounge Chair, 1925, by Marcel Breuer; and *Play* tapestry by Toogood.

Matt Gibberd & Faye Toogood

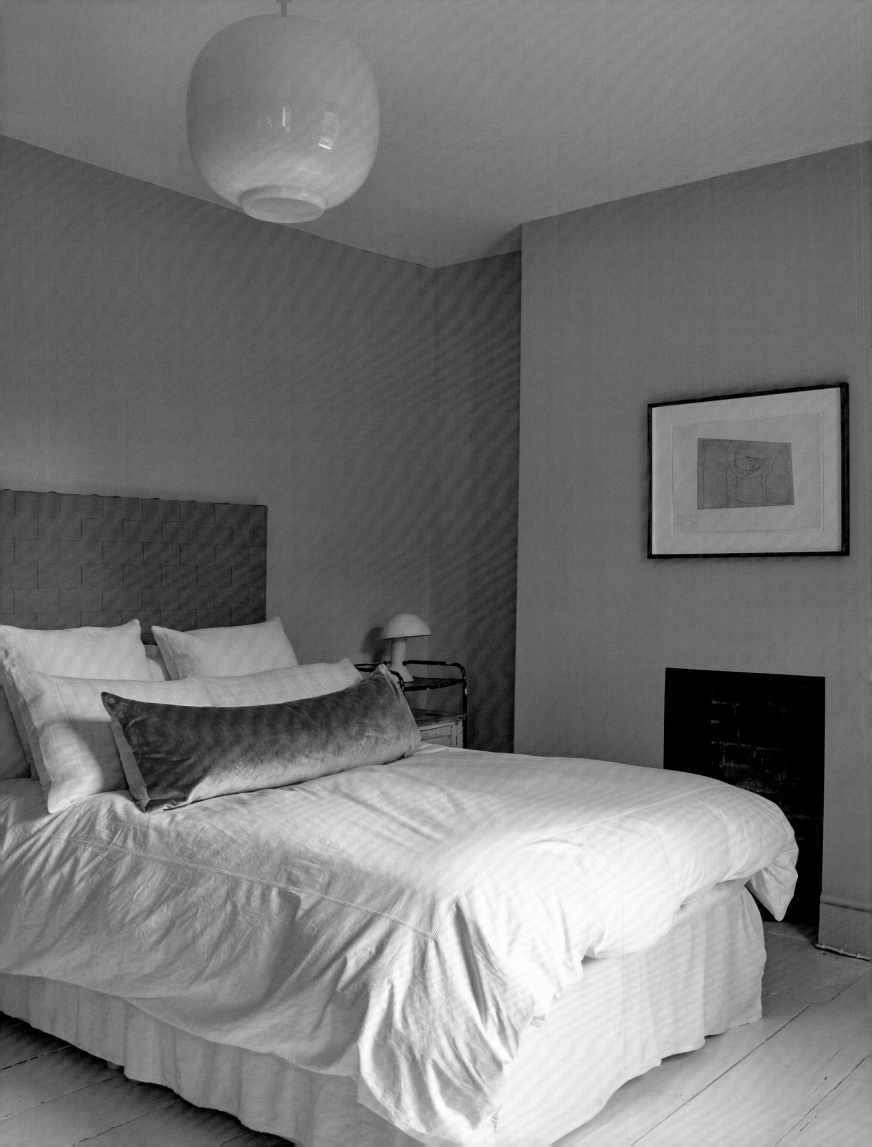

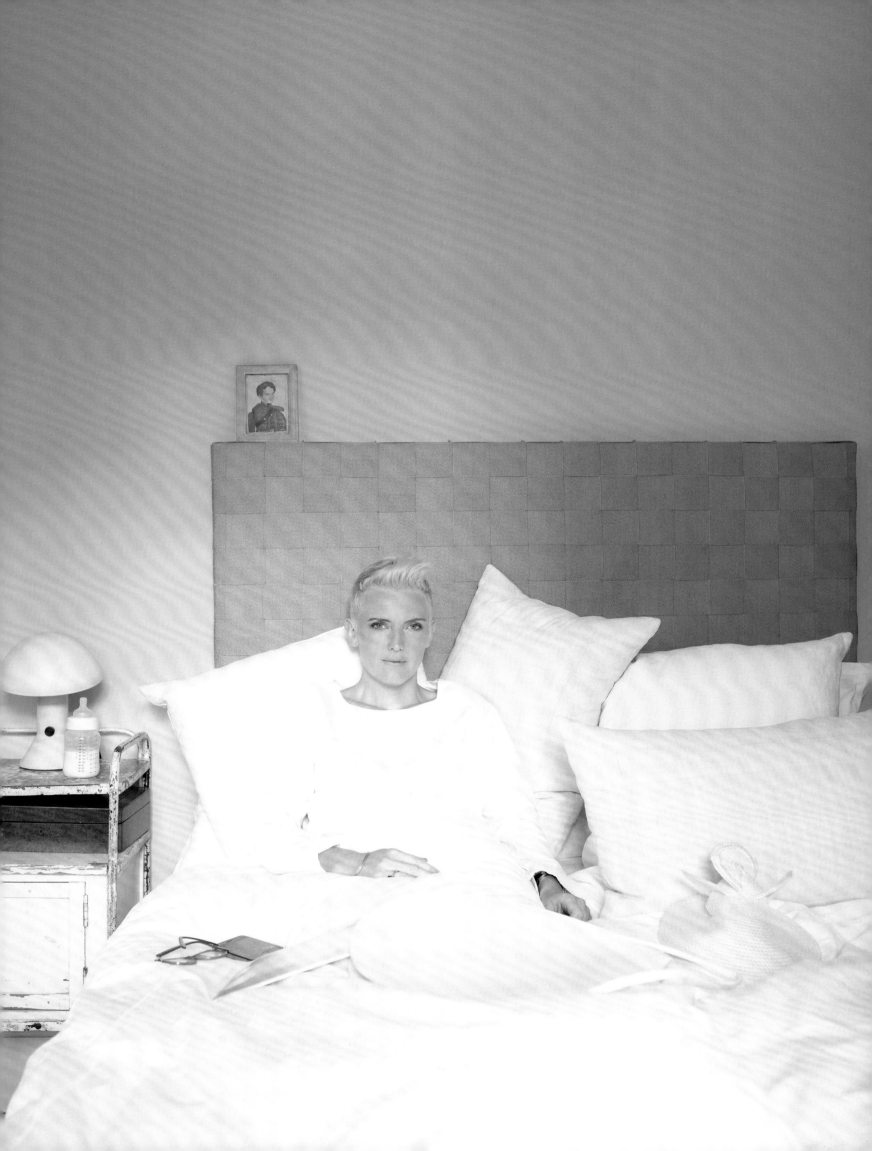

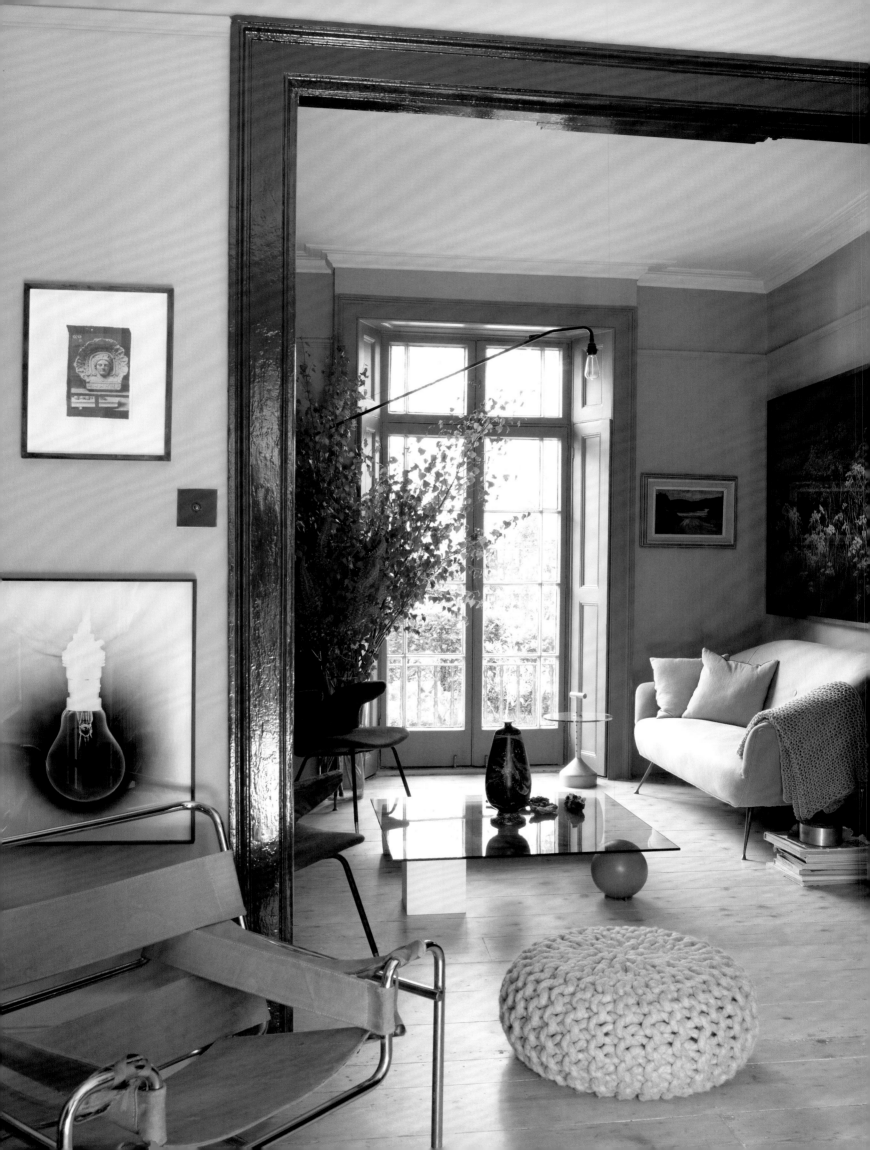

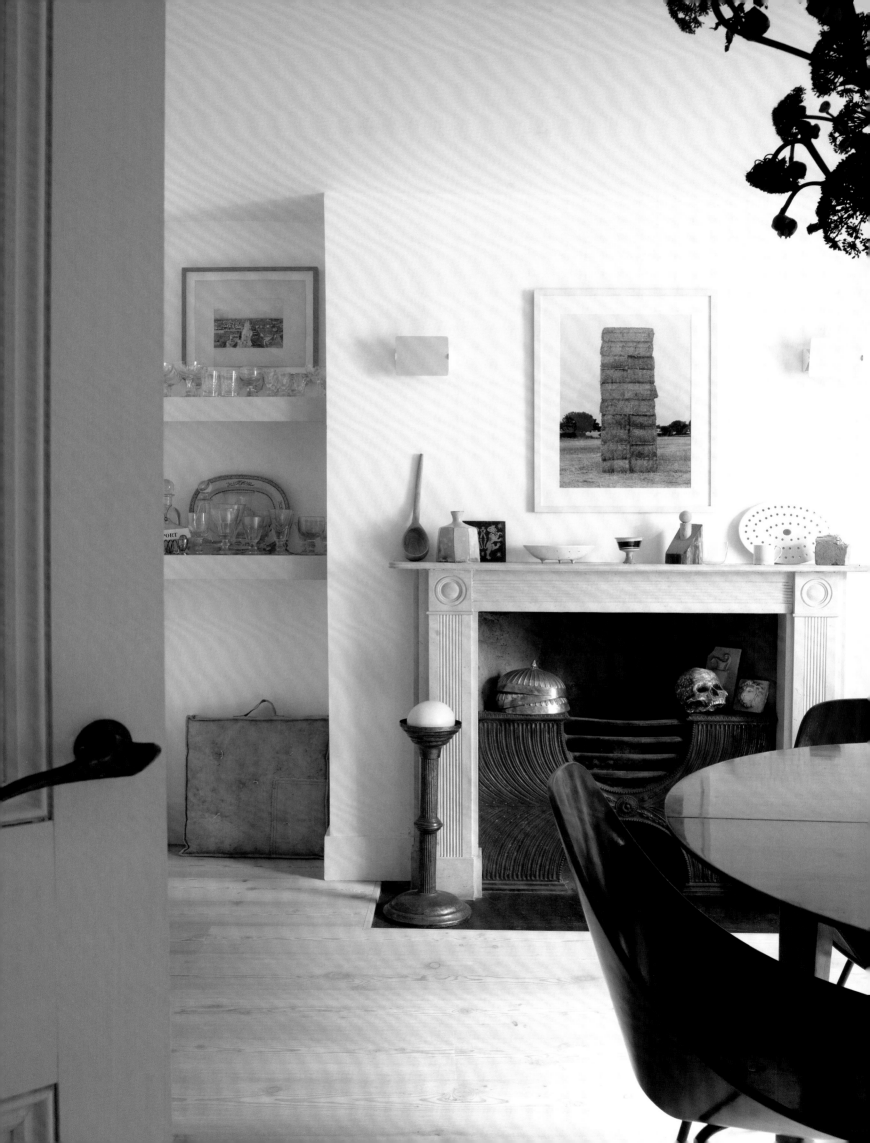

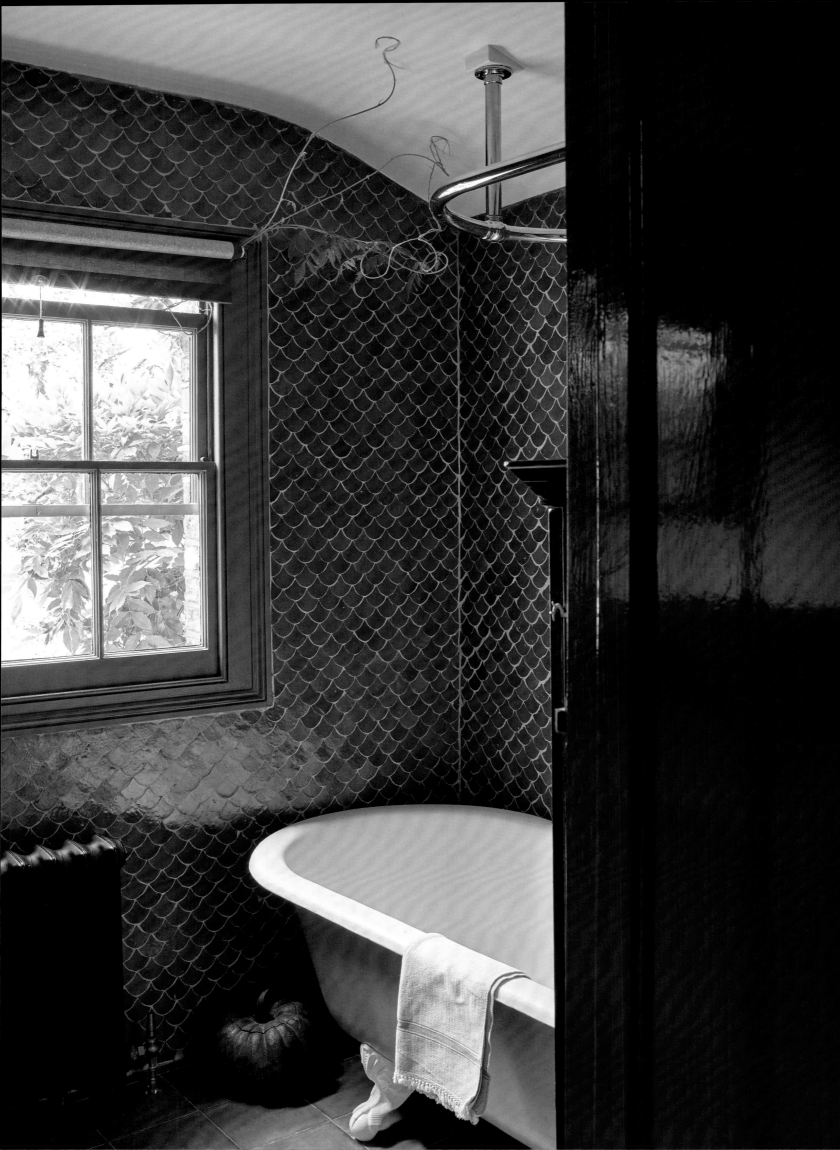

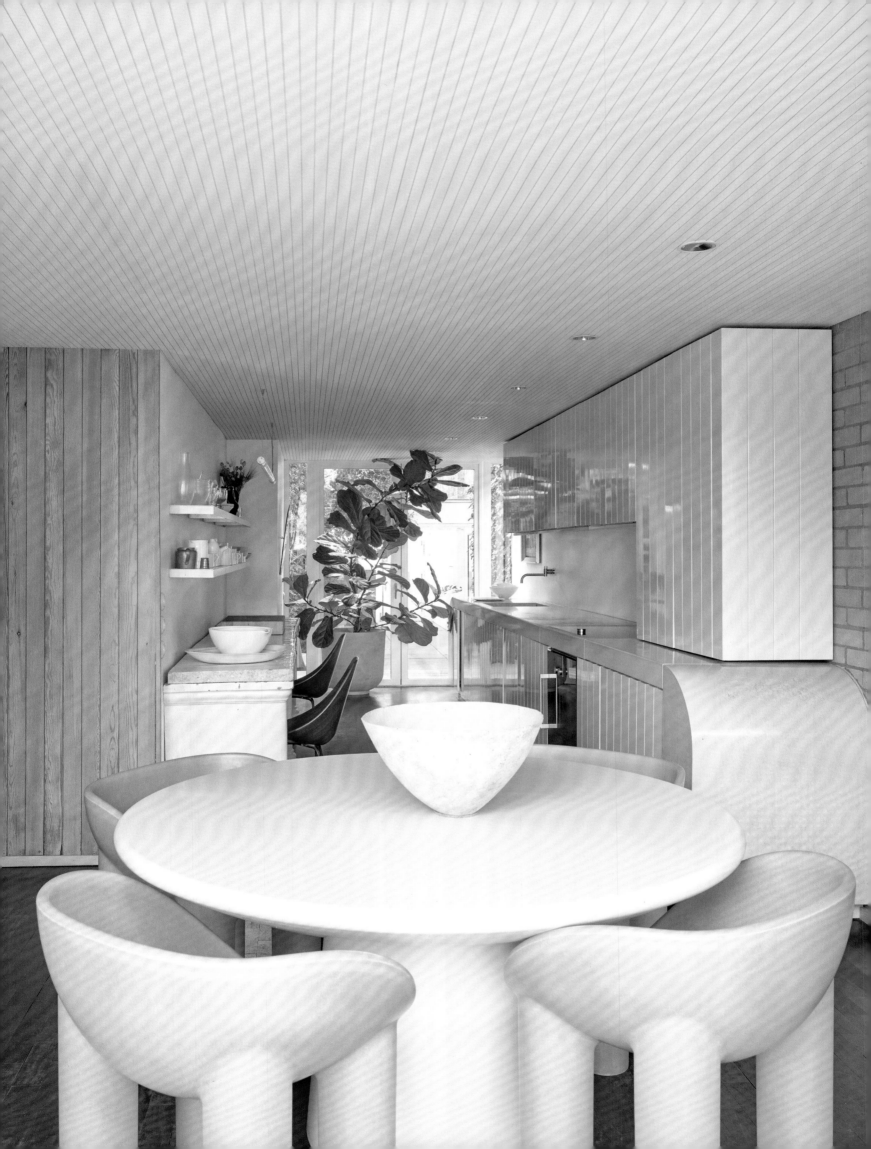

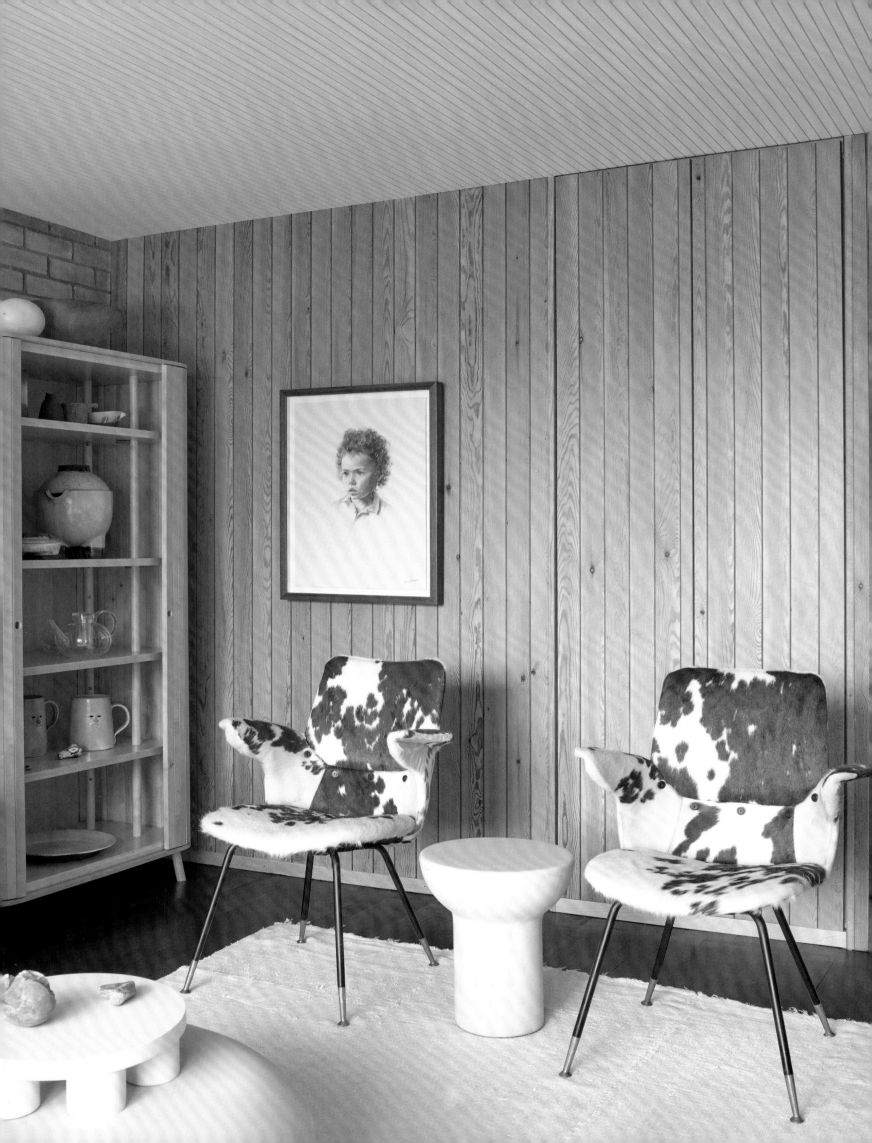

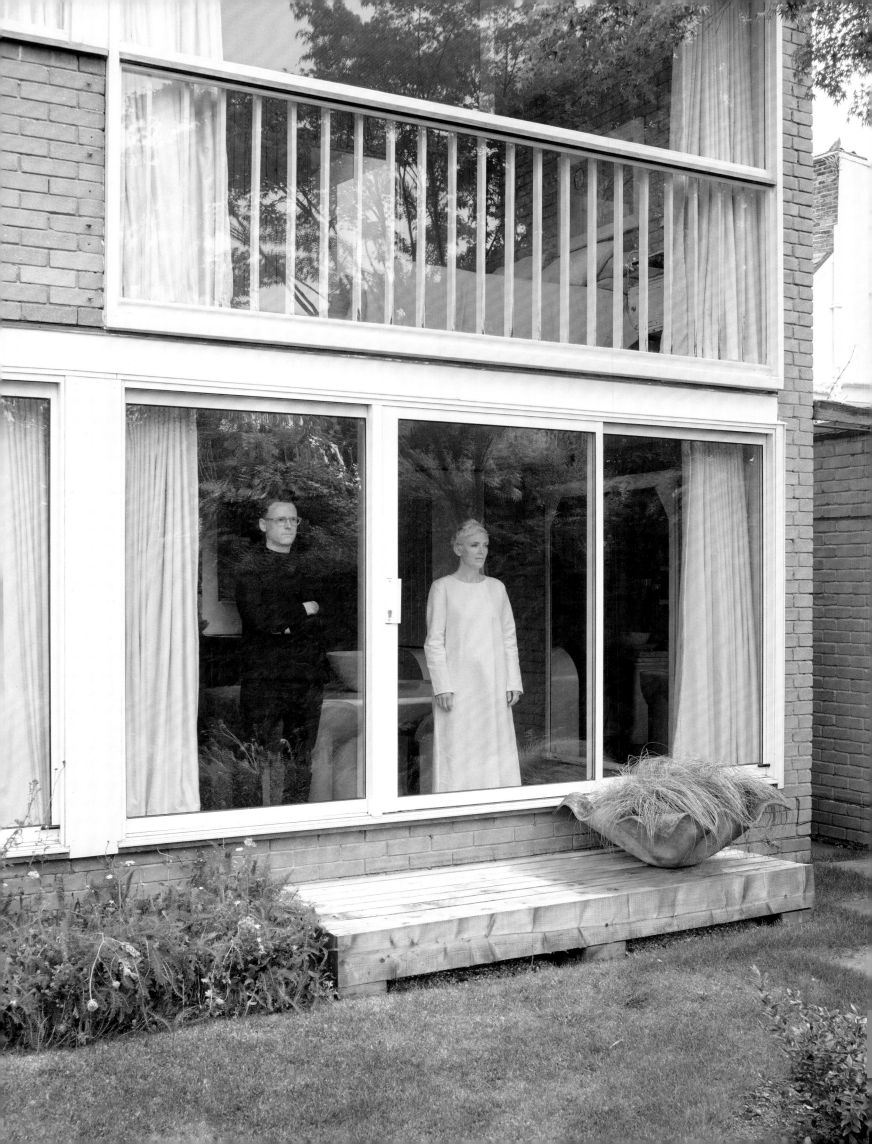

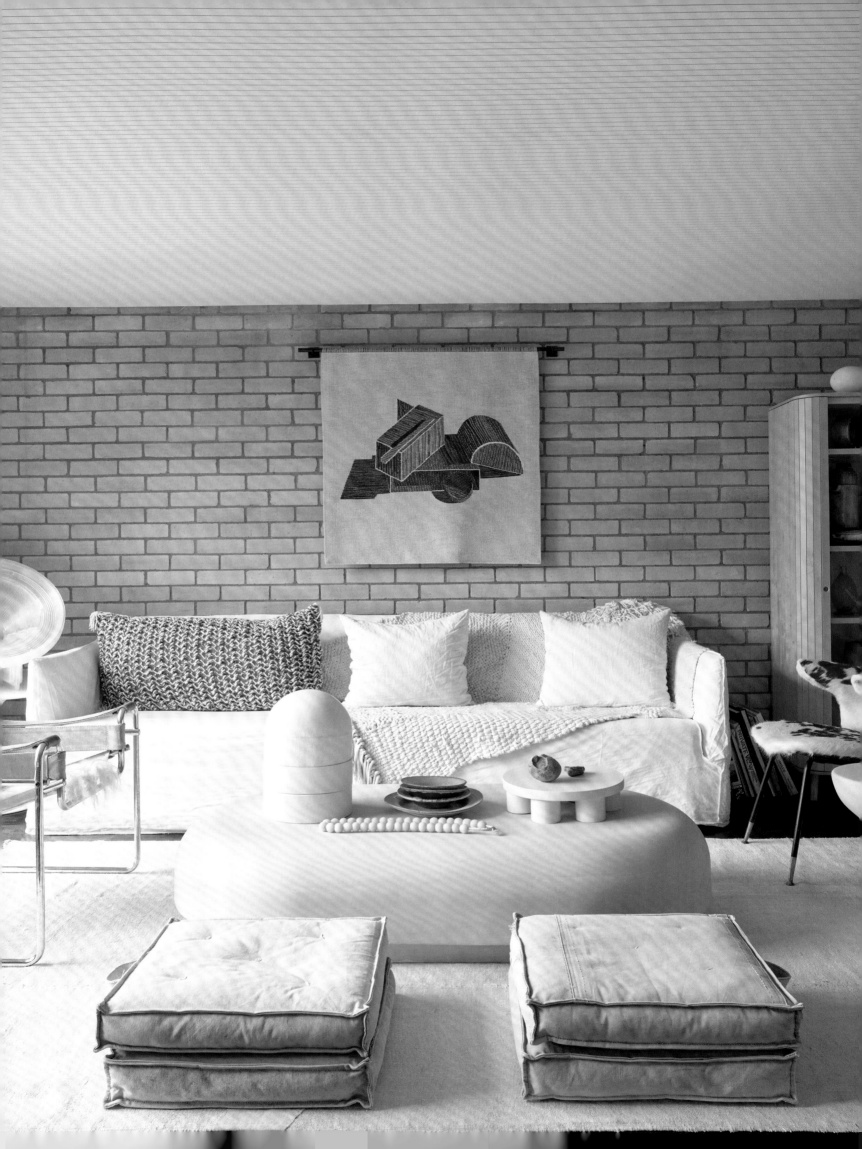

Paula Rego

Artist Paula Rego's studio was hidden behind a rather prosaic industrial facade in a North London backstreet. But inside, it was anything but ordinary. The former framer's factory, photographed in 2014, was crammed to the brim with a fantastical assemblage of items gathered over her decades of artistic life there—dolls, plastic flowers, ceramic animals, discarded furniture, and, of course, the distorted yet compelling papier-mâché mannequins that appeared with eerie regularity in her paintings. In an era of abstraction, Rego painted from physical forms, using both life models—often an assistant or family member—or those grotesque mannequins arranged with other found objects into vignettes based on the fairy tales and folklore of her native Portugal. Her paintings can be disturbing and surreal, but they are also unexpectedly delightful.

Rego moved from Portugal to London in the early 1950s to study at the Slade School of Fine Art, where she became part of the School of London, an informal movement of figurative painters that included at various points David Hockney, Lucian Freud, R. B. Kitaj, and Frank Auerbach. At Slade she also met her future husband, the artist and writer Victor Willing, whom she married in 1959. Willing was diagnosed with multiple sclerosis and died in 1988, and in 2017 their son, filmmaker Nick Willing, made a touching documentary, *Paula Rego, Secrets & Stories*, that traced with unflinching honesty the ups and downs of his parents' marriage and his mother's lifelong commitment to her art.

"She felt that London was a place without ghosts and would say to me, 'I feel more at home in my studio,' and that she made pictures to find out about things, almost like finding an itch so that she could scratch it," Willing says.

He also refers to his mother's powerful Abortion series, paintings of women who had undergone illegal abortions, which Rego created in 1998 after a national referendum was held that year in Portugal, unsuccessfully as it would turn out, to legalize abortion. Rego's art wielded considerable influence in her native country, and to her great satisfaction abortion eventually became legal there. Rego died in 2022, the year after a triumphant retrospective at Tate Britain. The work in that exhibition depicted the human condition in all its rich complexity, its joys and frailties, with equal curiosity.

Paula Rego's studio, Camden, London, photographed in 2014.

Page 190: Rego's studio with props: dolls, plastic flowers, ceramic animals, and discarded furniture. *Page 191:* Paula Rego. *Pages 192 and 193:* Rego's papier-mâché mannequins and paintings in progress. *Page 194:* Props in the studio. *Page 195:* Paula Rego.

Paula Rego

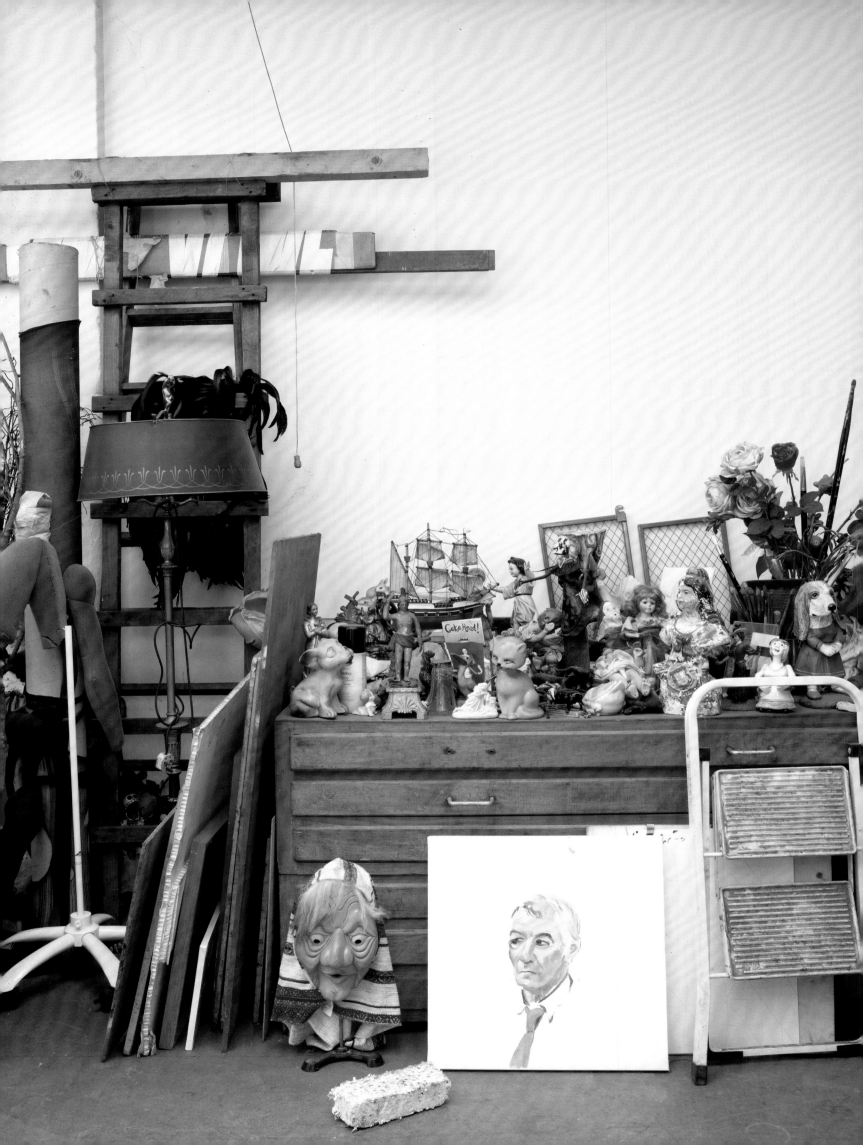

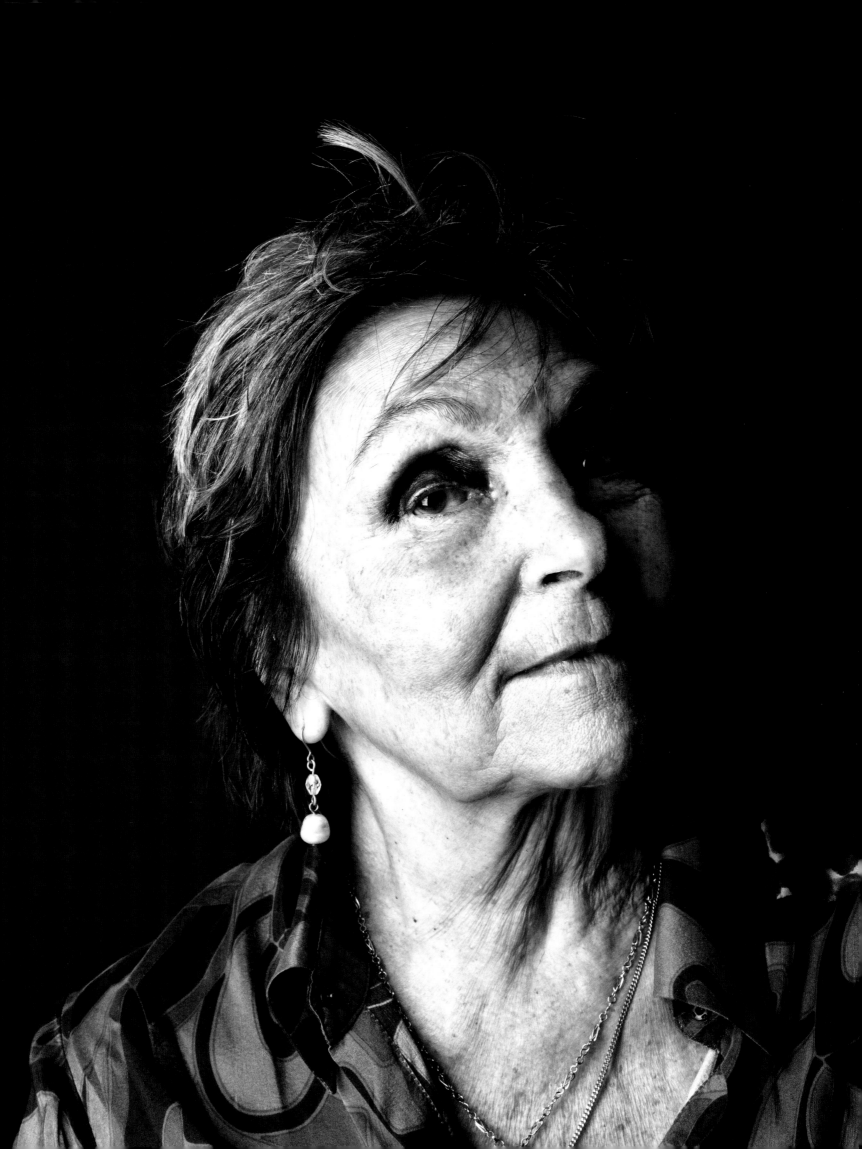

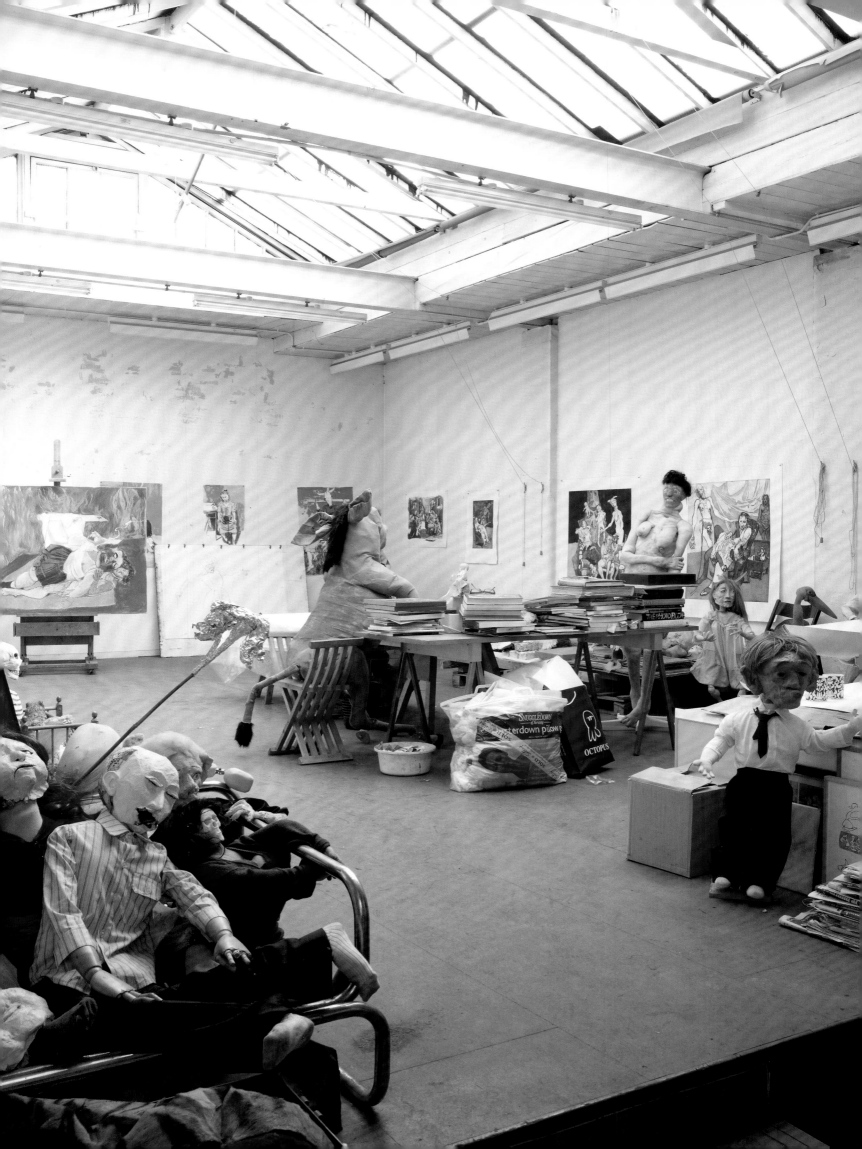

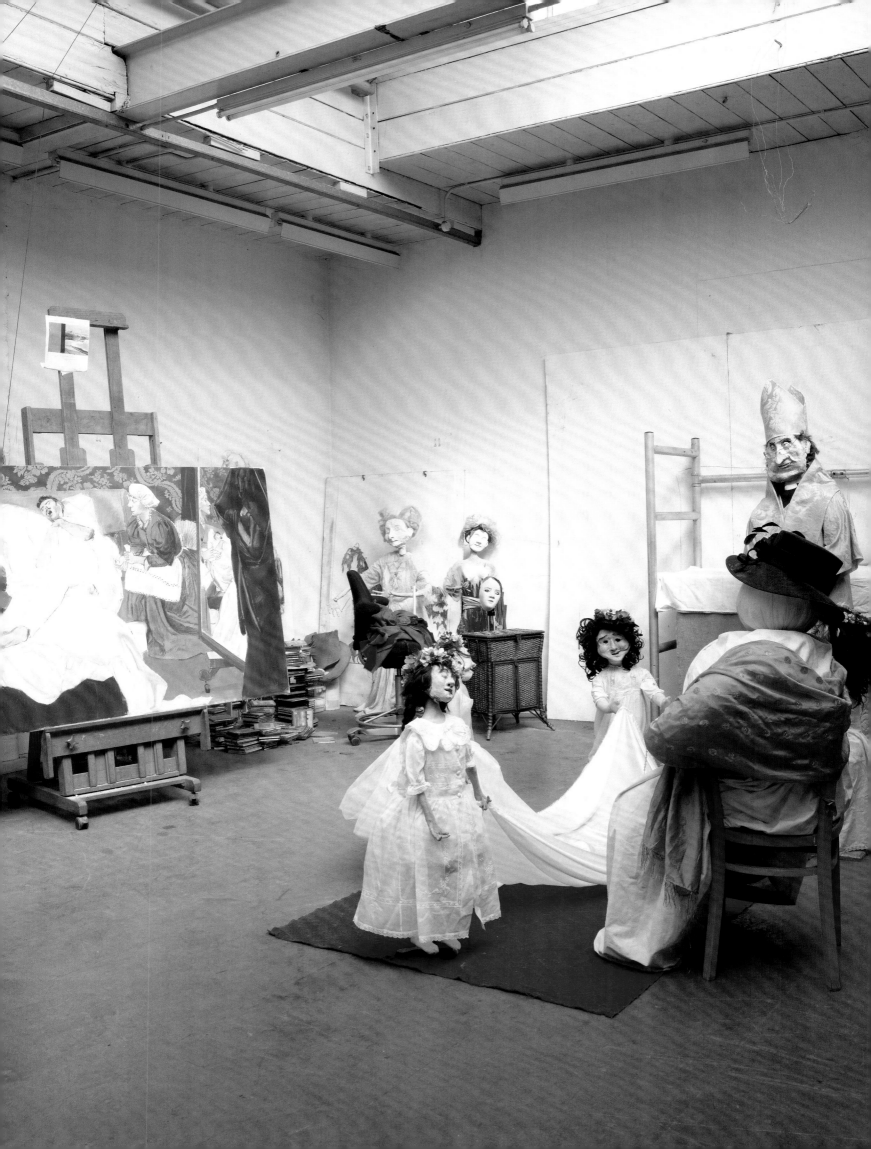

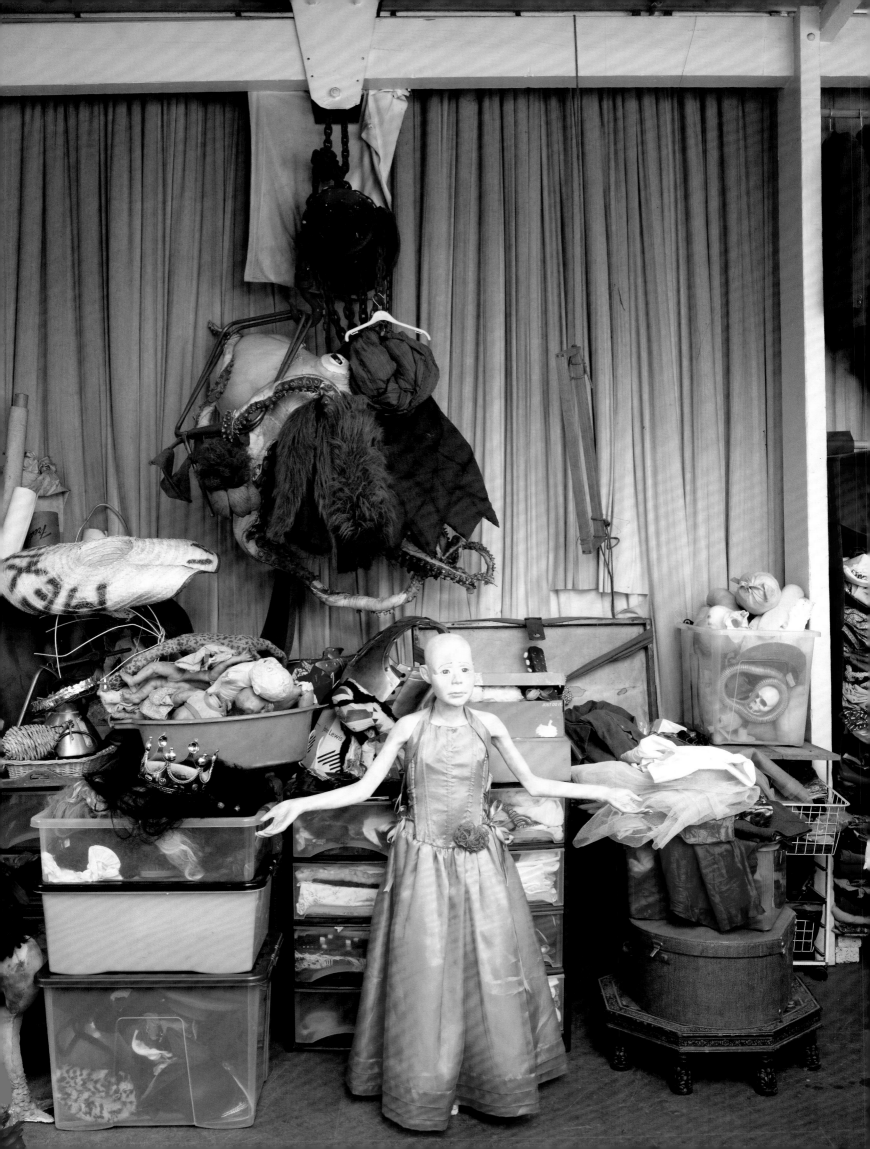

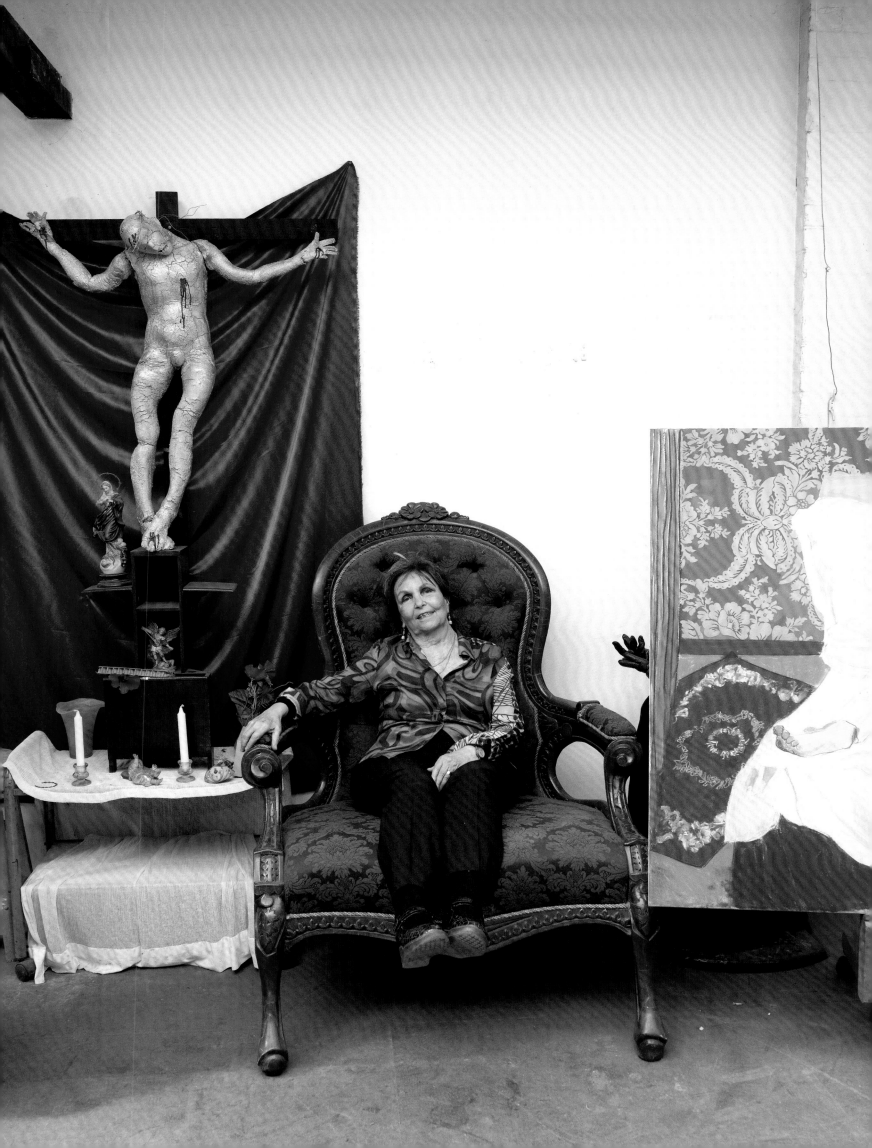

Harriet Anstruther

Designer Harriet Anstruther's large family home in London, which she shared with her husband, Henry Bourne, until 2020, was situated in South Kensington, near the Victoria & Albert Museum. When it was photographed in 2012, the home was filled with a lively mix of traditional and modern furniture and lighting, and an array of antique and contemporary artworks, all of which looked right at home within the home's neoclassical, mid-nineteenth-century architecture, with its crisp white-stucco front.

"I like the architecture, and the landscape which a property occupies, to be the story," Anstruther says. And she does unorthodox things with orthodox furniture. Take the pair of English sofas in the first-floor drawing room: Anstruther covered them in broad black-and-white striped cotton, but left the backs untouched so that the webbing—the interior architecture—was exposed.

Artworks by young and often emerging artists could be found all over the house, including that of her daughter, Celestia. Anstruther has collected for a long time, including work by artists and designers who were, or would soon become, the couple's friends. "I'm not interested in a formulaic approach. Life isn't like that, is it?" So over the living-room fireplace there are prints from Arcadia Britannica, Bourne's ongoing series of British folklore portraits, alongside a contemporary etching of the Duke of Wellington that belonged to Bourne's father, a renowned historian.

There are modern rooms in the house, like the kitchen–dining room extension with a large glass insert that brings light into the almost minimalist basement-level set of workspaces below, where Harriet Anstruther Studio and Bourne had separate areas. The kitchen has thick Carrara marble countertops paired with antique unlacquered brass hardware, which takes on the patina of age. "It's like a party with people of all ages, where everyone is invited," Anstruther reflects.

On the half-landing, an orchid-filled conservatory studio delivers light to a cantilevered stone staircase above and below. Just a step away is a tiny double-height powder room that is hung in black-and-white Malachite wallpaper from Fornasetti and offers, in lieu of a sink, an antique red fire bucket below a garden tap. Anstruther's eye is one of generosity, play, cultivation, and sophistication, deftly evading the trap of earnestness or, indeed, convention. The delight in the storytelling within her work is palpable and reveals much about her and her unique process.

Anstruther's design projects are imaginative and elegant, from an art collector's Upper East Side penthouse in New York to the renovation of a Georgian residence and garden in West Sussex, where for many years she and Bourne have owned a sixteenth-century farmhouse, near Petworth House, one of England's stately houses. The native plants and minerals of the region also inspired Anstruther to create a collection of paints and fabrics.

Bourne, who has photographed so many interiors, was somewhat reluctant to turn his attention to his own. It seemed, he says, "a little uncomfortable, almost intrusive at first." But he said that the experience gave him a fresh perspective—he was now the one whose home was being photographed—but with the house so full of light, beautiful objects, and wonderful memories, and of course, the fact that it was designed by his talented wife, it was impossible for him to do anything but succeed.

Harriet Anstruther's house, London, photographed in 2012.

Page 198: Hallway with chairs by Veronika Wildgruber; *Incurable Romantic Seeks Dirty Filthy Whore*, 2004, a watercolor by Harland Miller; and photograph by Bruce Rae on the mantelpiece. *Page 199:* Harriet Anstruther, 2008. *Page 200:* Drawing room with *AC/DC*, 2007, a painting by Caragh Thuring and *Lineamentum Calamus*, 2008, a print by Dawn Lincoln. *Page 201:* Drawing room with sofas by Howe; *Shirt*, a ceramic sculpture by Kaori Tatebayashi; *Pale Yellow Sandstone Study*, 2002, a sculpture by Boyle Family; *Display Case*, 2010, a painting by Caroline Walker; an artist book by Mats Gustafson; and a photographic portrait, 2009, from Henry Bourne's Arcadia Britannica series. *Page 202:* Dining room with photographic portraits, 2009, from Bourne's Arcadia Britannica series. *Page 203:* Powder room with black-and-white malachite-patterned Fornasetti wallpaper and antique fire-bucket basin.

Harriet Anstruther

2010s — HARRIET ANSTRUTHER

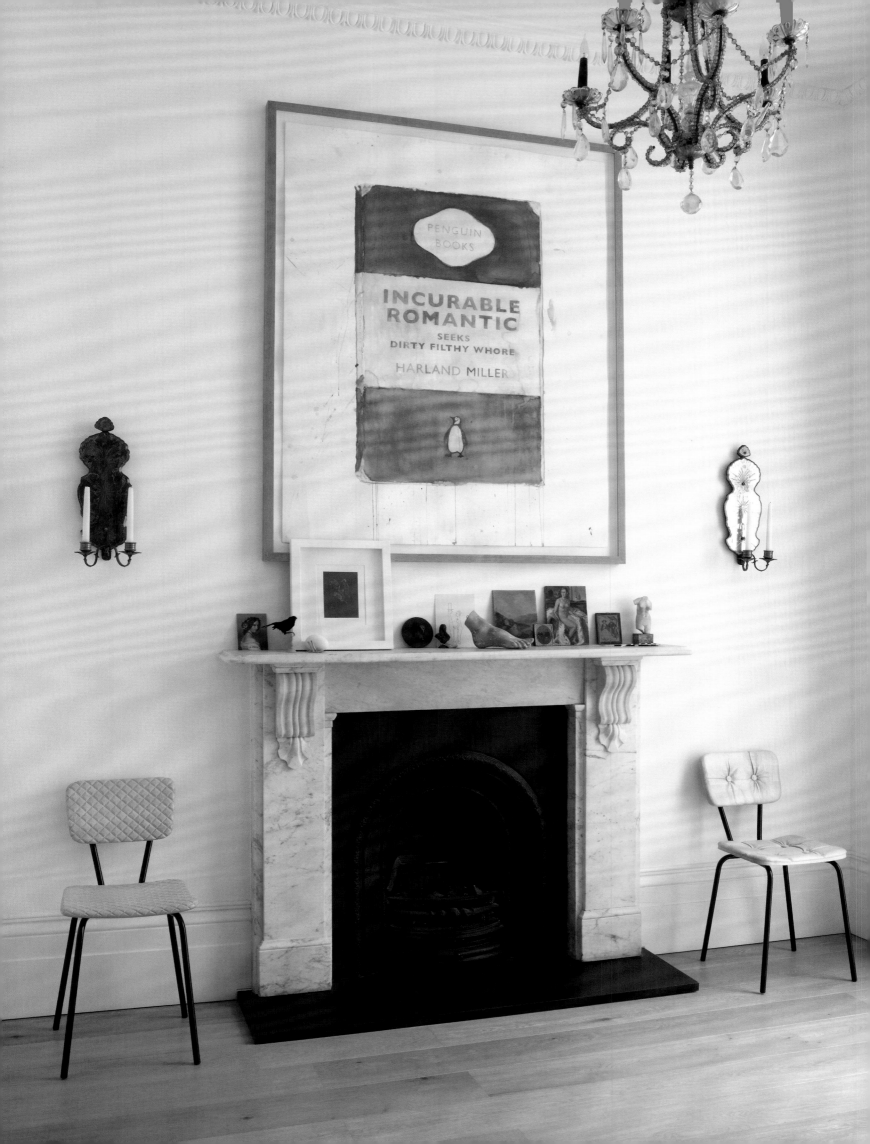

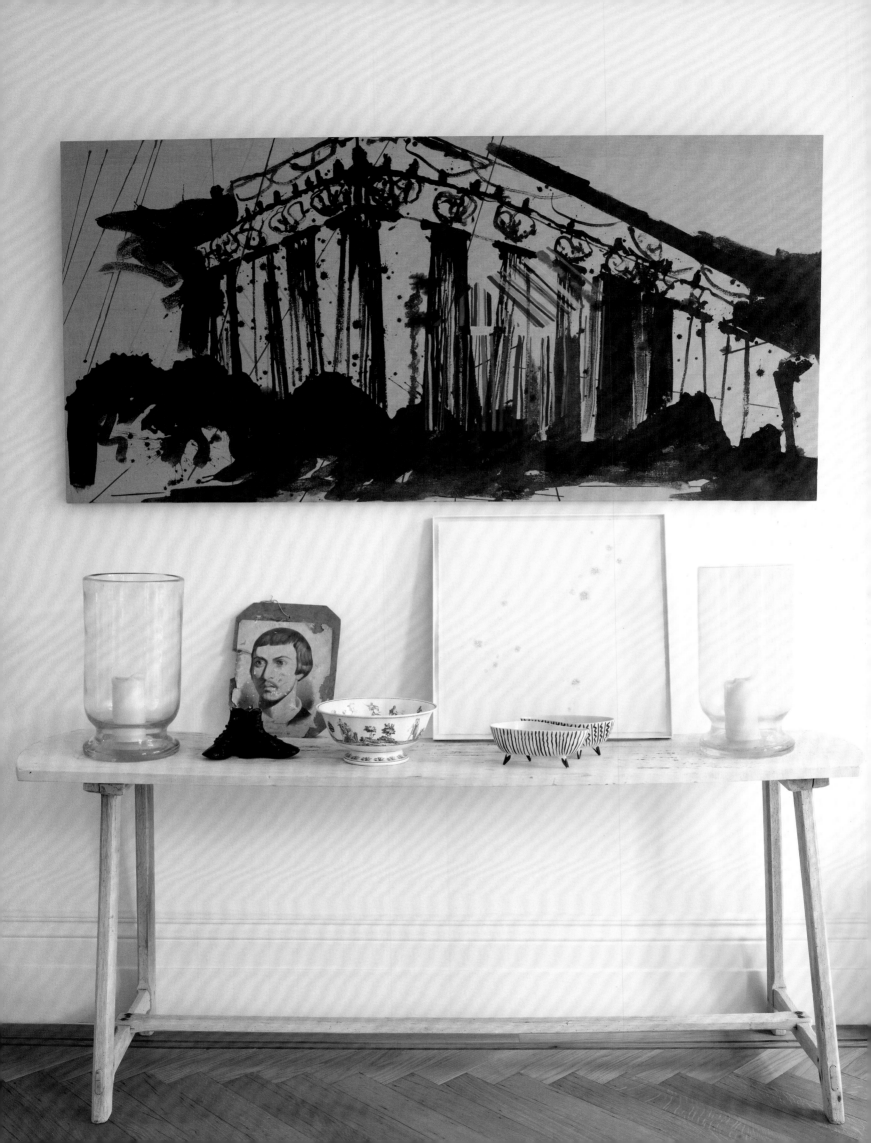

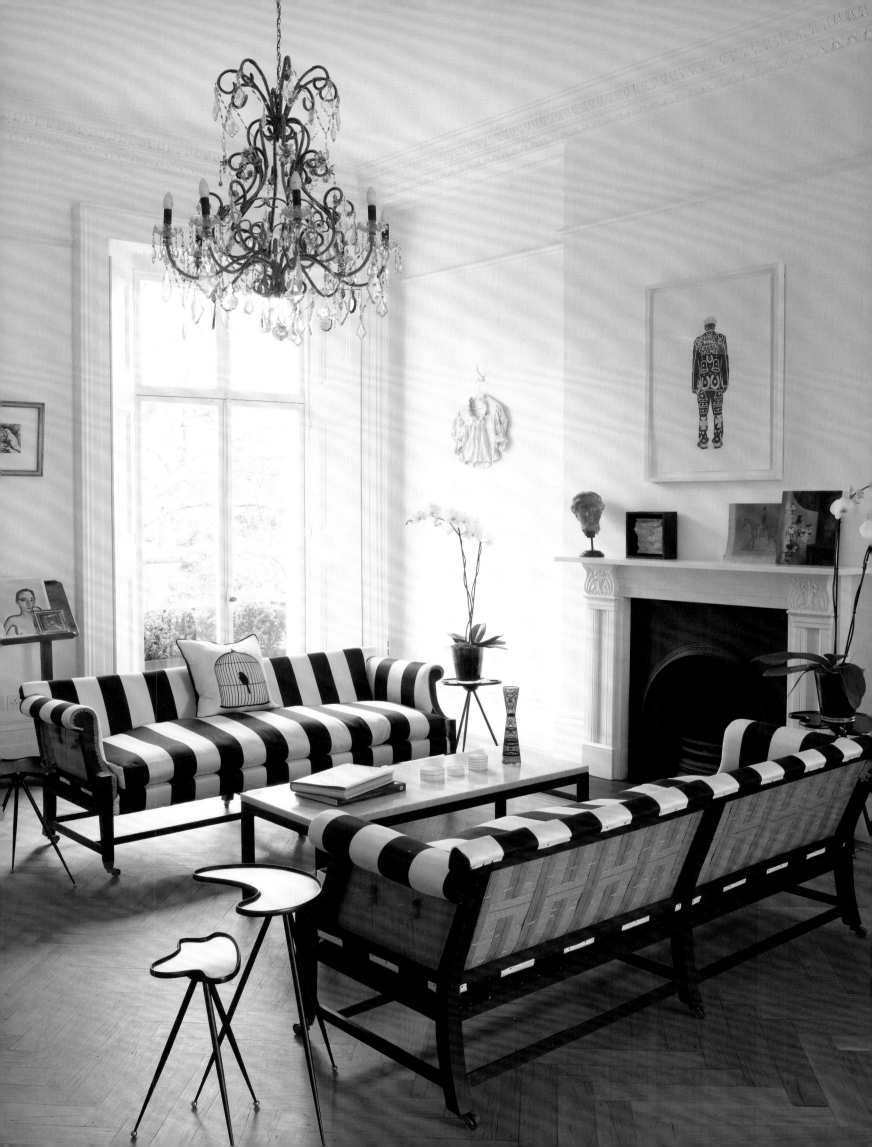

Victoria Press

The houses that stretch along London's celebrated Cheyne Walk hold a rich and varied history. Though Hilaire Belloc, Robin and Lucienne Day (page 22), Ian Fleming, Mick Jagger, and Dante Gabriel Rossetti all lived there at some point, Victoria Press's house was just as celebrated as home to the novelist George Eliot, who occupied it at the time of her death in 1880. And just shy of a century later Press and her husband, Sydney, a South African retail entrepreneur, acquired it.

An American by birth, Press had worked in the 1940s for the pioneering designer of versatile, practical clothing Claire McCardell. McCardell instilled in her a longtime practical approach to design in general, which, combined with a keen connoisseurship that Press taught herself, underpinned the decoration of the Cheyne Walk property. The stairwell's eighteenth-century murals by John Devoto and James Thornhill, for example, informed the color scheme for the whole house, and she meticulously scraped back layers of paint to get to the original colors of each room. The house was further filled with antique furniture, art, and Press's impressive collection of Chinese export porcelain.

But she was not entirely stuck in the past. As Press's daughter Jane recalls, "After I finished at Oxford, my mother adapted the top floor into a flat for me, as my older brothers and sisters had long moved away. The box room became a tiny kitchen painted in the same style as a Swedish palace. Two bedrooms were joined to become a wonderful living room, and I can't remember where I found iridescent wallpaper for my bedroom that overlooked the garden."

Victoria Press died in 2015, the year these photographs were taken. When items from the Cheyne Walk house were sold at auction, her friend Patrick Kinmonth delivered this tribute to her unimpeachably fine taste: "Physically a sparrow," he wrote, "albeit with an eagle's heart and eye, Victoria Press loved things of scale. . . . She would put a pair of Chinese vases more or less her height up taller on glamorous gold stands behind an open door, and then hang one of the smallest pictures that Marie Laurencin ever painted beside them. All would be the better for it." He concluded, "[Press] listened as hard to the places she lived in as to the people she brought together there, and captured echoes of their imagined past to create a brilliantly evocative present."

Victoria Press's house, Chelsea, London, photographed in 2015.

Page 206: Stairwell with ceiling mural by James Thornhill. *Page 207:* Victoria Press in her garden. *Page 208:* Dining room with portrait of Victoria Press, 1957, by Waalko Jans Dingemans. *Page 209:* Eighteenth-century murals by John Devoto and James Thornhill. *Pages 210 and 211:* Bedroom bedecked with silk taffeta; an eighteenth-century commode. *Page 214:* Dining room with a Venetian chair and gilded fire screen. *Page 213:* Victoria Press on a Louis XV chaise, with *Phryne Tempting Xenocrates*, a seventeenth-century painting by Salvator Rosa.

Victoria Press

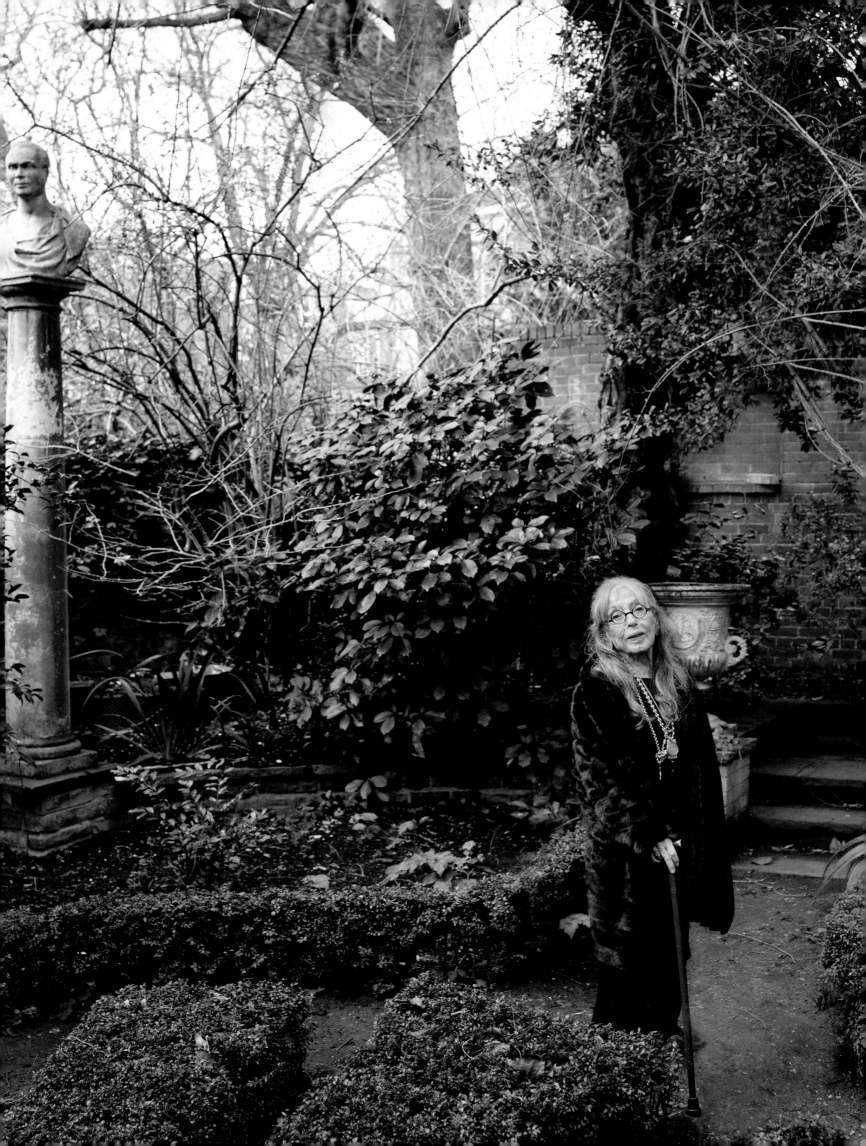

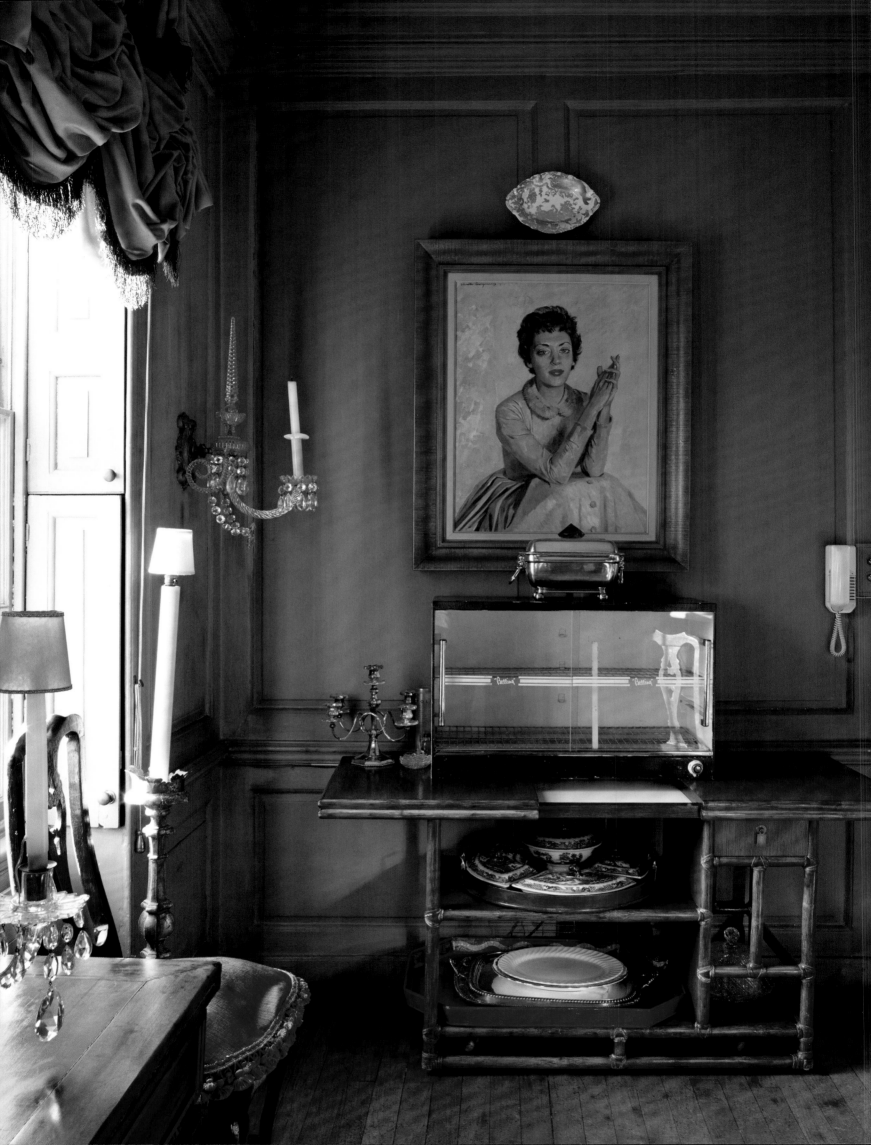

Thomas Flohr

St. Moritz, Switzerland. What at first appears to be a modest wooden chalet of the Upper Engadin is, upon closer inspection, a subterranean giant of a contemporary house, descending seven stories below—a 35,000-square-foot property that appears to be carved out of the very mountainside itself. Constructed for Thomas Flohr, founder and chairman of VistaJet, the structure, designed by Milan-based Ivana Porfiri and photographed in 2015, is fashioned from pine and larch, an ingenious and sophisticated blend of art and material.

The concept was inspired in part by the groundbreaking production design of Sir Ken Adam, best known perhaps for the earlier films in the James Bond franchise but equally notable for Stanley Kubrick's off-kilter *Dr. Strangelove* (1964). In short, the Flohr house is a seamless blend of old-world craftsmanship, contemporary art, and a radical, uncompromising design, a vast space entirely in tune with the sweeping landscape in which it finds itself.

Thomas Flohr's house, St. Moritz, photographed in 2015.

Page 217: Thomas Flohr.

Thomas Flohr

2010s

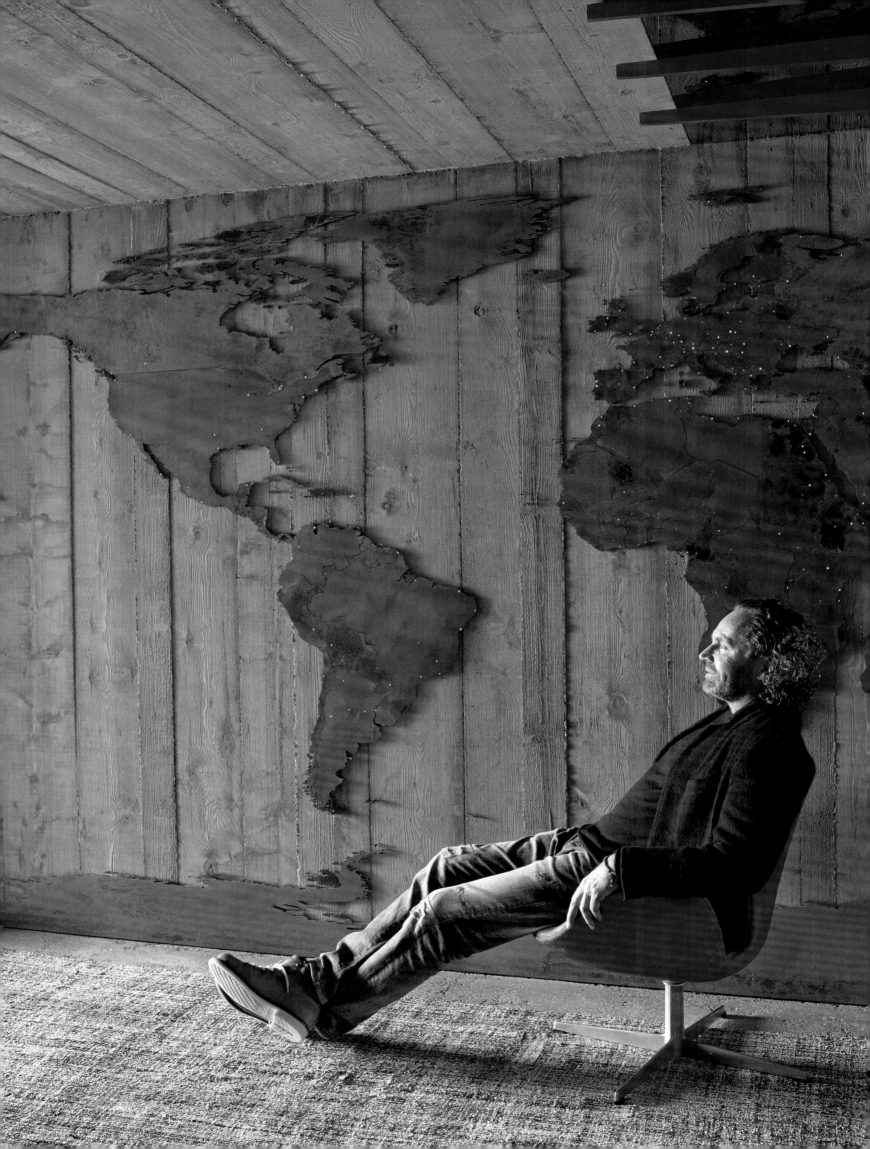

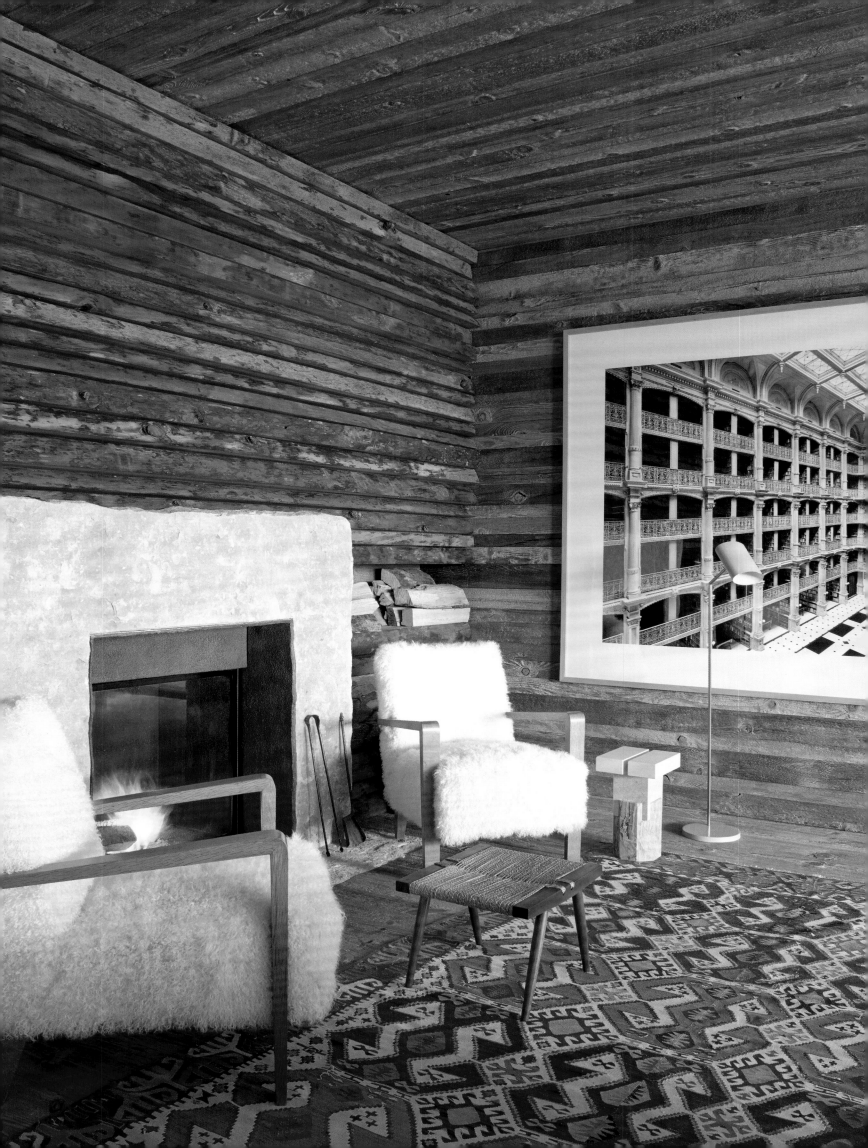

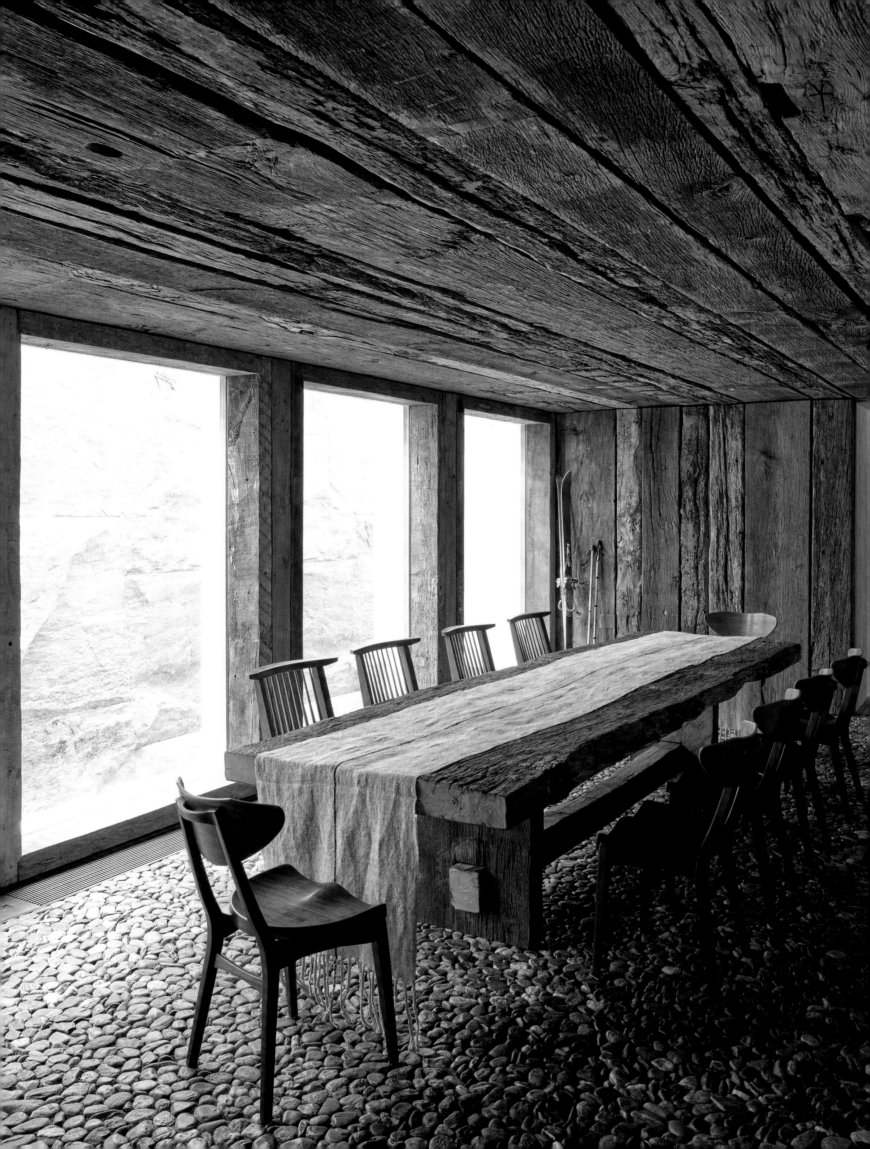

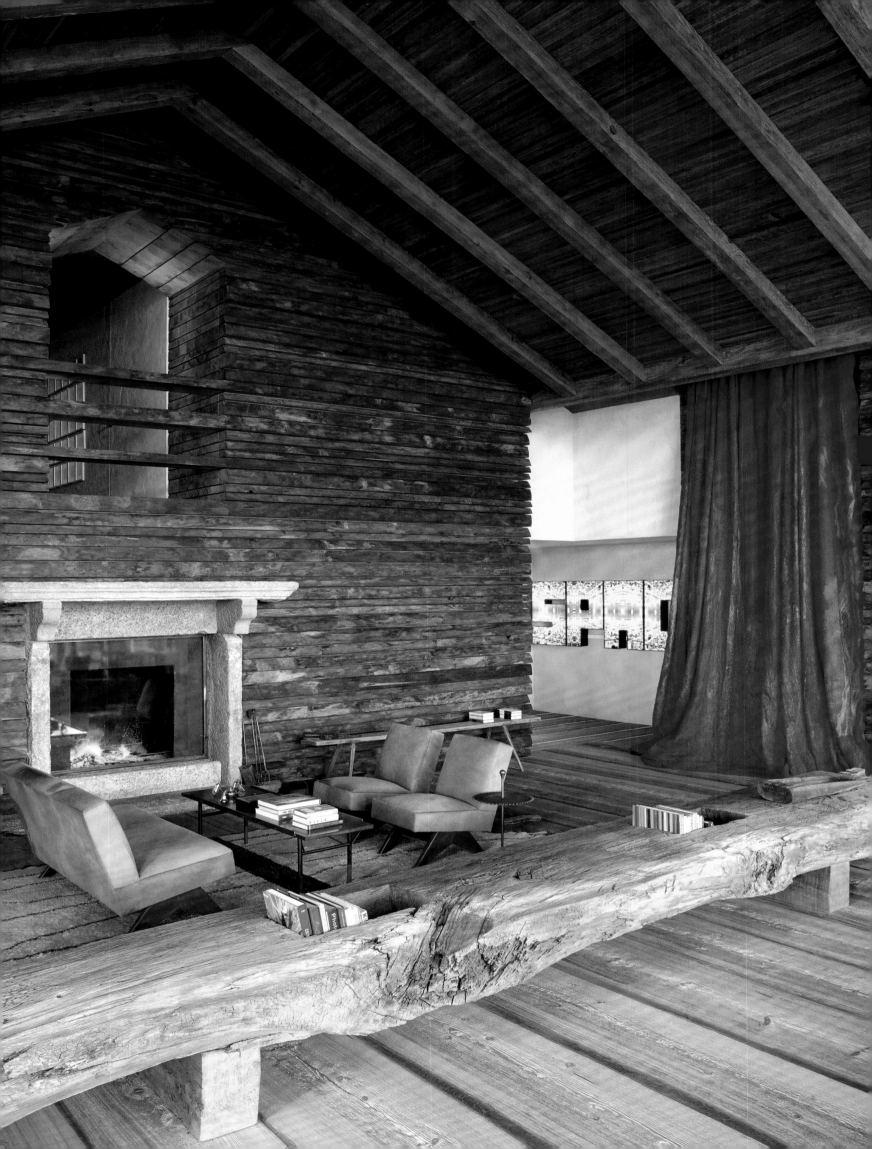

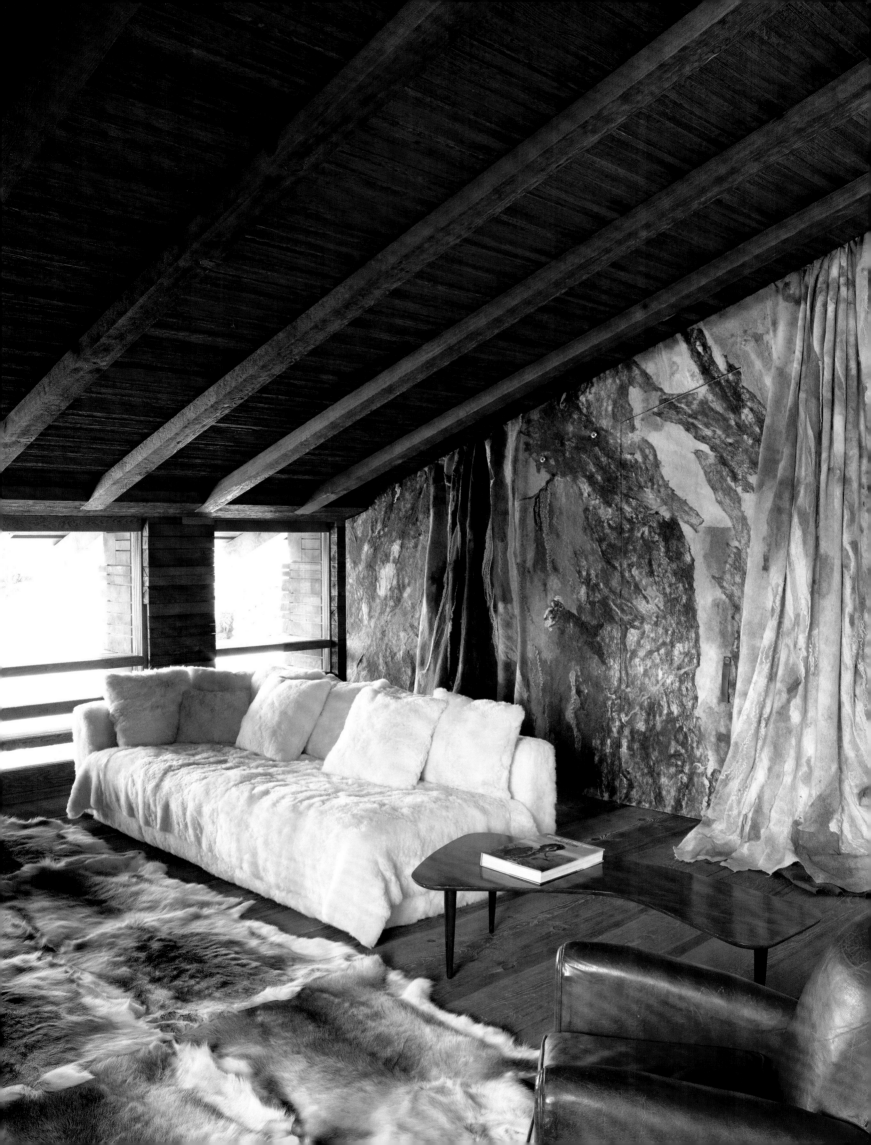

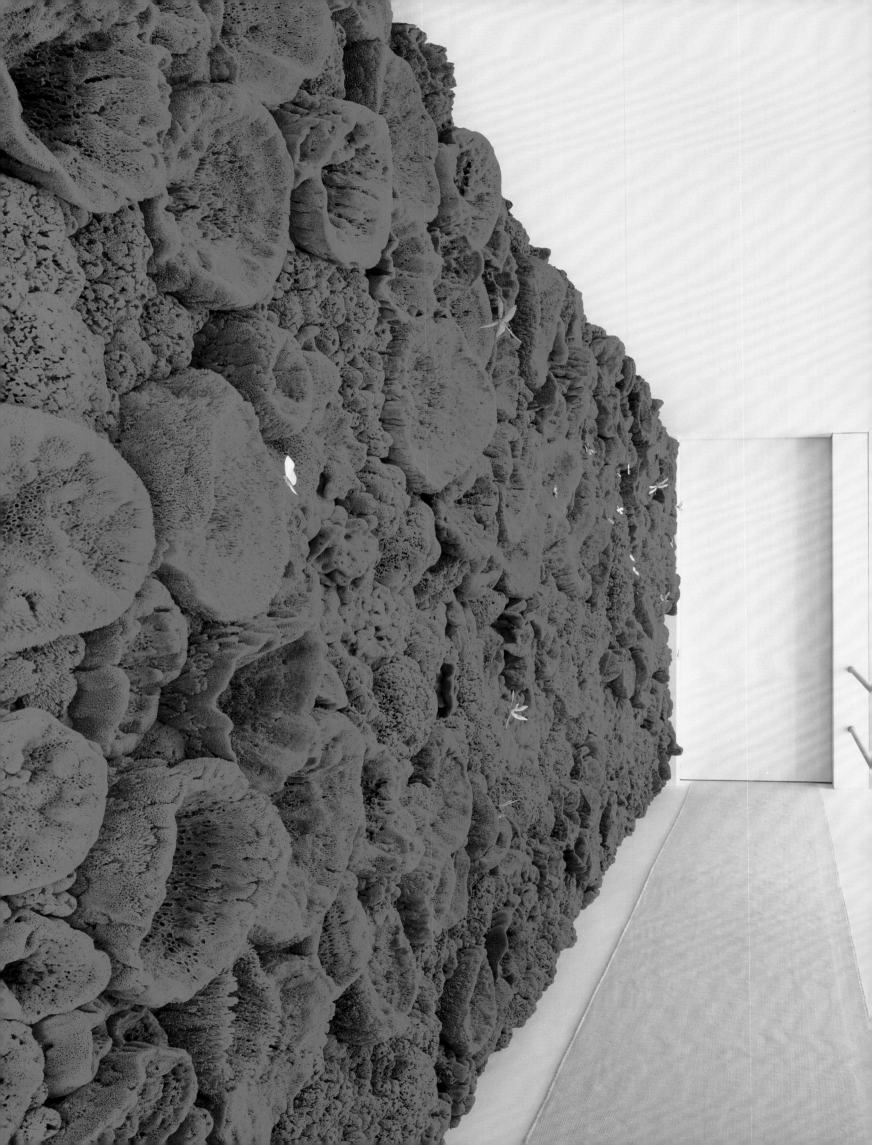

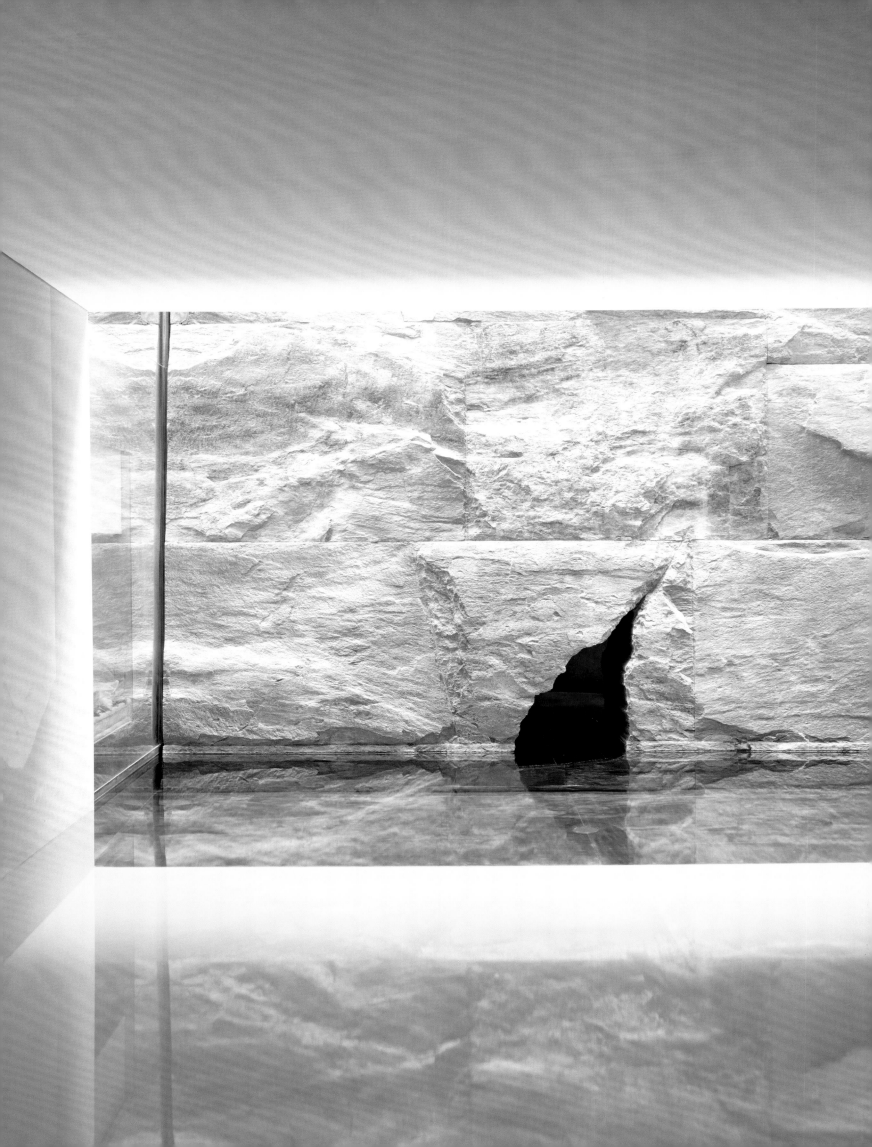

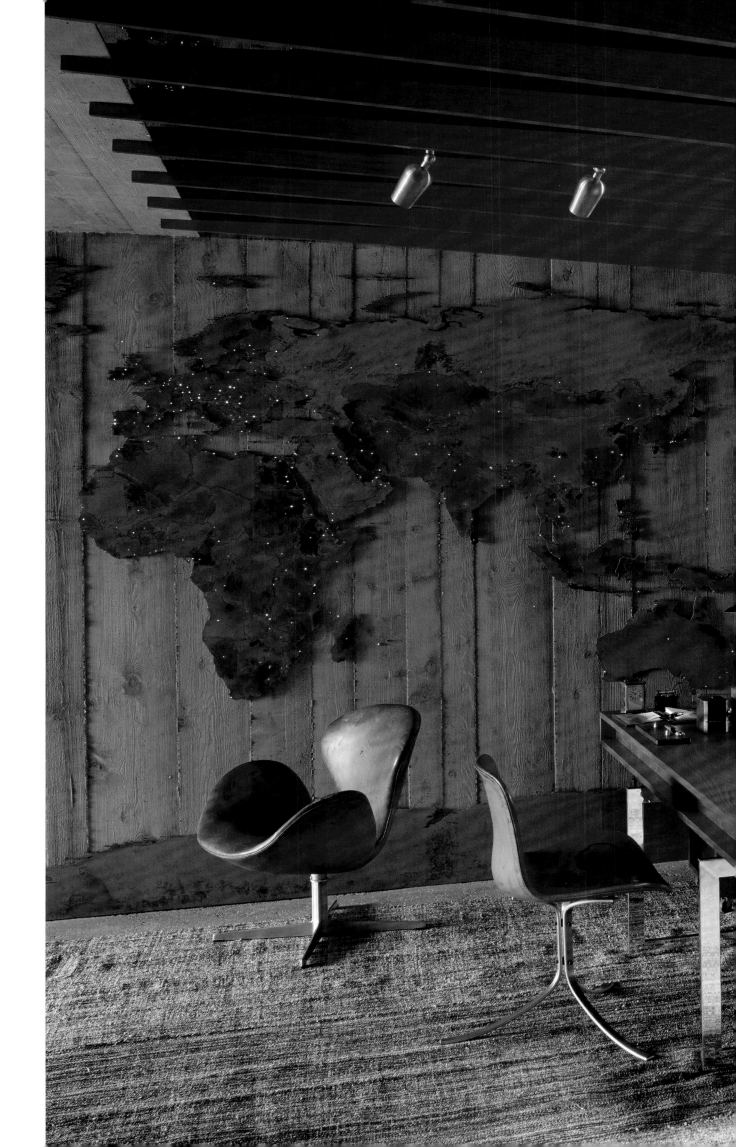

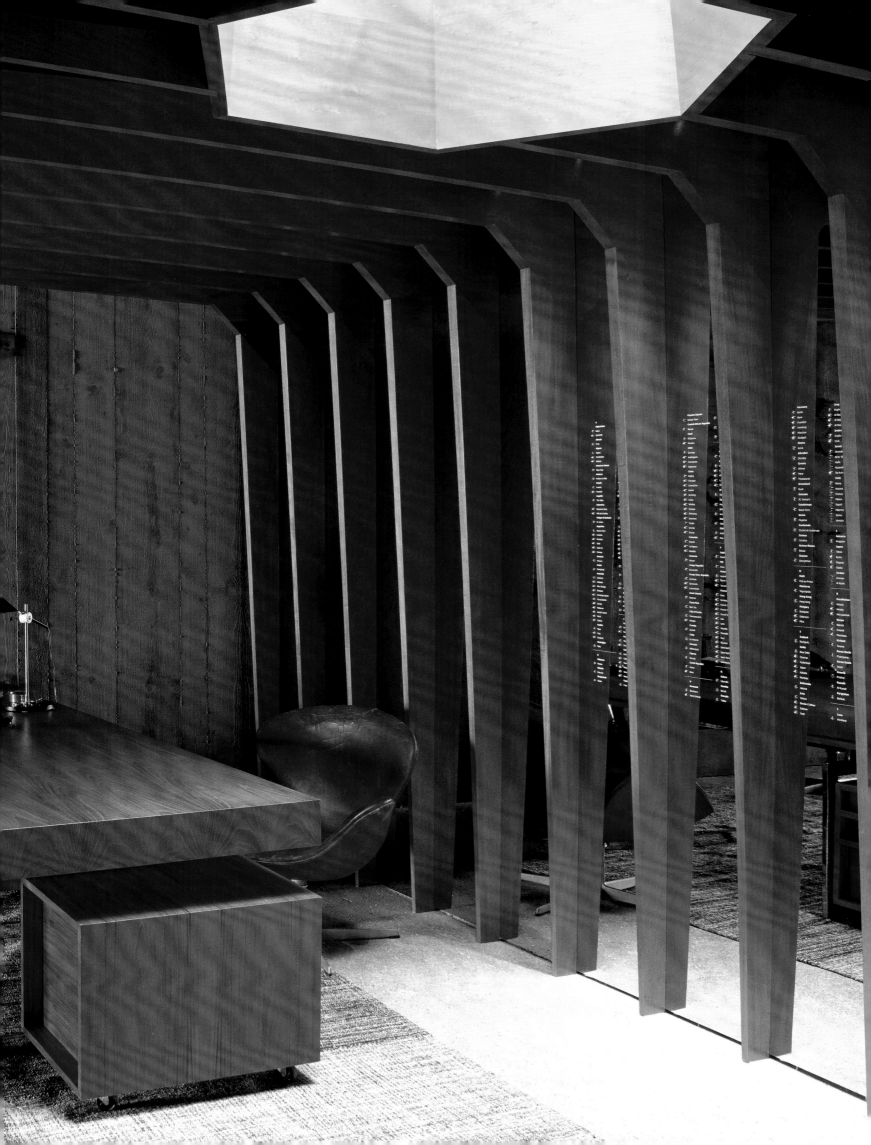

Cactus Dorée by Tom Dixon

Certainly it ought to sound unusual, if not highly unlikely, that a woman who commissioned an 11,000-square-foot house in the South of France from Tom Dixon should first have met the designer when he was part of a London-based eight-piece funk-dance band, some thirty years before. But back then the two had quickly become firm friends, and when the self-taught Dixon started making in his Notting Hill garage what might be termed "antiestablishment furniture"—that is to say, furniture welded from industrial castoffs and salvaged scrap metal—she became an early and enthusiastic patron.

Presently, Dixon established himself as a force in the design world, famously creating such pieces as the S-Chair, produced by the Italian company Cappellini, and the Jack lamp. By the late 1990s, Dixon was creative director of British retailer Habitat, a position he retained until 2002. He has since designed luxury furniture, lighting, tableware, and interiors under his own name, from a studio based in London's King's Cross.

Then in 2010, entirely out of the blue, his old friend surprised Dixon with a proposal: to design a house for her and her husband with an entirely free hand. The surprise was underscored by the knowledge that the designer's only previous familiarity with the practice of architecture had been the renovation some years earlier of a vacant water tower as a home for himself and his family. However, he knew that his clients shared with him a long-standing, if offbeat, enthusiasm for the military installations and wartime bunkers of the northern coast of France, and this would find expression in what turned out to be a brutalist concrete house, complete with a thirty-foot-high dome and arrow-slit windows. "Tom chose everything," the owners say, "and we changed nothing." This included, among other things, a tiny discotheque room with a spinning mirrored ball (naturally enough), where the lady of the house likes to dance alone.

In the end, the house—christened Cactus Dorée and photographed in 2019—took five years to complete, partly because of Dixon's being based in London and partly because, as his patron puts it, "you have to interpret what he says when you ask him a question." The couple "could never have imagined such a big house," she adds, "but when he drew it, we were pleasantly surprised. Tom said, 'I'm not an architect,' but I said, 'You are brilliant, and we will love it.'" He is and they did, though she became the general project manager as well as, ultimately, the interior designer.

The main constituent—reinforced, board-formed concrete—proved to be a little more expensive than anticipated, essentially to meet local seismic requirements, so the couple came up with an elegant, poetic solution: They sold almost all of their collection of early Dixon pieces to help defray the cost, in the full knowledge that the designer would not be in the slightest bit dismayed. "Tom doesn't dwell on the past!" his client confirms.

And yet, the living room, with its wall of sliding-glass doors offering a view of the sea (and the garden designed by Michel Desvigne), retains a serpentine, green leather–covered, custom-made sofa designed by Dixon. And the boiler room, with its highly polished copper pipes, has a Dixon chair, which sits on a marble floor that was rescued from Sir Norman Foster's renovation of Heathrow Airport—"Everyone in the world has walked on this floor!" Dixon's client says with evident pride.

Back upstairs, the corridor leading to the main bedroom is ranged with wooden cabinets sourced from London's Natural History Museum. Originally used to store butterfly specimens, they now hold shoes and handbags. "These were Tom's idea," she says with delight. "You see, Tom likes things with a story."

Cactus Dorée, France, designed by Tom Dixon, photographed in 2019.

Page 228: Domed roof of Cactus Dorée. *Page 229:* Interior stairwell. *Pages 230 and 231:* Exteriors. *Page 232:* Living room with custom-designed sofa by Dixon. *Page 233:* Hall with early seventeenth-century painting, ceiling light by Philippe Malouin, and bench by Gio Ponti. *Page 234:* Corridor with cabinets from London's Natural History Museum and artwork by Joel-Peter Witkin. *Page 235:* Exterior. *Page 236:* Boiler room with *Monaco Harbour*, 1954, a painting by Joseph Consavela, and limestone floor salvaged from Heathrow Airport. *Page 237:* The discotheque. *Page 238:* Garden. *Page 239:* Tom Dixon, 2009, photographed in London.

Cactus Dorée
by Tom Dixon

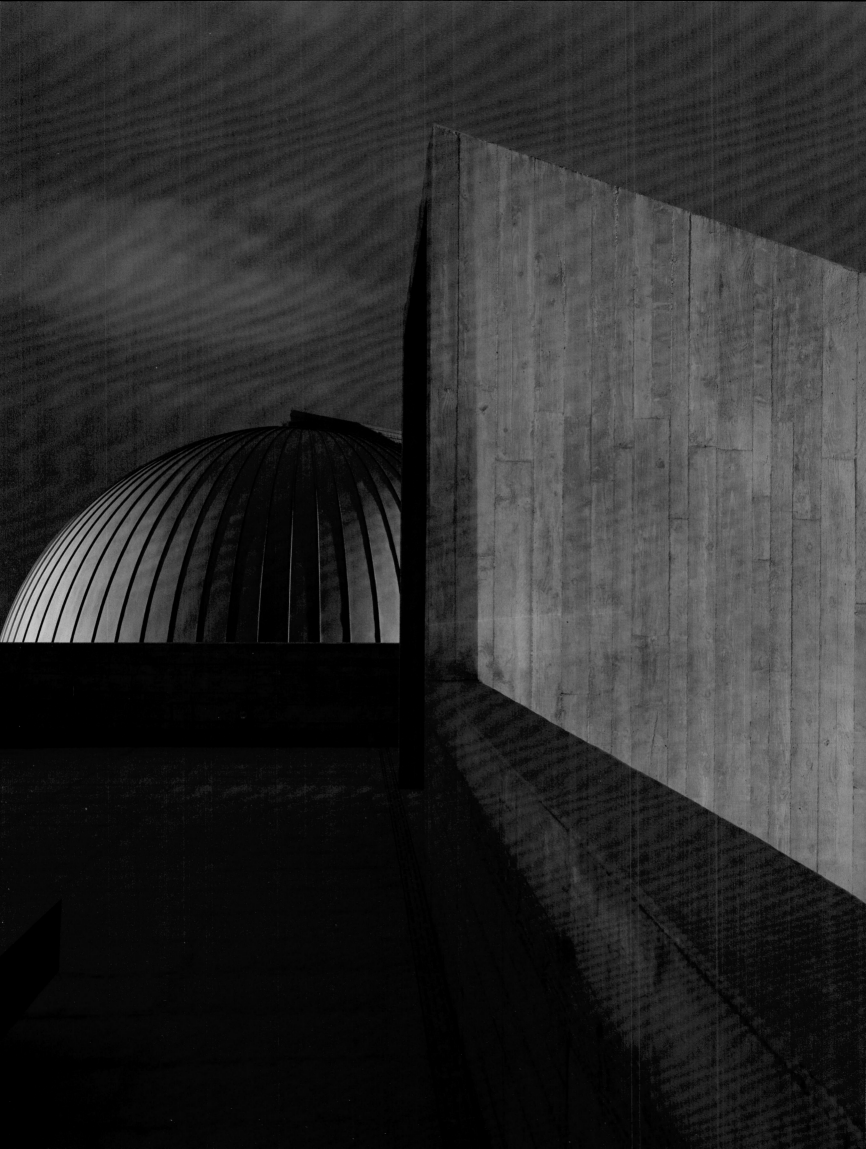

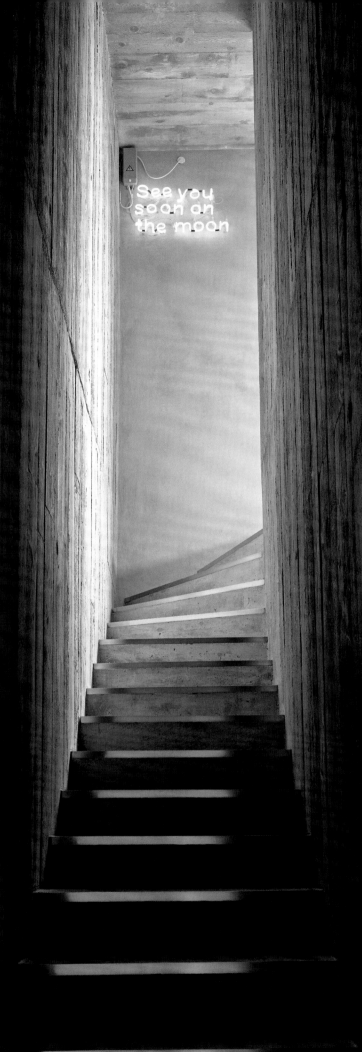

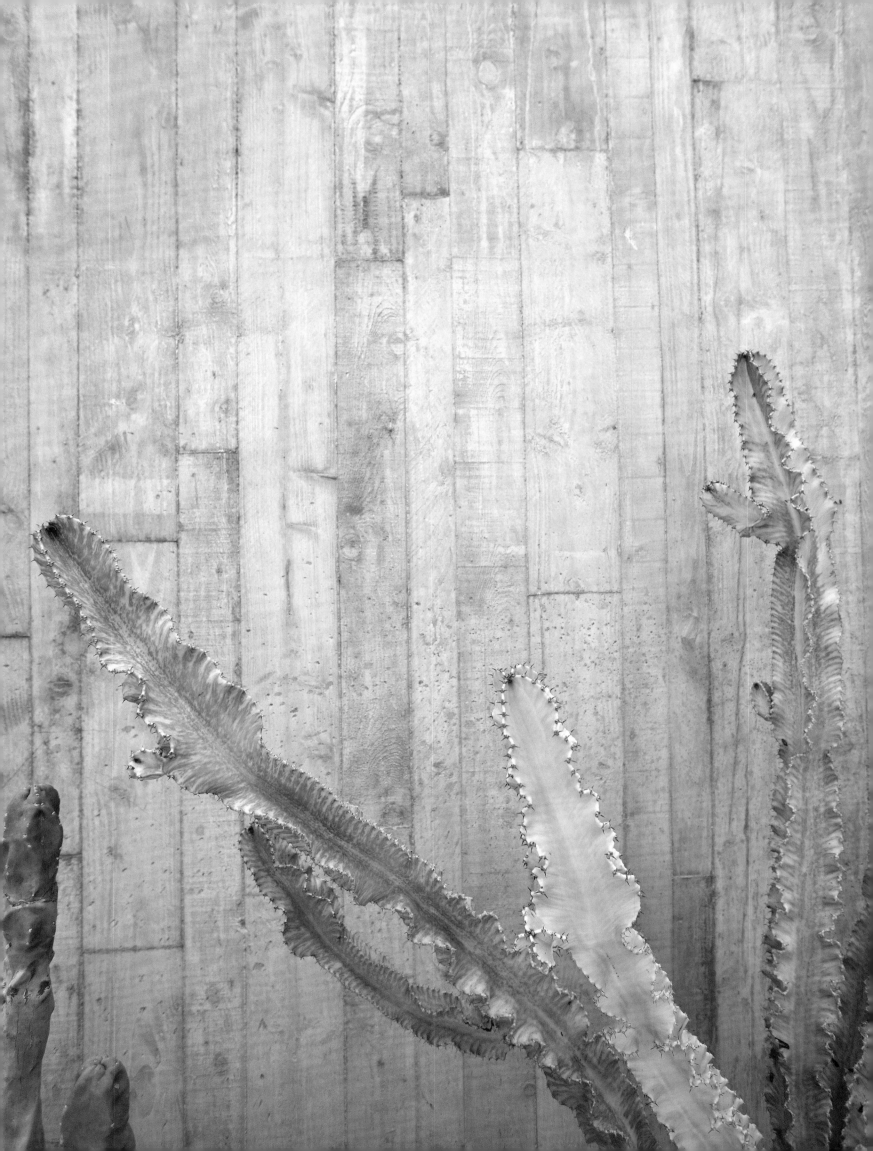

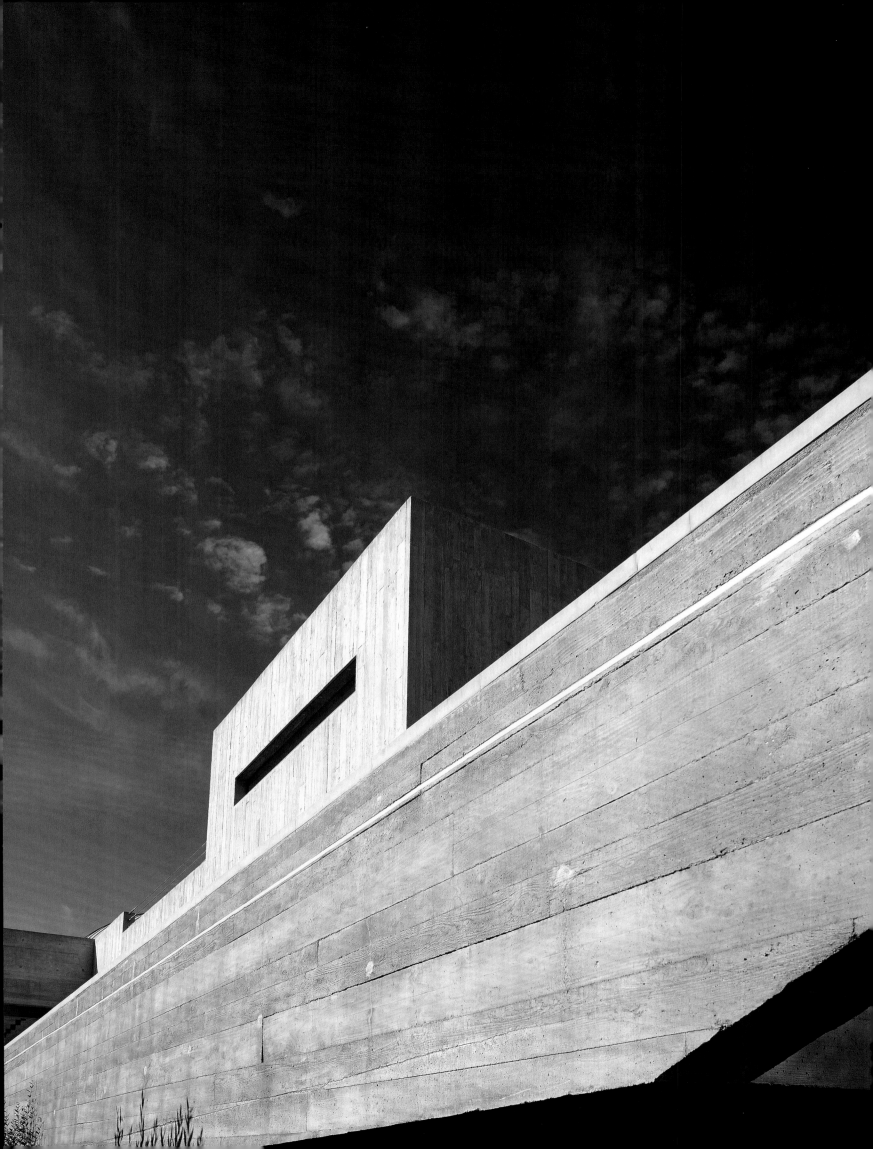

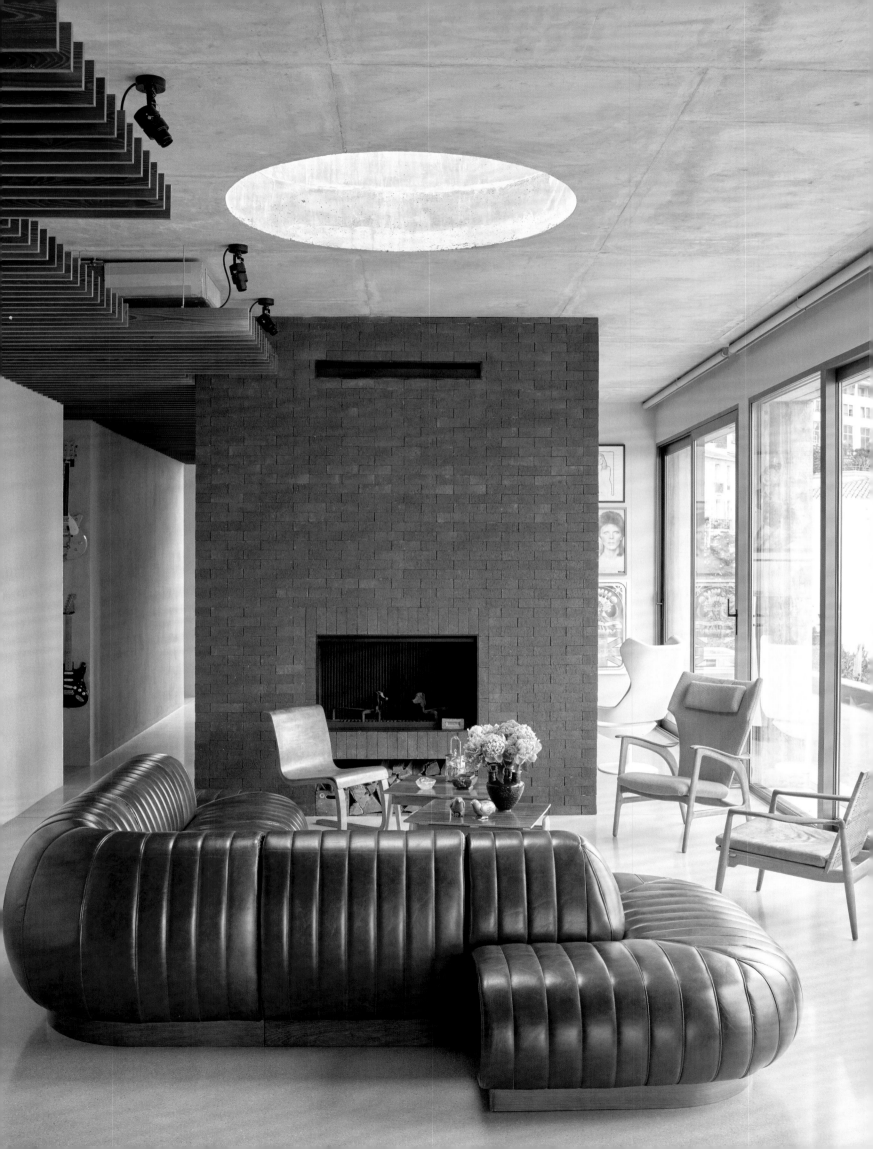

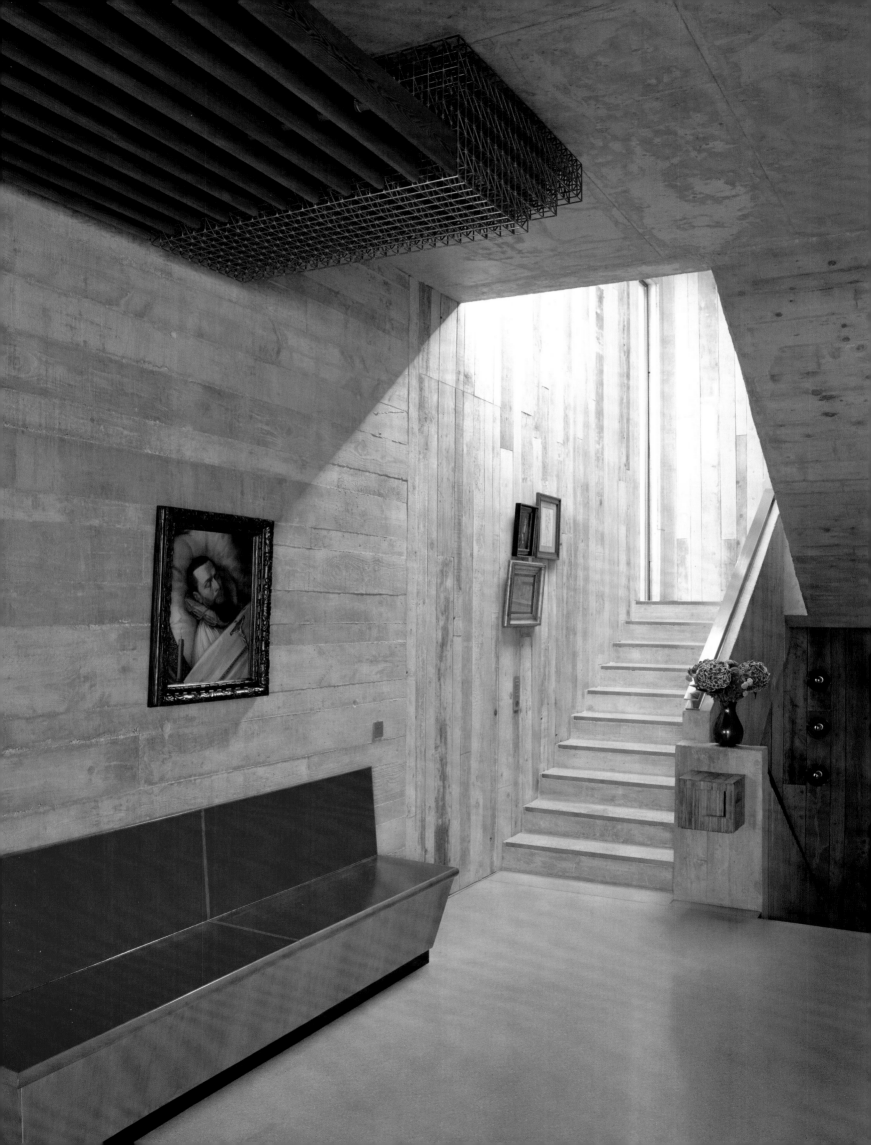

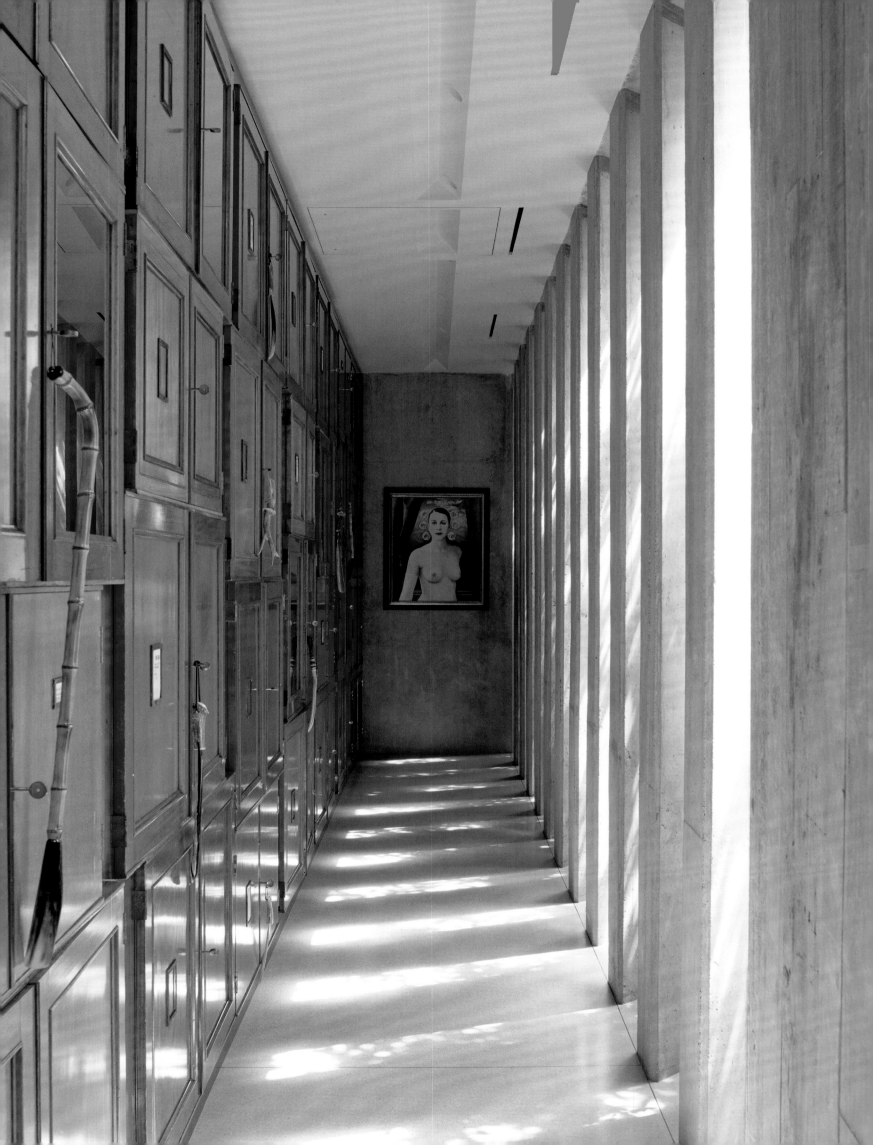

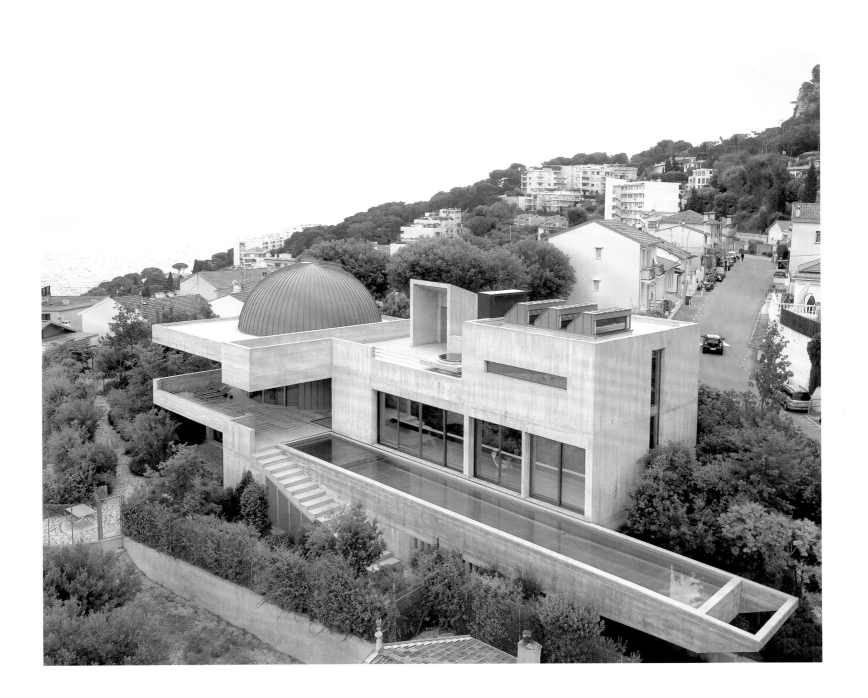

La Filanda by Luca Guadagnino

To even the most casual viewer of the films of Luca Guadagnino, it is clear that the settings, interiors, and backdrops, elaborately layered and distinctive, are just as significant to his auteur's vision as anything else. The more so when one learns that the director disdains industry prop houses in favor of bespoke (and presumably wildly expensive) artifacts. When Federico Marchetti, founder of YOOX Net-a-Porter Group, and his partner, journalist Kerry Olsen, decided to turn La Filanda, a 10,000-square-foot former silk mill on the shore of Lake Como, into a weekend retreat, they asked their friend if he would consider collaborating on the interiors. Guadagnino agreed at once (even though he was in preproduction for his next film), promptly establishing, in presumably record time, an interior-design practice, Studio Luca Guadagnino.

Though Marchetti and Olsen chose to keep La Filanda's exterior as relatively anonymous and as industrial-looking as an ex–silk mill could be, they didn't want a house, they explain, that was "beautiful but cold." And so it is inside—sleek and textured and subtle—where the story unfolds in glorious color. "He has such a strong work ethic," Marchetti says in admiration, "and an incredible eye for color."

Photographed in 2018, La Filanda is filled with a collection of twentieth-century furniture and artworks the couple has chosen together. A wood-lined spiral staircase leads up from the hallway, where ribbed oak paneling is trimmed with brass, hanging lights by Michael Anastassiades animate the ceiling, and a patterned rug from La Manufacture Cogolin enlivens the floor. In the living room, Guadagnino hung a large photograph by Candida Höfer above an Italian bar cabinet, where it overlooks a group of 1930s caned mahogany chairs by Kaare Klint. A Frits Henningsen sofa, side tables by Hermès, and, in contrast to these clean-lined furnishings, a George Nakashima coffee table made from a slice of tree trunk on an emerald-green carpet. The main bedroom is more neutral-toned, with a custom marble fireplace and overmantel. An early midcentury modernist chair, designed by Pierre Jeanneret for Knoll, sits near another Cogolin rug, this one in a vibrant green. Kvadrat fabrics cover the furniture, and the lamps are from the Dutch gallery Morentz.

While bedrooms were designed for the couple, their daughter, and guests—"We have lots of guests, more than in Milan" (they are mostly based there)—Olsen and Marchetti have their own refuges. For Olsen it's her dressing room. "I'm very lucky to have a room to call my own," she says. "It's very orderly, with a small sofa, a radio, a dressing table. I feel like I'm in another era." For Marchetti: the swimming pool. "I was born by the sea," he says, adding with evident delight that the pool "is a piece of art. And no one can reach me on the phone." A gardening enthusiast, Olsen collaborated with Gaia Chaillet Giusti, Guadagnino's colleague, on chevron-patterned parterres for the large garden that overlooks the lake.

"It was a real education working with Luca. I learned so much," Olsen says. Guadagnino would ask their daughter, for example, what she liked, and he would listen and adapt her ideas. On one occasion Olsen accompanied Guadagnino to the Nymphenburg porcelain factory in Bavaria, where the director was entranced by the glaze on a pink teacup from the archive. This naturally enough evolved into an entire tea service. "It's exactly that level of detail that Luca applies to his movies," Marchetti says. And it made the couple's house an elegantly layered, totally comfortable—and entirely idiosyncratic retreat.

La Filanda, Federico Marchetti and Kerry Olsen's house designed by Luca Guadagnino, Lake Como, photographed in 2018.

Page 242: Lake Como. *Page 243:* Luca Guadagnino, photographed in Como. *Page 244:* Kitchen. *Page 245:* Laundry room. *Page 246:* Living room with chairs by Kaare Klint, side tables by Hermès, sofa by Frits Henningsen, table by George Nakashima, and a photograph by Candida Höfer of the national library in Naples. *Page 247:* Living room with fireplace by Studio Luca Guadagnino, sconces by Michael Anastassiades, Salon chairs by Maxime Old, table by Peter Hvidt and Orla Mølgaard-Nielsen, table by Jorge Zalszupin, rug by La Manufacture Cogolin, lamp by Maison Jansen, and photograph by Thomas Ruff. *Page 248:* Bedroom with chairs by Pierre Jeanneret for Knoll, 1952, and rug by La Manufacture Cogolin. *Page 249:* Guest bedroom.

La Filanda
by Luca Guadagnino

2010s

Oliver Gustav

Danish-born Oliver Gustav, a self-described "designer, curator of spaces, and antiques dealer," has a way with gray. His Copenhagen apartment, dating from 1734 and photographed nearly three centuries later, in 2017, has an almost monochromatic stillness—even the stairwell entrance is painted the perfect shade of gray.

Much of the apartment's original architecture has survived the centuries: paneled rooms and doors, walls now lopsided and bending, and wooden floors that are organically worn and gently sloping. All mark the passage of time. Ascending the stairs to Gustav's apartment on a—naturally—gray February morning with Tom Delavan, the design director and editor of *T Magazine*, felt like entering a Vilhelm Hammershøi painting to Delavan and Bourne: the soft natural northern light inspired thoughts of the painter's subdued, enigmatic, lonely compositions. In 1898 Hammershøi moved into a house very close by; he repeatedly depicted his immediate surroundings, and in those meditative domestic interiors it's the contrast of light and shadow that mattered most to the artist.

In each room of Gustav's apartment, he mixes his designs, frequently upholstered in gray linen, with his favorite historical and twenty-first-century pieces. In the living room, a sofa of his design cohabits with a table by Rick Owens and a floor lamp by Vincenzo De Cotiis; alongside, a nineteenth-century white porcelain stove meets a modern concrete plinth by Karl Troels Sandegård. In the dining room, contemporary paintings by Julia Haller look effortlessly compatible with an eighteenth-century Venetian chair and a travertine table. The contrast of light and dark in each room can be subtle or pronounced, but the play of natural Scandinavian light is the consistent element throughout and, with Gustav's sensitive use of a gray palette, fundamental to the tranquil atmosphere he achieved.

Oliver Gustav's apartment, Copenhagen, photographed in 2017.

Page 252: Bedroom with painting by Julia Haller. *Page 253:* Dining room with 1970s travertine table, a Venetian chair, painting by Julia Haller, and aluminum chair by Erik Magnussen. *Page 254:* Kitchen. *Page 255:* Staircase. *Page 256:* Living room with Arne Jacobsen Drop chair, 1958, edition by Gustav; artwork by Jorge Stever; and floor lamp by Vincenzo De Cotiis. *Page 257:* Living room with artworks by Emil Westman Hertz, Ratio table in metal by Jonathan Nesci, and an artwork by Bret Slater atop the Ration table. *Pages 258–259:* Oliver Gustav with *Self Portrait*, a concrete sculpture by Karl Troels Sandegård; table by Rick Owens; and floor lamp by Vincenzo De Cotiis.

Oliver Gustav

2010s

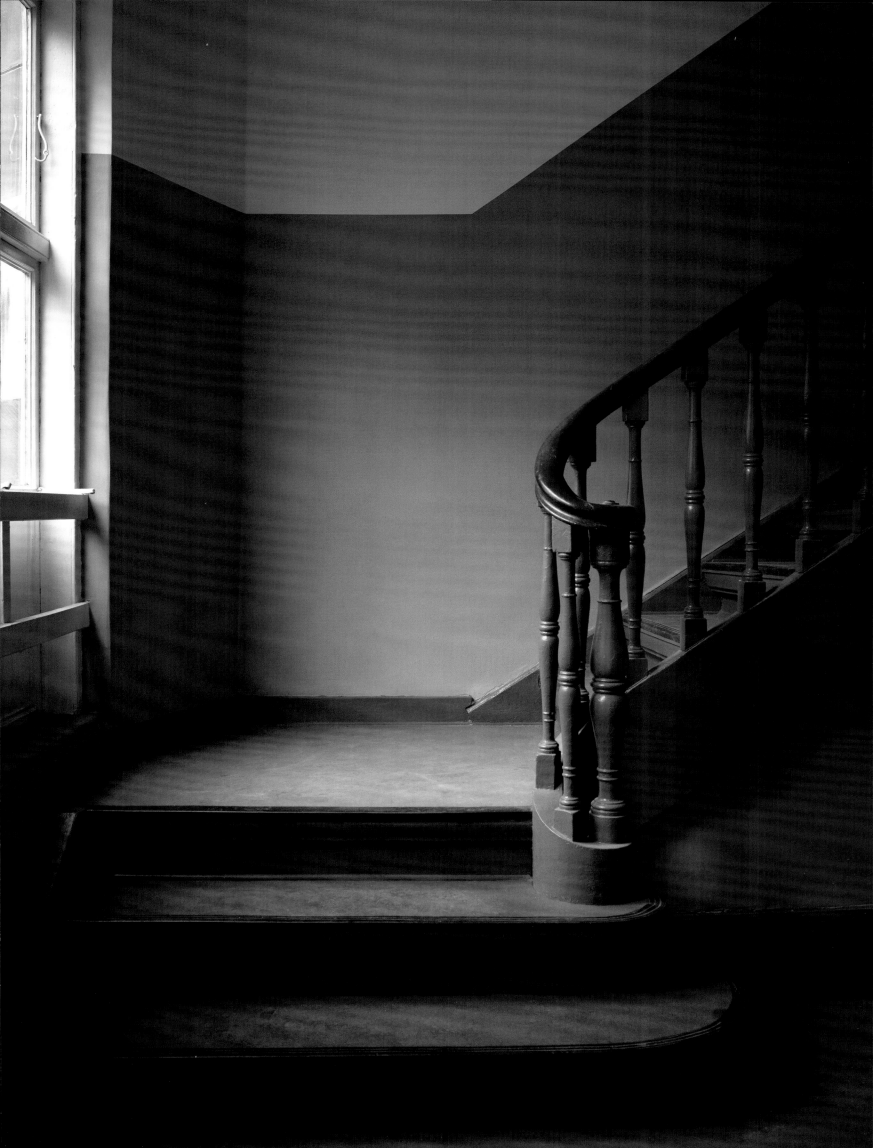

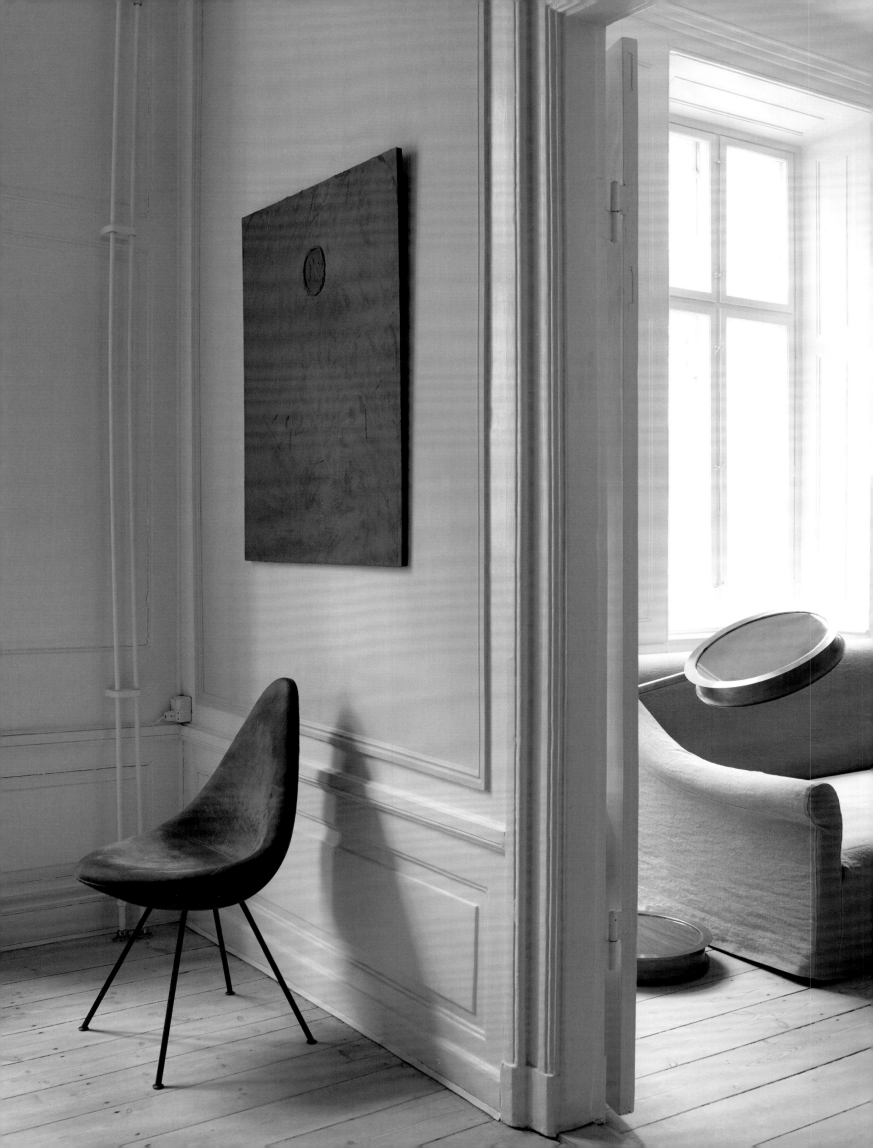

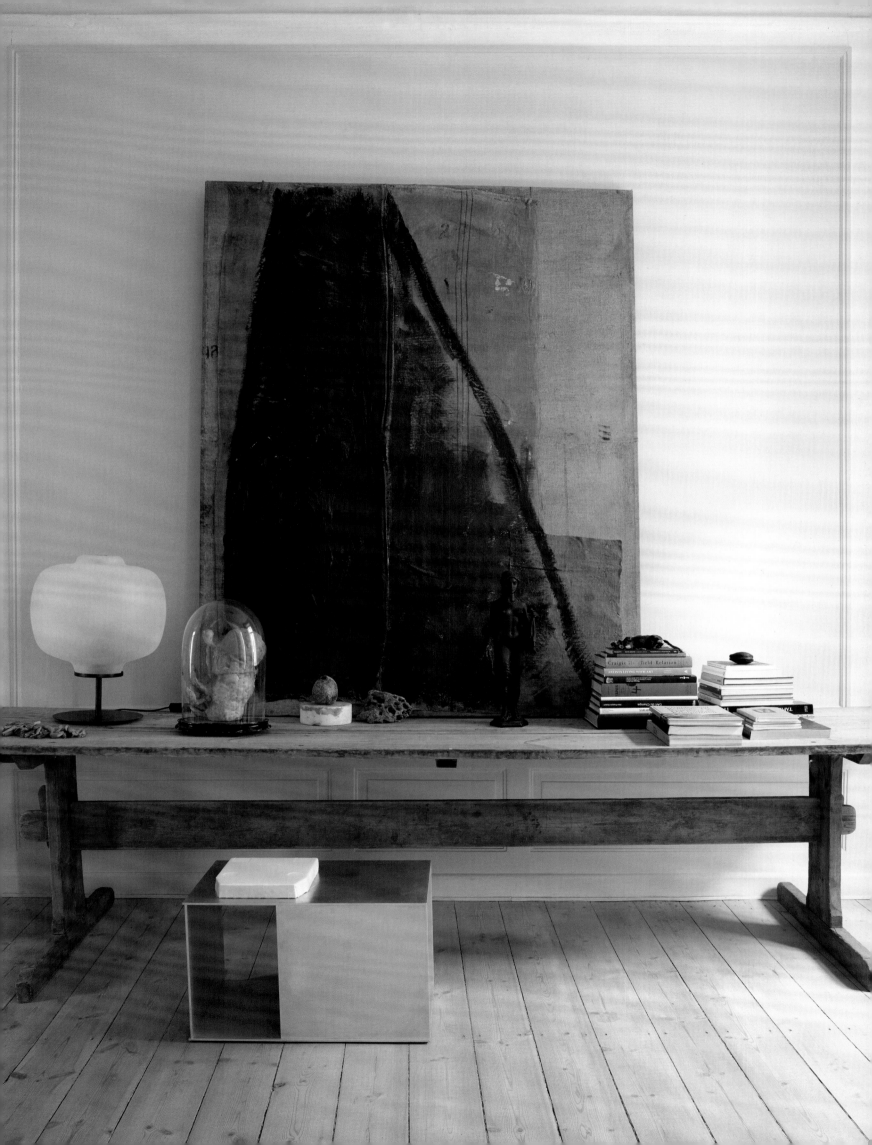

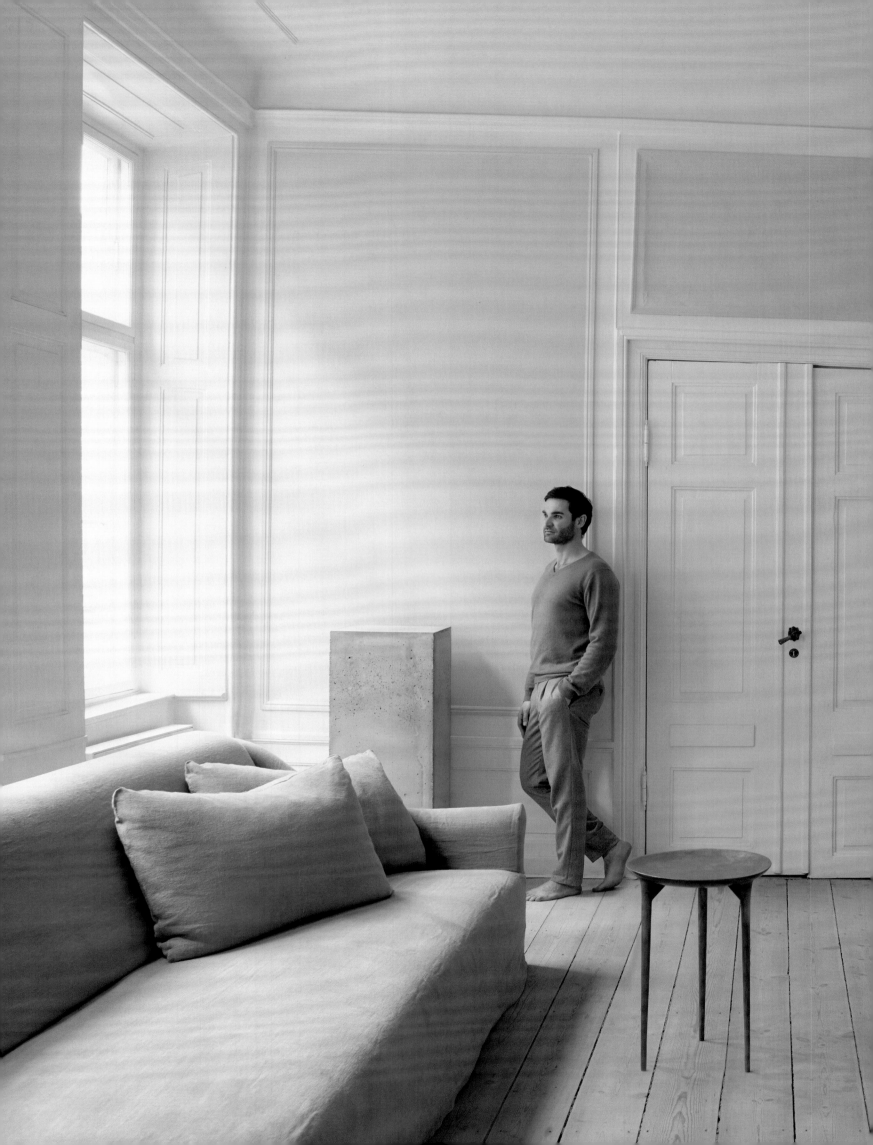

Joerg & Maria Koch

The Koch family's Berlin home began life as the rectory of St. Agnes, a Catholic church and complex built in 1967 on the outskirts of what was once the parish of West Berlin. Now regarded as a brutalist icon, it was designed by architect and city planner Werner Düttmann, himself now recognized as a visionary of postwar German modernism. The gallerist Johann König acquired the deconsecrated church and its adjoining community center in 2012, and embarked upon a restoration program that transformed the historically protected but tired buildings into a creative and cultural hub with living spaces.

When they moved in, the Kochs viewed the apartment's raw shell of concrete walls as an opportunity. Photographs from 2014 reveal floors and walls lined with iridescent purple carpeting that offset the cool concrete, and contemporary furniture played against antique pieces: Konstantin Grcic's expansive 2003 Pallas table twinned with a nineteenth-century painting; a cylindrical Biedermeier cabinet positioned in sight of a strategically angled Supreme baseball bat and a Luminator floor lamp, 1954, by Achille and Pier Giacomo Castiglioni. The sophisticated mingling of rough concrete and lush carpet was not lost on the Koch children, who commandeered the luminous purple room as their personal weekend nightclub.

Creative director and publisher Joerg Koch founded the magazine *032c* in 2000, later expanding it into a media and fashion company. Now a collective, once based at St. Agnes, 032c generates, among other ventures, ready-to-wear collections for which Joerg's wife, Maria, is creative director. In keeping with the revived spirit of St. Agnes, the members of 032c describe "the 032c universe" as "a place for freedom, research, and creativity, where fantasy is reality, aspiration is attainment, and everything is culture in the making."

Joerg and Maria Koch's apartment, Berlin, photographed in 2014.

Page 262: St. Agnes, 1967, designed by architect Werner Düttmann. *Page 263:* Living room. *Pages 264 and 265:* Living room with a Luminator floor lamp, 1954, by Achille and Pier Giacomo Castiglioni; nineteenth-century painting by an unknown artist; Biedermeier cabinet; and Supreme baseball bat. *Pages 266 and 267:* Bedroom with Odin sofa, 2005, by Konstantin Grcic. *Page 268:* The church tower of St. Agnes. *Page 269:* Joerg Koch. *Page 270:* Dining area with Pallas table, 2003, by Konstantin Grcic. *Page 271:* Joerg Koch.

Joerg & Maria Koch

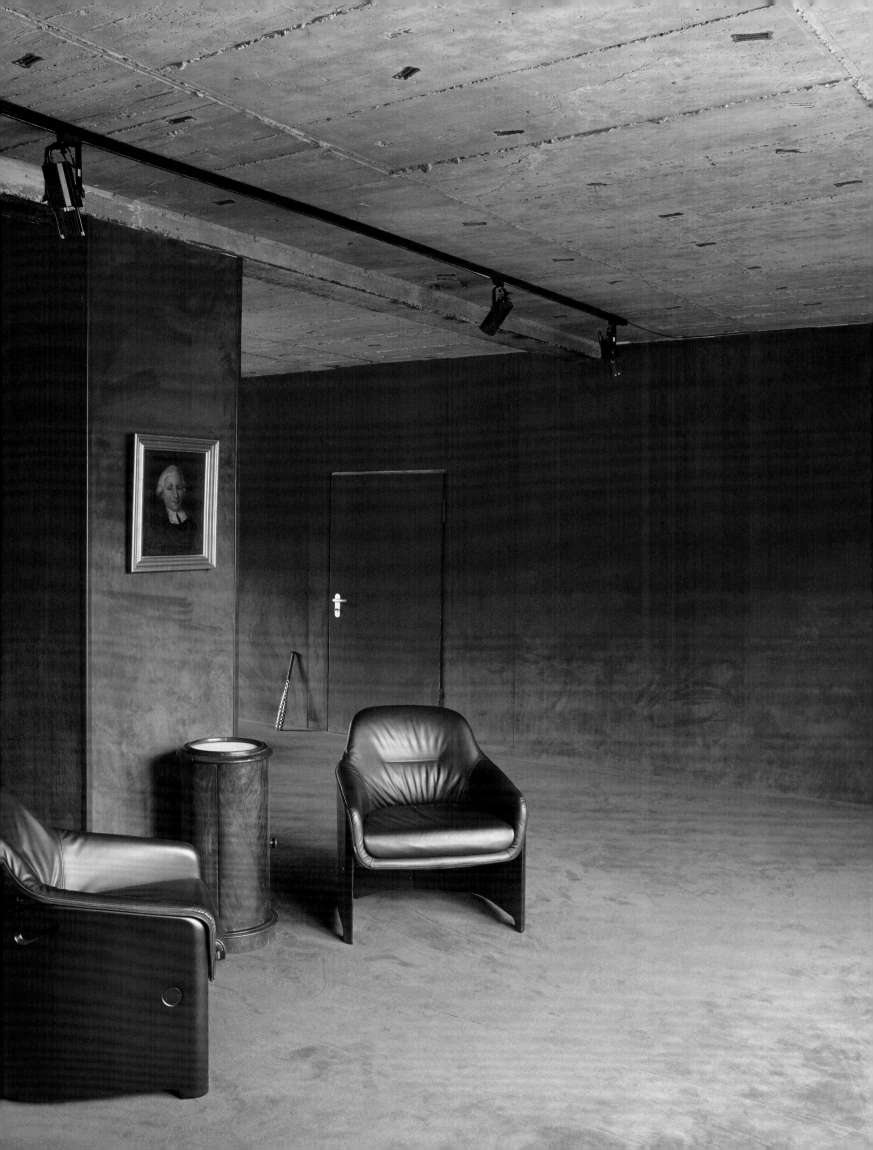

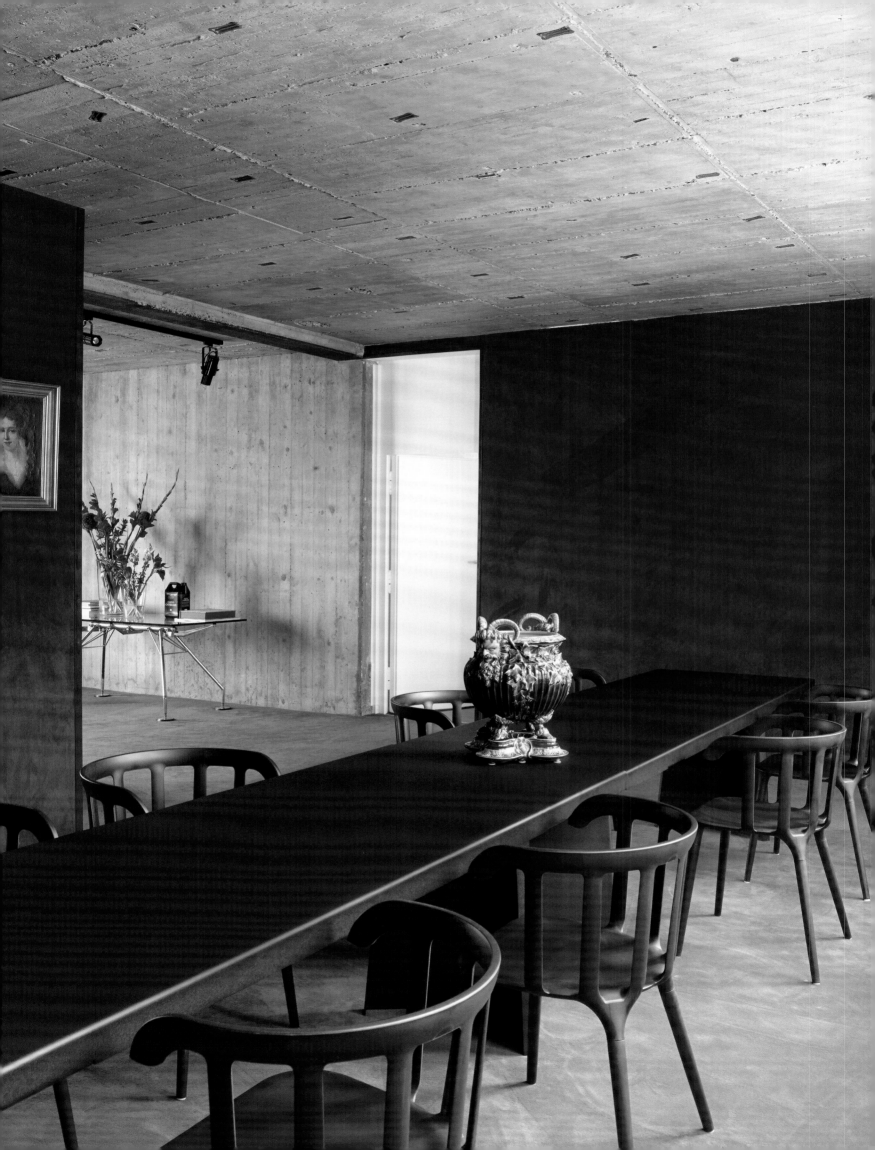

Acknowledgments

For Harriet and Celestia

Firstly, I thank the many homeowners and subjects who so graciously participated in this book and, in certain cases, the support of their estates or representatives; without them this publication would not have been possible.

I also thank my numerous colleagues who have contributed to this body of work. These stories are a team effort, and they would not have been possible without the talents of many editors, art directors, writers, stylists, hair and makeup artists, photography directors, and photographic assistants.

I owe a huge debt of gratitude to all the publishers and magazine editors who have commissioned me over the years; they have granted me access to extraordinary subjects and given me faith and support, which have been essential.

In particular, I would like to thank:

My friend Eve MacSweeney, whose encouragement and support of this project were invaluable

My longtime colleague Pilar Viladas, who wrote her texts so eloquently

Jane Withers, for her foreword that makes sense of all the disparate threads of this book

Robin Muir, whose advice, expertise, and hard work have been essential, generous, and unwavering

Inspirational photography directors Dennis Golonka, Scott Hall, Caroline L. Hirsch, Stephanie Waxlax Hughes, Isabella Kullmann, Gina Liberto, Chloe Limpkin, Carter Love, Rory Walsh-Miller, Jennifer Pastore, Lauren Poggi, Judith Puckett-Rinella, Jamie Sims, Michael Trow, and Nadia Vellam

Editors in chief Sally Brampton, Ilse Crawford, Min Hogg, Patrick McCarthy, Marian McEvoy, Deborah Needleman, Justine Picardie, Margaret Russell, Alexandra Shulman, Sally Singer, Rupert Thomas, Elizabeth Tilberis, Stefano Tonchi, and Hanya Yanagihara

Managing editor Harriet Wilson

Creative directors Debi Angel, Fabien Baron, Marissa Bourke, Clive Crook, Robin Derrick, Paul Eustace, Dennis Freedman, Jo Hay, Patrick Li, Florentino J. Pamintuan, Chris Parker, Jaime Perlman, Peter Saville, David Sebbah, Michael Tighe, and Faye Toogood

Editors and writers Vanessa Barneby, Marella Caracciolo Chia, Tom Delavan, Susie Forbes, Natasha Fraser-Cavassoni, Fiona Golfar, Nancy Hass, Violet Henderson, Pippa Holt, Rita Konig, Nonie Niesewand, Anoop Parikh, Melissa Barrett Rhodes, Caroline Roux, Sue Skeen, Dana Thomas, Elspeth Thompson, Guy Trebay, Marco Velardi, Pilar Viladas, and Jane Withers

Photographic assistants Chris Horwood, Steve Kenward, Kensington Leverne, Dimitri Ramazankhani, Rowan Ann Spray, and Henrik Stenberg.

I also thank my editor, Philip Reeser, and the designers of this book, Guy Marshall and Joanna Haskins, and their team at StudioSmall.

Jude Barnes, Wilhelmina Bunn, Romano Crolla, Jane da Mosto, Nick Fry, Georgina Godley, Roger Howie, Patrick Kinmonth, Caroline Press, Olivia Putman, Ivan Shaw, Emily Smith, and Vivienne Tam for their help and advice.

Thank you to my wife, Harriet Anstruther, and my stepdaughter, Celestia Anstruther, for their never-ending patience and support of this book. — *Henry Bourne*

Credits

Villa Volpi by Tomaso Buzzi 12
A selection of photographs was originally published in the October 1997 issue of *W* magazine. Patrick McCarthy, editor in chief; Dennis Freedman, creative director; Natasha Fraser-Cavassoni, writer.

Robin & Lucienne Day 22
A selection of photographs was originally published in the October 1996 issue of British *Elle Decoration*. Ilse Crawford, editor in chief; Jane Withers, associate editor; Sue Skeen, deputy editor; Catherine Caldwell, art director; David Redhead, writer.

Vincent Van Duysen 28
A selection of photographs was originally published in the October 1996 issue of British *Elle Decoration*. Ilse Crawford, editor in chief; Jane Withers, associate editor; Sue Skeen, deputy editor; Catherine Caldwell, art director; Anoop Parikh, writer.

Amanda Harlech 36
A selection of photographs was originally published in the March 1995 issue of *W* magazine. Patrick McCarthy, editor in chief; Dennis Freedman, creative director; Natasha Fraser-Cavassoni, writer.

Peter Saville 46
A selection of photographs was originally published in the December 1997 issue of British *Elle Decoration*. Ilse Crawford, editor in chief; Debi Angel, art director; Yvonne Sporre, fashion editor; Jackie Beeke, assistant fashion editor; Jane Withers, associate editor and writer. Mannequins by Adel Rootstein; skirt by Clements Ribeiro.

Scott Crolla 56
A selection of photographs was originally published in the December 1995 issue of British *Elle*. Sally Brampton, editor in chief; Clive Crook, creative director; Debi Angel, art director; Sasha Miller, writer.

Richard Prince 64
A selection of photographs was originally published in the May 1996 issue of *Elle Decor*. Marian McEvoy, editor in chief; Margaret Russell, editor; Jo Hay, creative director; Quintana Roo Dunne, photography editor; Neville Wakefield, writer. Artworks reproduced with the kind permission of Richard Prince.

***Pharmacy* by Damien Hirst** 72
A selection of photographs was originally published in the March 1998 issue of *Harper's Bazaar* (US). Elizabeth Tilberis, editor in chief; Fabien Baron, creative director; Paul Eustace, art director; Eve MacSweeney, features director; Jane Withers, writer. Used by permission of Hearst Magazine Media, Inc. Artworks reproduced with the kind permission of Damien Hirst and Science Ltd.

Cholmeley Dene 80
A selection of photographs was originally published in the November 1990 issue of *The World of Interiors*. Min Hogg, editor in chief; Michael Tighe, creative director; Elspeth Thompson, features editor, producer, and writer. Used by permission of The Condé Nast Publications Ltd. Artworks reproduced with the kind permission of the Cholmeley Dene Artists and the Arc Collective.

Marc Newson 92
A selection of photographs was originally published in the October 1999 issue of *Harper's Bazaar* (US). Karin Upton Baker, consultant and editor in chief; Paul Eustace, art director; Eve MacSweeney, features editor; Dennis Golonka, photography editor; Melissa Barrett Rhodes, design editor and producer; Jane Withers, writer. Used by permission of Hearst Magazine Media, Inc. In addition, a selection of photographs was published in the October 1999 issue of British *Vogue*. Alexandra Shulman, editor in chief; Robin Derrick, creative director; Marissa Bourke, design director; Isabella Kullmann, picture editor; Alice Rawsthorn, writer. Used by permission of The Condé Nast Publications Ltd.

John Pawson 100
A selection of photographs was originally published in the February 2000 issue of British *Vogue*. Alexandra Shulman, editor in chief; Robin Derrick, creative director; Marissa Bourke, design director; Isabella Kullmann, picture editor; Susie Forbes, writer. Used by permission of The Condé Nast Publications Ltd.

Tim Noble & Sue Webster 110
A selection of photographs was originally published in the February 2003 issue of British *Vogue*. Alexandra Shulman, editor in chief; Robin Derrick, creative director; Marissa Bourke, design director; Caroline Roux, writer. Used by permission of The Condé Nast Publications Ltd. Artworks reproduced with the kind permission of Tim Noble and Sue Webster.

Andrée Putman 120
A selection of photographs was originally published in the 2005 "Fall Design" issue of *T: The New York Times Style Magazine*. Stefano Tonchi, editor in chief; Janet Froelich, creative director; David Sebbah, art director; Kathy Ryan, photography director; Judith Puckett-Rinella, senior photography editor; Scott Hall, photography editor; Jennifer Pastore, assistant photography editor; Pilar Viladas, design editor and writer.

Seizure by Roger Hiorns 128
A selection of photographs was originally published in *Crystallized*, 2008. Chris Parker, creative director; Charles Darwent, writer. Artwork reproduced with the kind permission of Roger Hiorns, Artangel, and the Jerwood Charitable Foundation.

Zaha Hadid 134
A selection of photographs was originally published in the January 2008 issue of British *Vogue*. Alexandra Shulman, editor in chief; Robin Derrick, creative director; Jaime Perlman, art director; Michael Trow, photography director; Pippa Holt, sittings editor; Nonie Niesewand, writer; Adie Hannah, hair; Zoë Taylor, makeup. Used by permission of The Condé Nast Publications Ltd.

Marc Newson & Charlotte Stockdale 142
A selection of photographs was originally published in the March 2010 issue of British *Vogue*. Alexandra Shulman, editor in chief; Robin Derrick, creative director; Jaime Perlman, art director; Michael Trow, photography director; Vanessa Barneby, writer. Used by permission of The Condé Nast Publications Ltd.

Britt Moran & Emiliano Salci 154
A selection of photographs was originally published in the 2013 "Fall Women's Fashion" issue of *T: The New York Times Style Magazine*. Deborah Needleman, editor in chief; Patrick Li, creative director; Pilar Viladas, design editor; Nadia Vellam, photography director; Jamie Sims, senior photography editor; Caroline L. Hirsch, photography editor; Tom Delavan, writer.

Daniel & Juliet Chadwick 164
A selection of photographs was originally published in the October 2014 issue of British *Vogue*. Alexandra Shulman, editor in chief; Robin Derrick, creative director; Jaime Perlman, art director; Fiona Golfar, sittings editor; Michael Trow, photography director; Violet Henderson, writer; Gia Mills, hair and makeup. Used by permission of The Condé Nast Publications Ltd. Artworks reproduced with the kind permission of Daniel Chadwick.

Matt Gibberd & Faye Toogood 176
A selection of photographs was originally published in the 2013 "Winter Travel" issue of *T: The New York Times Style Magazine*. Deborah Needleman, editor in chief; Patrick Li, creative director; Rita Konig, European editor; Nadia Vellam, photography director; Jamie Sims, senior photography editor; Caroline L. Hirsch, photography editor; Pilar Viladas, design editor and writer.

Paula Rego 188
A selection of photographs was originally published in the November 2014 issue of British *Harper's Bazaar Art*. Justine Picardie, editor in chief; Marissa Bourke, creative director; Chloe Limpkin, photography director; Hannah Ridley, picture editor; Sophie Elmhirst, writer. Artworks reproduced with the kind permission of Paula Rego and Nick Willing.

Harriet Anstruther 196
A selection of photographs was originally published in the 2012 "Spring Design" issue of *T: The New York Times Style Magazine*. Sally Singer, editor in chief; David Sebbah, creative director; Andrew Gold, senior photography editor; Stephanie Waxlax Hughes, photography editor; Rory Walsh-Miller, associate photography editor; Pilar Viladas, design editor and writer.

Victoria Press 204
A selection of photographs was originally published in the April 2015 "Culture" issue of *T: The New York Times Style Magazine*. Deborah Needleman, editor in chief; Patrick Li, creative director; Tom Delavan, design editor; Rita Konig, European editor; Nadia Vellam, photography director; Gina Liberto, senior photography editor; Caroline L. Hirsch, photography editor; Marella Caracciolo Chia, writer.

Thomas Flohr 214
A selection of photographs was originally published in the November 2015 "Travel" issue of *T: The New York Times Style Magazine*. Deborah Needleman, editor in chief; Patrick Li, creative director; Tom Delavan, design editor; Nadia Vellam, photography director; Caroline L. Hirsch and Carter Love, photography editors; Dana Thomas, writer.

Cactus Dorée by Tom Dixon 226
A selection of photographs was originally published in the September 2019 "Design & Luxury" issue of *T: The New York Times Style Magazine*. Hanya Yanagihara, editor in chief; Patrick Li, creative director; Tom Delavan, design editor; Nadia Vellam, photography director; Carter Love, senior photography editor; Esin Ili Göknar and Lauren Poggi, photography editors; Nancy Hass, writer.

La Filanda by Luca Guadagnino 240
A selection of photographs was originally published in the September 2018 "Design & Luxury" issue of *T: The New York Times Style Magazine*. Hanya Yanagihara, editor in chief; Patrick Li, creative director; Tom Delavan, design editor; Nadia Vellam, photography director; Carter Love, senior photography editor; Esin Ili Göknar and Lauren Poggi, photography editors; Guy Trebay, writer.

Oliver Gustav 250
A selection of photographs was originally published in the March 2017 "Design" issue of *T: The New York Times Style Magazine*. Patrick Li, creative director; Nadia Vellam, photography director; Carter Love, senior photography editor; Esin Ili Göknar and Lauren Poggi, photography editors; Tom Delavan, design editor and writer.

Joerg & Maria Koch 260
A selection of photographs was originally published in the October 2014 "T@10" issue of *T: The New York Times Style Magazine*. Deborah Needleman, editor in chief; Patrick Li, creative director; Tom Delavan, design editor; Nadia Vellam, photography director; Gina Liberto, senior photography editor; Carter Love, photography editor; Marco Velardi, writer.

Cover:
The living room of Dimorestudio designers Britt Moran
and Emiliano Salci, Milan, photographed in 2013. Oushak
rug and velvet Zanuso chairs, 1951.

Page 2:
The Apartment, Mayfair, London, 1995, for Meiré und Meiré,
photographed in 1997. Concept by Peter Saville, interior
architecture by Ben Kelly; project architect: Helen Abadie.
Bust of Louis XIV and *Exotics*, 1997, a white glitter painting
by Martin McGinn.

Page 5:
Cactus Dorée, France, designed by Tom Dixon, photographed
in 2019. Hall with early seventeenth-century painting,
a Philippe Malouin light, and bench by Gio Ponti.

First published in the United States of America in 2024 by
Rizzoli International Publications, Inc.
300 Park Avenue South
New York, New York 10010
www.rizzoliusa.com

Publisher: Charles Miers
Senior Editor: Philip Reeser
Production Manager: Alyn Evans
Design Coordinator: Olivia Russin
Copy Editor: Claudia Bauer
Managing Editor: Lynn Scrabis

Copyright © 2024 by Henry Bourne
Foreword by Jane Withers
Text by Pilar Viladas with Robin Muir

Design by StudioSmall

The publisher and author would like to thank those individuals
who, and institutions that, have granted permission to reproduce
photographs in Turn of The Century and any copyright holders
for granting permission to reproduce works of art illustrated in
this book. Every effort has been made to contact the holders and
identify copyrighted material, and any omissions will be corrected
in future printings if the publisher is notified in writing.

ISBN: 978-0-8478-9992-0
Library of Congress Control Number: 2023945640
2024 2025 2026 2027 / 10 9 8 7 6 5 4 3 2 1
Printed and bound in China

MIX
Paper | Supporting
responsible forestry
FSC® C008047